IN AMERICA
A LEXICON
OF FASHION

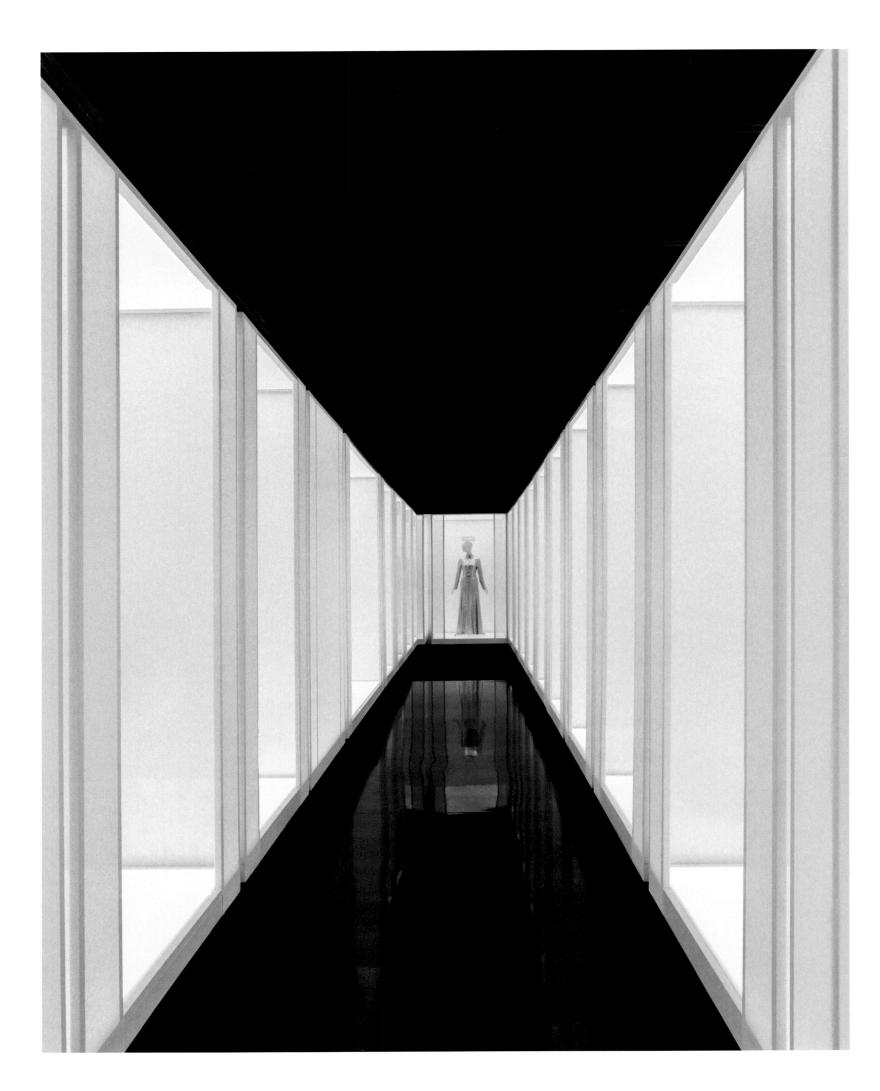

—

IN AMERICA
A LEXICON
OF FASHION

—

Andrew Bolton and **Amanda Garfinkel**

with **Jessica Regan** and **Stephanie Kramer**
Photographs by **Anna-Marie Kellen**

THE METROPOLITAN MUSEUM OF ART, NEW YORK

DISTRIBUTED BY YALE UNIVERSITY PRESS, NEW HAVEN AND LONDON

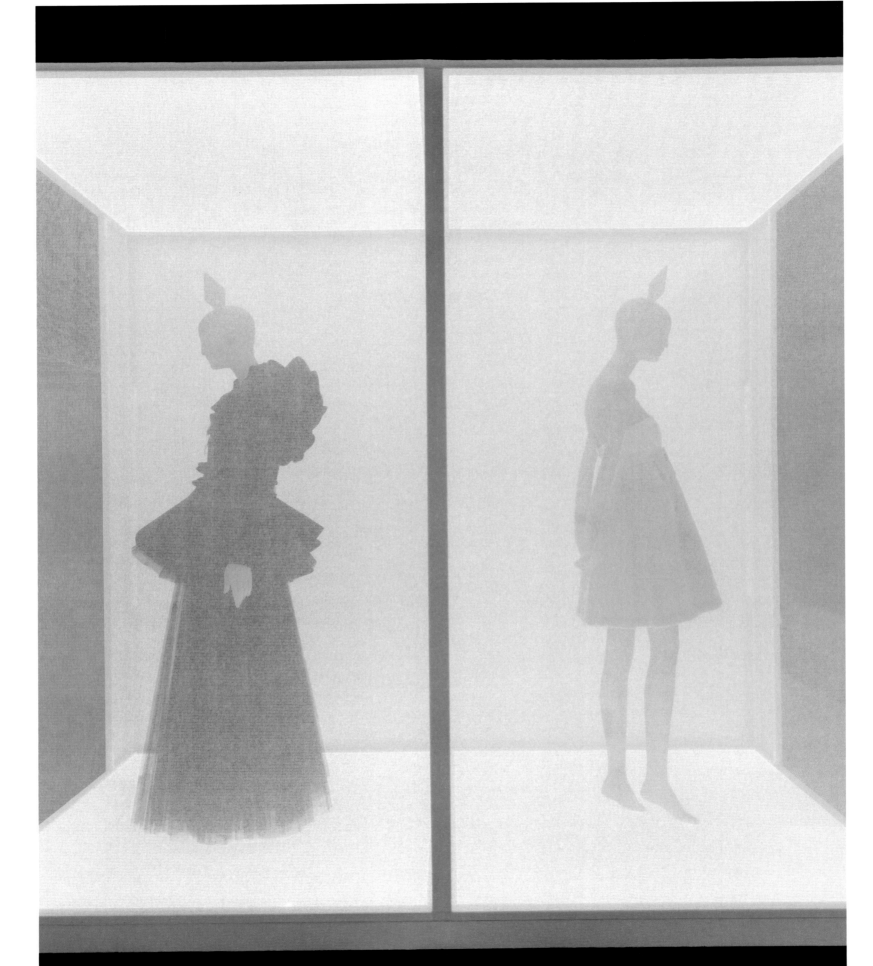

Contents

—

Sponsor's Statement

—

EVA CHEN
VICE PRESIDENT OF FASHION
INSTAGRAM

Instagram has been a longtime supporter of The Met and The Costume Institute, and this year we are especially excited to sponsor the two-part exhibition *In America: A Lexicon of Fashion* and *In America: An Anthology of Fashion*.

From its earliest days, Instagram has been a home for fashion—a place for people to get inspired, discover new brands, launch businesses, and build community. As a platform, we have helped democratize the fashion industry, as we believe in supporting all designers, from the emerging to the established. Over the last year, Instagram has also been a venue for real-time conversations related to activism and global movements for social and racial justice. We were inspired to see that this year's exhibition—with garments by a group of young, diverse designers—highlights many of the issues at the core of our culture.

We are honored to be part of this historic exhibition and hope it helps spark a global conversation on what fashion in America means today and tomorrow.

Director's Foreword

—

MAX HOLLEIN
MARINA KELLEN FRENCH DIRECTOR
THE METROPOLITAN MUSEUM OF ART

The Metropolitan Museum of Art is proud to present this publication, *In America: A Lexicon of Fashion*, which both celebrates The Costume Institute's 75th anniversary and explores a modern vocabulary of American fashion. It accompanies the exhilarating first part of a bipartite exhibition that opened in the Anna Wintour Costume Center on September 18, 2021. The second part, *In America: An Anthology of Fashion*, which opens in the Museum's American Wing period rooms on May 5, 2022, uncovers complex sartorial narratives as they relate to the histories of those spaces, bringing to light questions about race, class, and gender in American culture.

Fashion is both a harbinger of cultural change and a record of the forces, beliefs, and events that shape our lives. *In America: A Lexicon of Fashion* features garments created by designers working in the United States from the 1940s to the present, selected for their emotional resonance. Organized into categories that include Nostalgia, Belonging, Exuberance, Joy, Sweetness, Fellowship, Optimism, Strength, Desire, Spontaneity, Comfort, and Reverence, they show how feelings infuse a broad range of designs, each defined by its own expressive qualities.

Andrew Bolton, Wendy Yu Curator in Charge of The Costume Institute, conceived of and organized the exhibition and this catalogue with the support of Amanda Garfinkel, Assistant Curator. They selected the over one hundred objects featured in these pages that represent a new rhetoric of American fashion, giving special attention to designers who are often overlooked in the canon of fashion history. The organizing principle underlying the show—a patchwork quilt, itself a metaphor for American culture—is reflected in the diversity of the designers and their creations. Well-known works by established designers are interwoven with ones by emerging talents, many of whom are included in an exhibition at The Met for the first time.

The exhibition was designed by production designer Shane Valentino, working with cinematographer Bradford Young and The Met's Design Department to create a three-dimensional patchwork quilt. Milliner Stephen Jones designed the arresting "word bubble" headpieces on the exhibition mannequins. Eminent book designer Willem van Zoetendaal, aided by Maud van Rossum, created the stunning design for this publication, which features new photography by Anna-Marie Kellen, Associate Chief Photographer in The Met's Imaging Department. I would also like to thank the staff at The Costume Institute and other departments at The Met as well as the many freelancers who worked through challenging conditions during the ongoing pandemic.

I am profoundly grateful to Instagram for its support and sponsorship of both parts of this multifaceted exhibition, the related Costume Institute benefits, and this accompanying publication. Special thanks to the head of Instagram, Adam Mosseri, and to Eva Chen, Vice President of Fashion, for the company's extraordinary generosity. I am also thankful to Condé Nast for its continued support, and to Met Trustee Anna Wintour, who oversees The Met Gala, the primary fundraising source for The Costume Institute. For this two-part exhibition, she chaired the event celebrating the opening of *In America: A Lexicon of Fashion*—the first gala to be held since the pandemic and a signifier for us of the reemergence of this great city—and will do so again for *In America: An Anthology of Fashion*.

As you turn the pages of this book, I hope you will delight in the emotions evoked by the varied designs. This expressive dimension is sparking a renaissance of American fashion, with designers spearheading social, political, and philosophical conversations that are moving culture toward greater plurality and diversity. This revival highlights the importance of fashion and its ability to both reflect and represent the zeitgeist.

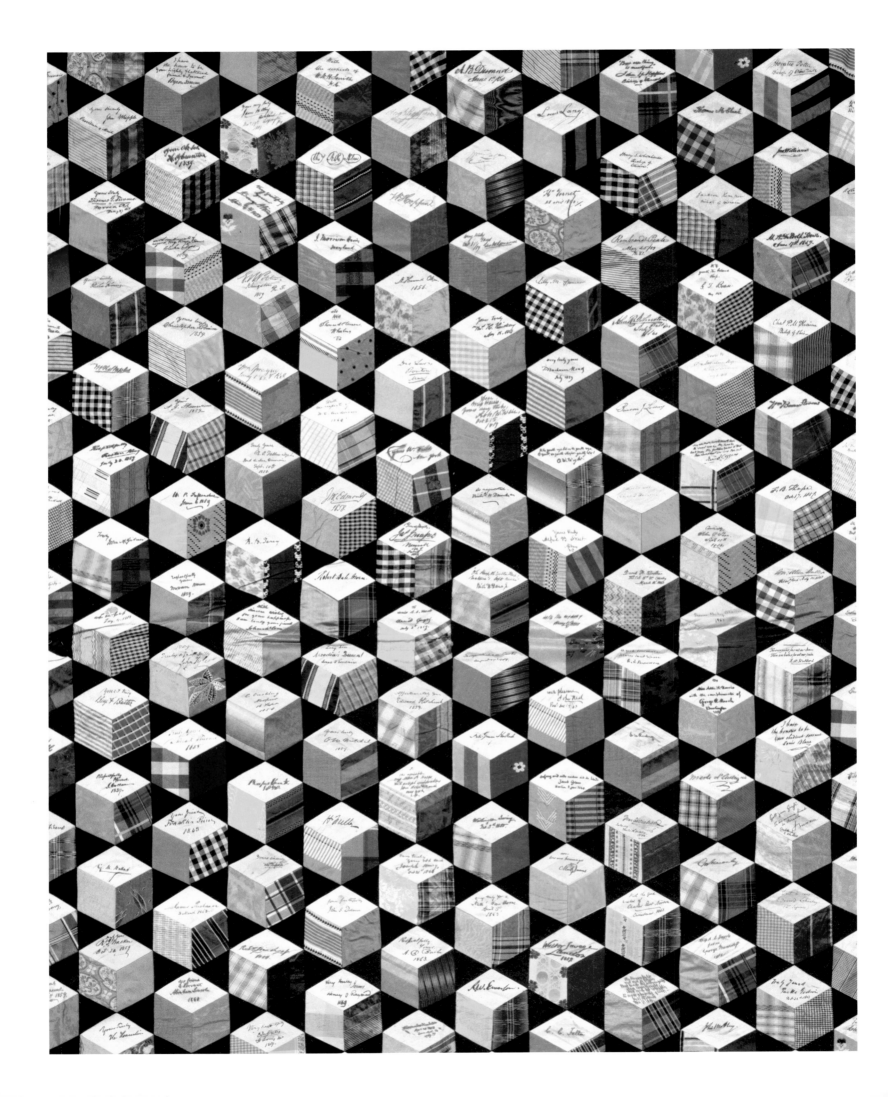

A Common Thread

—

ANDREW BOLTON

The year 2021 marked the seventy-fifth anniversary of The Costume Institute. When the department was founded in 1946, it was guided by the dual principles of representing fashion as an art form as well as supporting the American fashion industry. This support was seen as crucial in an era when American fashion was defining itself as independent from the design influences of Europe, and it came in the form of the collection itself—as an inspirational resource—and through exhibitions that highlighted the ingenuity of American designers.

In America: A Lexicon of Fashion represents a renewal of that original commitment and is dedicated to celebrating the originality and creativity of designers working in the United States. The importance of that founding mission became especially apparent during the past two years, given the impact of the COVID-19 pandemic on the fashion industry. Like in many creative industries, the pandemic—and the various social justice movements of 2020 and 2021—has prompted the fashion industry to undergo a process of self-reflection and reinvention. American designers are emerging as leaders in conversations about diversity and inclusion as well as sustainability and transparency. This leadership is generating a renaissance in American fashion similar to that witnessed during the founding era of The Costume Institute. Accordingly, we wanted to take the opportunity of our anniversary to celebrate this exciting new chapter in American fashion with the exhibition *In America: A Lexicon of Fashion*, which this catalogue complements.

Traditionally, American style has been defined in relation to the principles of utility, practicality, simplicity, and egalitarianism, and it has been largely denied the emotional rhetoric often applied to European fashion. To address this imbalance, *Lexicon* presents a revised vocabulary of American fashion based on its expressive qualities. This emphasis on fashion's emotional resonance was inspired in part by the work of a new generation of designers who prioritize feelings and sentiments over the pragmatics of clothing. However, as the exhibition and the catalogue reveal, these emotive qualities have always been present within American fashion, beginning with the pioneers of American sportswear in the 1930s and 1940s, such as Bonnie Cashin, Elizabeth Hawes, Vera Maxwell, and Claire McCardell.

This new lexicon is also intended to articulate the heterogeneity of American fashion, which cannot be adequately described through a narrow and universalizing set of terms. To reflect this diversity, *A Lexicon of Fashion* is based on the organizing principle of a patchwork quilt. In his speech at the 1984 Democratic National Convention, the Reverend Jesse Jackson suggested the quilt as a metaphor for the United States. As he described it, "America is not like a blanket—one piece of unbroken cloth, the same color, the same texture, the same size. America is more like a quilt—many patches, many pieces, many colors, many sizes, all woven and held together by a common thread." The quilt is an equally apt metaphor for American fashion, and the designers chosen for inclusion in *Lexicon*—both established and emerging—were selected to collectively represent the various aesthetics, emotional resonances, and cultural identities that form this multifaceted patchwork.

To introduce this conceit, *Lexicon* highlights a quilt made by a young American woman, Adeline Harris Sears. Beginning in 1856, seventeen-year-old Harris sent small diamond-shaped pieces of white silk to people she esteemed as the most important figures of her day, asking each to sign these patches of silk and return them to her for incorporation into the quilt. Over a time span of eleven years, Harris amassed a collection of 360 autographs that compose a nearly complete gathering of the most famous Americans of her era. These signatures include eight American presidents (notably, Abraham Lincoln) and luminaries from the worlds of science, religion, education, and the arts. Stitching these pieces into the quilt, Harris grouped similar professionals together in rows, creating a patchwork portrait of mid-nineteenth-century America.

This remarkable and immaculately constructed signature quilt with its tumbling-blocks pattern provided the inspiration

Adeline Harris Sears (American, 1839–1931).
Signature Quilt, "Tumbling Blocks" Pattern (detail), begun 1856. Silk

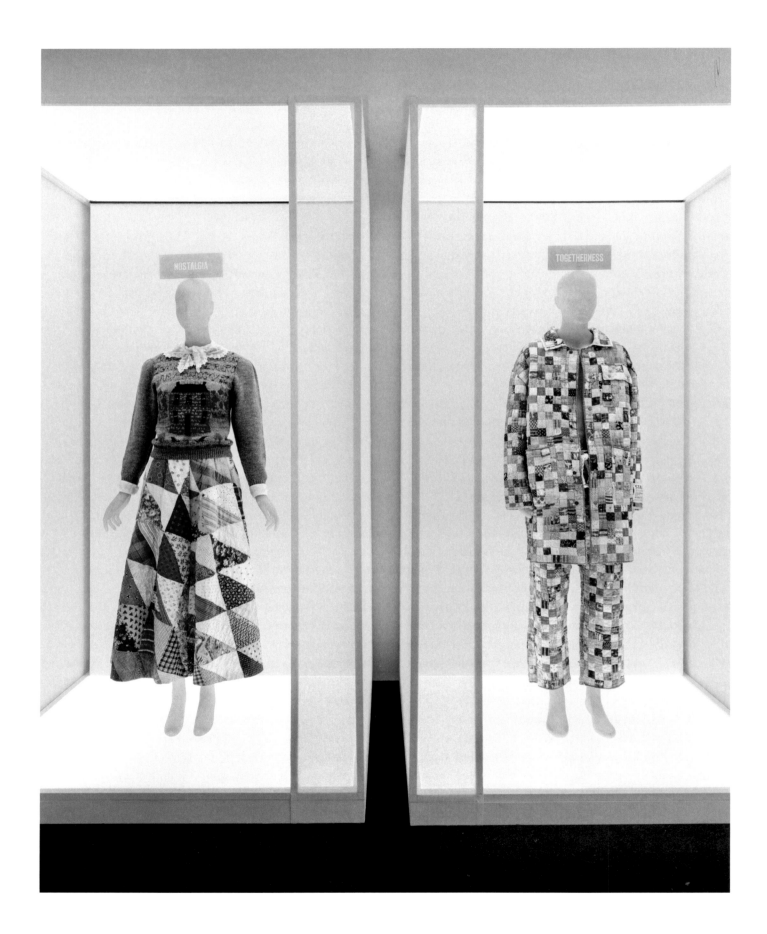

for both the design and organization of the exhibition and the catalogue. In the exhibition, single garments were enclosed within fabric-wrapped cases—like three-dimensional quilt squares. Here, they are likewise presented individually and shown alongside details that highlight key design elements. Dating from the 1940s to the present, garments are organized into twelve categories that explore defining emotional qualities of American fashion, including: Nostalgia, Belonging, Exuberance, Joy, Sweetness, Fellowship, Optimism, Strength, Desire, Spontaneity, Comfort, and Reverence. Within each of these sections, individual costumes reflect various expressions of these sentiments, and the accompanying text enriches the connection between the garment and the word chosen to represent it. While each of these words is distinct to the associated design, as a whole, they are stitched together through their emotional resonance, resulting in a richly textured quilt of American fashion that is as diverse as the nation itself.

Lexicon begins with a section anchored by the sentiment Nostalgia, which presents a series of patchworked garments that reflect connections to the past through their use of—and reference to—antique textiles, garments, and craft traditions. United by their patchwork composition, these fashions underscore the central metaphor of the quilt. The term "Nostalgia" is itself highlighted through an ensemble by Ralph Lauren from his autumn/winter 1982–83 collection comprising a skirt made from an antique quilt paired with a sweater inspired by nineteenth-century needlework samplers depicting a house and letters of the alphabet. Other designs include an ensemble by Tristan Detwiler for his label Stan constructed from a late nineteenth-century one-patch pattern quilt and a jacket by Emily Adams Bode composed of a crazy-pattern quilt, characterized by the haphazard arrangement of fabric patches in various shapes and sizes. The word "Togetherness" was chosen to represent Detwiler's ensemble, reflecting the camaraderie of the quilting circle that he belongs to and that influenced his collection. "Sentimentality" is used to describe Bode's design, as her use of vintage fabrics is intended to evoke a sense of connection to—and longing for—the past.

The following sections reveal the broad spectrum of sentiments conveyed by American fashion and the expressive power of American design—past and present. To reflect fashion's continuing and fundamental commitment to sustainable practices, *Lexicon* ends with the sentiment Reverence and includes the work of designers who place ethical processes at the center of their creativity. Most of the pieces are one-of-a-kind, customized garments made from deadstock fabric or recycled and repurposed clothing. One design by Miguel Adrover, associated with the word "Authenticity," is made from a vintage Burberry trench coat that has been turned inside out and dressed back to front. Another design, by Sophie Andes-Gascon and Claire McKinney for their label SC103, consists of interlocking strips of deadstock leather. Its affinity with the emotion Gratitude is a nod to the influence of Susan Cianciolo, an early exponent of upcycling and recycling who taught Andes-Gascon and McKinney at the Pratt Institute in New York and whose work is also featured in this section under the word "Permanence."

The curators selected the term specific to each garment by considering several criteria, including interviews with the designers or reviews of their collections. Sometimes the words reflect our own personal opinions or emotional responses to the fashions. While curators usually strive for a certain level of objectivity in their endeavors, we felt justified on this occasion to indulge in such a subjective exercise given that our aim was to arrive at a modern vocabulary of American fashion based on its expressive qualities. Fashion is so familiar, so accessible, and so ubiquitous to our experience that it is open to a wide range of interpretations. Indeed, since its power lies in its complete integration in our lives, fashion inspires confidence in the essential aptness of our judgments. It is our hope, therefore, that visitors to the exhibition and readers of this catalogue engage with and reflect upon their own emotional reactions to the garments, facilitating an expanded vocabulary—or lexicon, if you will—of the defining qualities of American fashion that fully encompasses its vitality, diversity, richness, and complexity.

A LEXICON OF FASHION

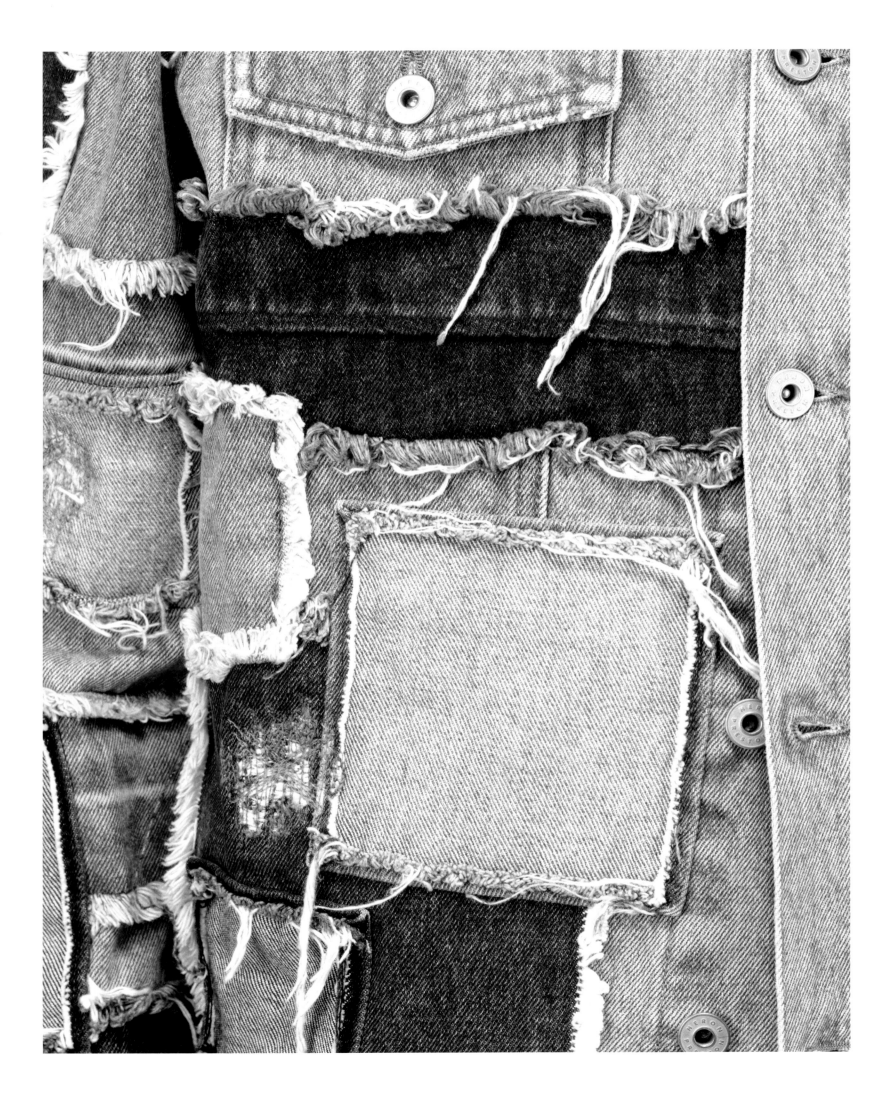

NOSTALGIA

—

NOSTALGIA

TOGETHERNESS

REMEMBRANCE

SENTIMENTALITY

YEARNING

REMINISCENCE

REVERIE

WISTFULNESS

CONTINUITY

COMMEMORATION

CELEBRATION

CONNECTION

ATTACHMENT

—

NOSTALGIA

—

A wistful or sentimental yearning
for a return to or the return of some real
or romanticized period of the past

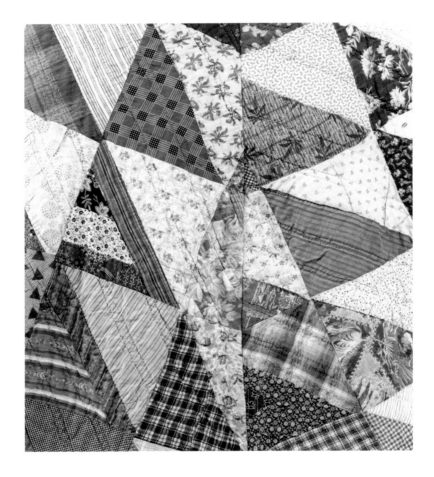

For his autumn/winter 1982–83 collection, Ralph Lauren referenced American folk art
and crafts. Nineteenth-century needlework samplers, which often featured the letters of
the alphabet and the motif of the home, inspired the design of this hand-knit sweater.
Lauren's use of antique patchwork quilts to construct the accompanying skirt reflects
his appreciation for handwork. Speaking to a journalist in 1982, Lauren said, "Folk art,
for me, represents the integrity that is America."

Ralph Lauren (American, born 1939)
ENSEMBLE, AUTUMN/WINTER 1982–83
Sweater of polychrome wool intarsia knit;
skirt of patchwork quilted, polychrome printed cotton plain weave;
blouse of white linen plain weave and cotton lace

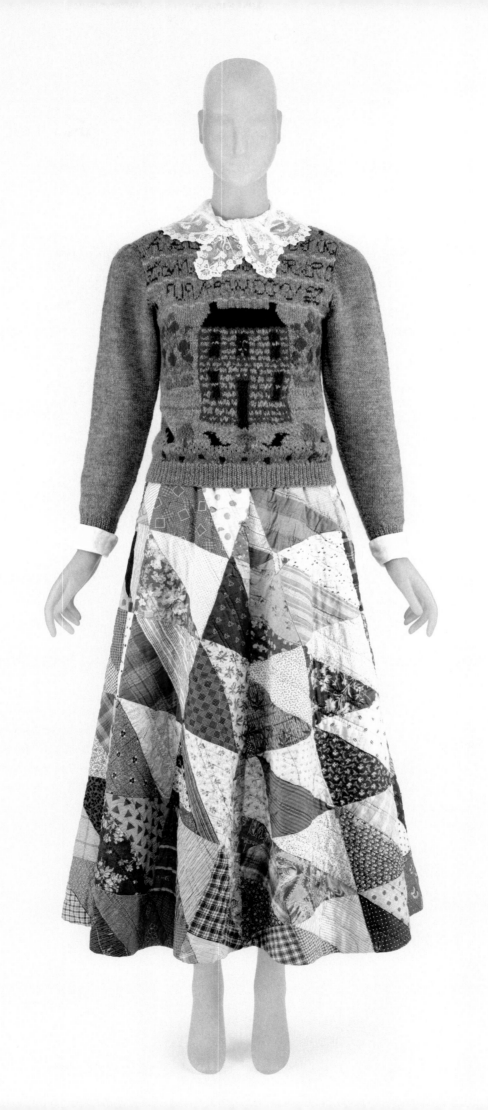

TOGETHERNESS

—

*The quality or state of being
or belonging together or of forming related parts
of a unified whole*

Tristan Detwiler of Stan began reworking antique quilts into garments in 2018.
A chance encounter with eighty-year-old quilt maker Claire McKarns introduced Detwiler
to the Bumann Quilters of Olivenhain, California. After becoming a member, he applied
the group's shared knowledge to his autumn/winter 2021–22 collection. He constructed
this ensemble using a late nineteenth-century one-patch pattern quilt given to him
by McKarns. By cutting the jacket and trouser patterns directly from the quilt, he was
able to maintain its original design.

Stan (American, founded 2020)
Tristan Detwiler (American, born 1997)
ENSEMBLE, AUTUMN/WINTER 2021–22
Patchwork quilted, polychrome printed cotton plain weave

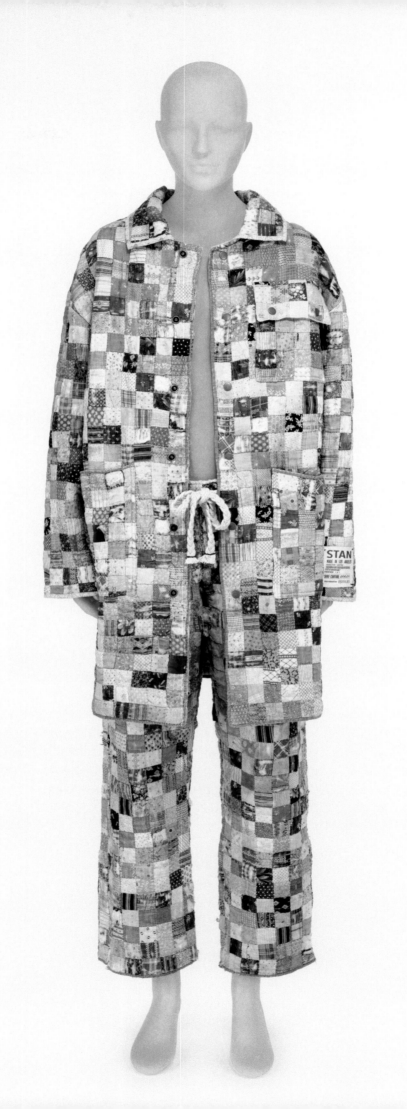

REMEMBRANCE

—

1 — The state of bearing in mind; the state of remembering
2 — A memory of a person, thing, or event
3 — Something that serves to keep in or brings to mind

In her designs, Mimi Prober incorporates delicate antique fabrics that she first mends using traditional methods of embroidery, appliqué, lace making, beading, and dyeing. For this ensemble from her autumn/winter 2018–19 collection, Prober reworked a crazy-pattern quilt into the shape of a motorcycle jacket—two objects known for bearing traces of their owners. Prober preserved the quilt's date and its maker's signature as evidence of its origins.

Mimi Prober (American, born 1986)
ENSEMBLE, AUTUMN/WINTER 2018–19
Jacket of patchwork polychrome silk plain weave and
silk velvet embroidered with cotton thread;
trousers of patchwork polychrome wool, cotton flannel,
and cotton twill embroidered with cotton thread

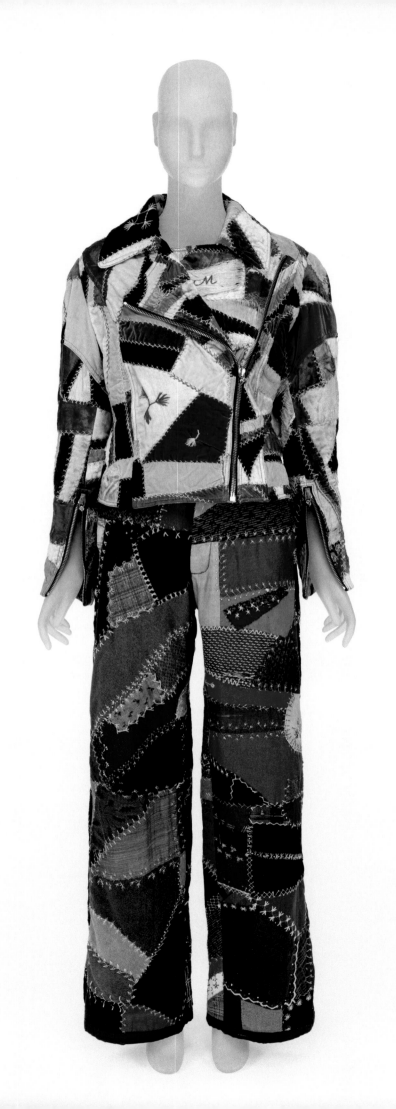

SENTIMENTALITY

—

*The quality or state of being marked
or governed by feeling, sensibility,
or emotional idealism*

Emily Adams Bode launched her namesake menswear label in spring/summer 2018
with a collection of garments made entirely of antique textiles. She continues to create
one-of-a-kind garments using internationally sourced vintage fabrics that evoke the
periods and places in which they were produced. The jacket in this ensemble is
constructed from a crazy-pattern quilt, identifiable by the haphazard arrangement
of fabrics in varied shapes and weaves. The history of each fragment reflects the
element of storytelling embedded in Bode's fashions.

Bode (American, founded 2016)
Emily Adams Bode (American, born 1989)
ENSEMBLE, 2020–21
Jacket and trousers of patchwork polychrome cotton, synthetic,
and wool plain weave jacquard and twill embroidered with cotton thread;
shirt of white synthetic georgette embroidered with cotton thread

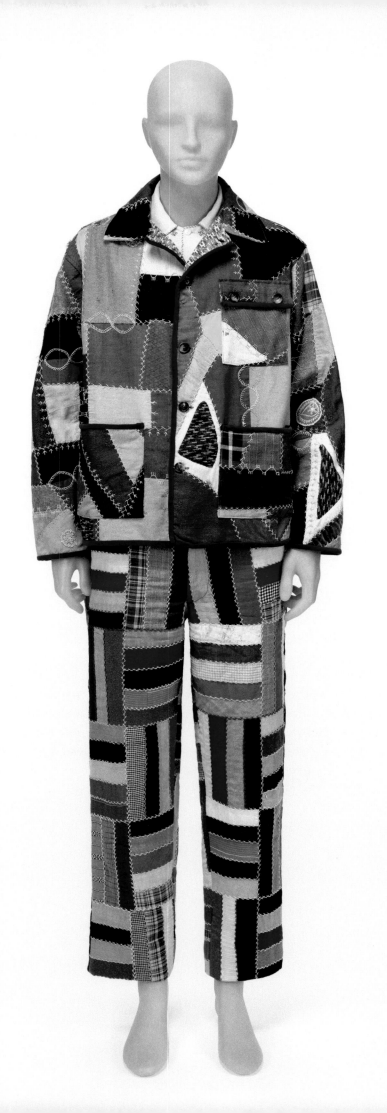

YEARNING

A tender or urgent longing

Stephen Bruce, Preston (Patch) Caradine, and Calvin Holt opened the Serendipity3 boutique on the Upper East Side of Manhattan in 1954. Tagged "America's Most General Store," it began as an antiques shop and developed into a restaurant and boutique famed for its outsize desserts and distinctive fashions. This full-length, A-line robe from the 1976 denim collection—pieced together from remnants of discarded garments—aligns with the period's romantic idealization of the past.

Serendipity3 (American, founded 1954)

ROBE, 1976

Patchwork blue cotton denim

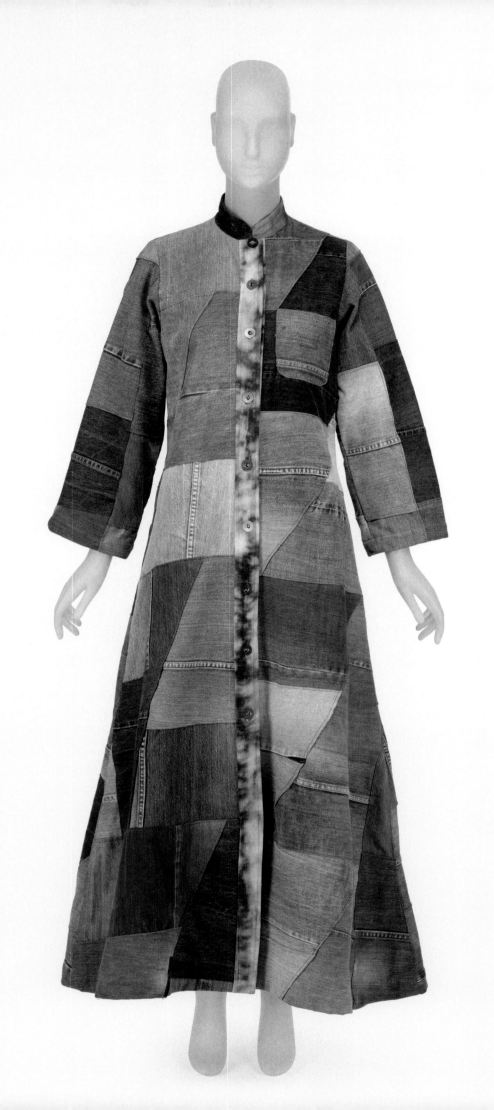

REMINISCENCE

—

*The process or activity of thinking
or telling about past experiences*

Heron Preston's spring/summer 2021 collection concentrated on the trademarks of his
namesake label: the simplicity and durability of work wear, exemplified by this ensemble.
Preston densely layered the jacket and trousers with denim remnants from past
collections in a patchwork pattern suggesting generations of use and repair. The raw
edges convey a sense of spontaneity and an unfinished quality appropriate for
hard-wearing garments.

Heron Preston (American, born 1983)
ENSEMBLE, SPRING/SUMMER 2021

Patchwork blue cotton denim embroidered with orange cotton thread

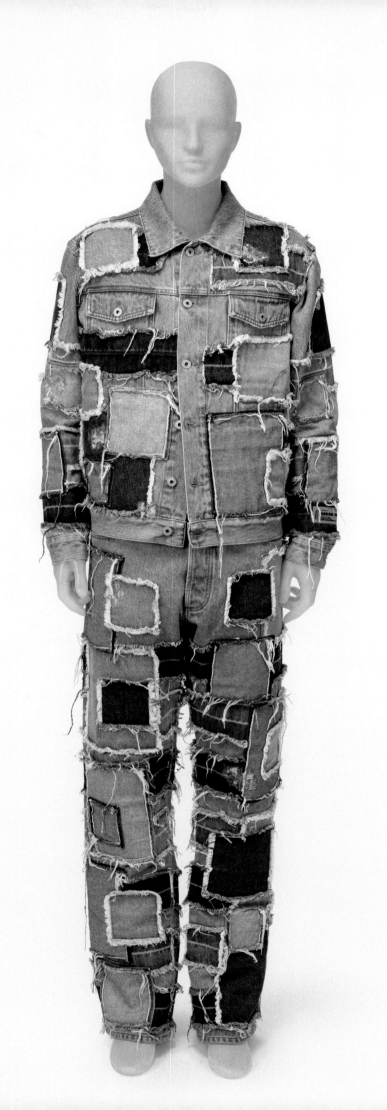

REVERIE

The condition of being lost in thought

No Sesso, the label founded by Pierre Davis in 2015, translates from Italian as "no sex/
gender." Although a commitment to gender-neutral design is fundamental to her practice,
Davis is equally dedicated to sustainable production and diverse representation. For her
autumn/winter 2017–18 collection, she imagined a wardrobe for Black bodies in an
optimistic future. This wrap coat features a kaleidoscopic arrangement of repurposed
denim finished with a buoyant flounce at the top edge and bottom hem.

No Sesso (American, founded 2015)
Pierre Davis (American, born 1989)
ENSEMBLE, AUTUMN/WINTER 2017–18

Patchwork blue cotton denim

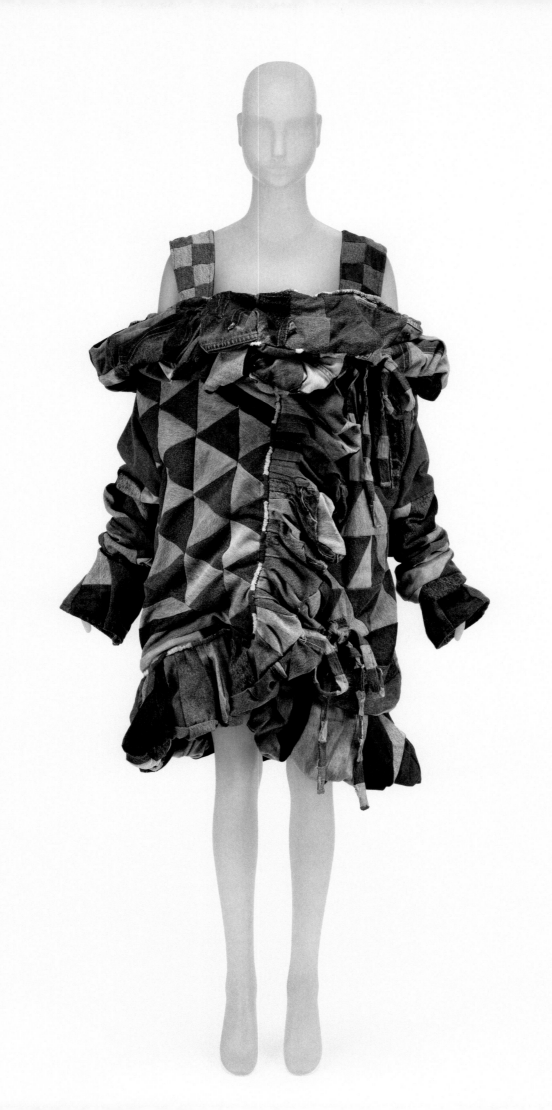

WISTFULNESS

—

Full of yearning or desire tinged with melancholy

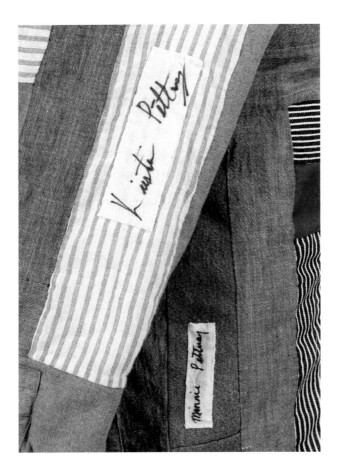

As inspiration for his spring/summer 2021 collection, Greg Lauren (nephew of Ralph Lauren) cited the celebrated quilt makers and quilt-making traditions of Gee's Bend, a historic Black community in Alabama. As a coda to the collection, Lauren collaborated with Gee's Bend quilters on an edition of fourteen custom garments. Using scrap fabric from Lauren's studio, the quilters created patchwork panels applied to jackets, trousers, and accessories. This jacket is tagged with the names of its Gee's Bend makers: Priscilla Hudson, Kristin Pettway, and Minnie Mae Pettway.

Greg Lauren (American, born 1970)
Priscilla Hudson (American, born 1963)
Kristin Pettway (American, born 1998)
Minnie Mae Pettway (American, 1939–2021)

SHIRT, 2021

TROUSERS, SPRING/SUMMER 2021

Shirt of patchwork polychrome cotton chambray, oxford, ticking, and denim; trousers of cotton twill and patchwork polychrome cotton denim, chambray, and linen plain weave

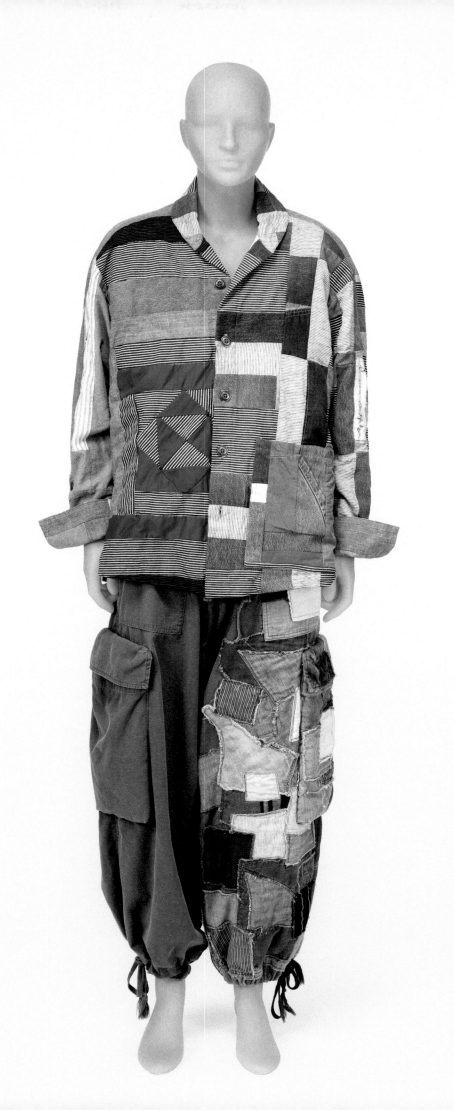

CONTINUITY

—

Uninterrupted connection, succession, or union

Erin Beatty debuted Rentrayage, French for "to mend" or "to make whole again," in 2019.
Formerly codesigner of the label Suno, Beatty has turned her focus to sustainable
production and the creation of new garments from old ones. Here, Beatty fused sections
of three garments together along three seams—two horizontal and one vertical. Although
the original silhouettes remain largely unaltered, the short sleeve on the left side of
the garment and the full sleeve on the right skew the proportions of the new design.

Rentrayage (American, founded 2019)
Erin Beatty (American, born 1979)
"CARRIE'S PROM DRESS," AUTUMN/WINTER 2019–20
Polychrome printed cotton-synthetic plain weave trimmed with white synthetic lace

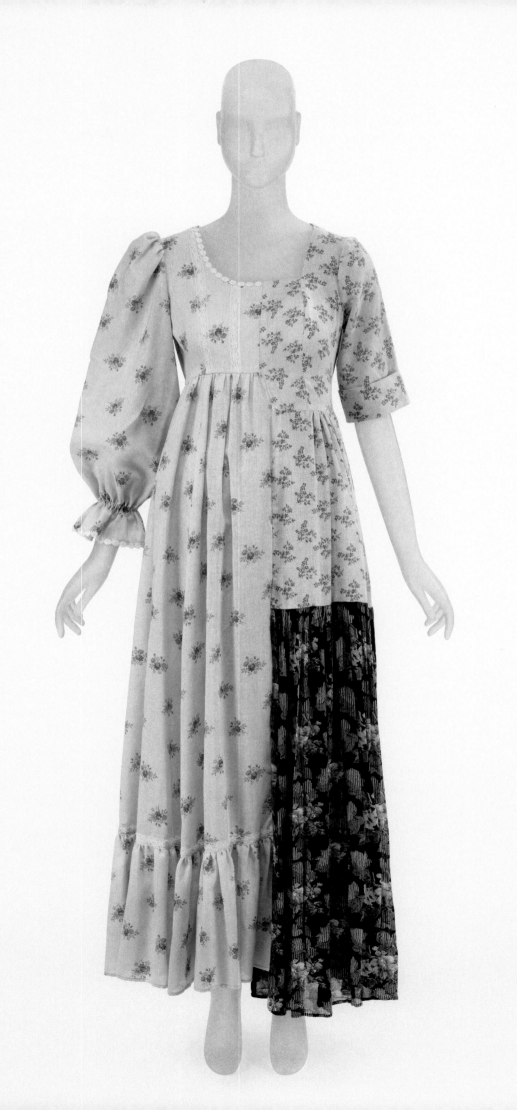

COMMEMORATION

—

The act of calling to remembrance

Sarah Nsikak's fashions for La Réunion celebrate the resilience and creativity of African makers. This ensemble features her signature one-of-a-kind patchwork dress inspired by the traditional costumes of Namibia's Herero tribe that are pieced from the remnants of used garments and modeled after the nineteenth-century silhouettes of German colonists. Made of locally sourced surplus cotton, Nsikak's dress combines panels of printed fabric in a carefully organized arrangement of pattern and color on the skirt, which falls in voluminous folds from a band at the bust line supported by flat straps at the shoulder.

La Réunion (American, founded 2019)
Sarah Nsikak (American, born 1991)
ENSEMBLE, 2021
Dress of pieced polychrome printed and embroidered cotton,
linen and silk plain weave, twill, and satin; shirt of blue and white cotton chambray

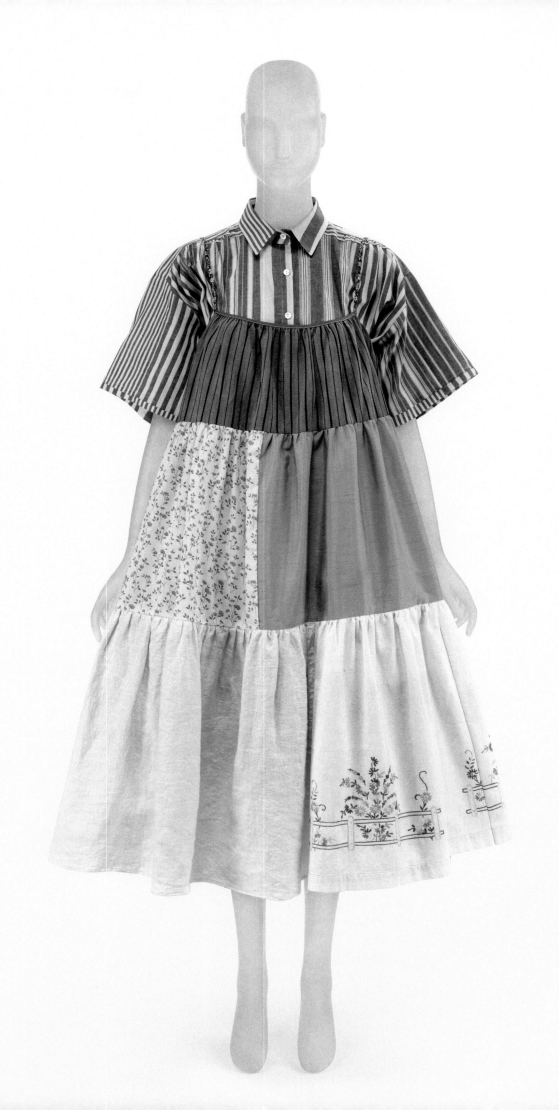

CELEBRATION

—

*The act of marking by festivities
or other deviation from routine*

Artist and designer Carly Mark founded Puppets and Puppets in 2018. Her eccentric designs convey a sense of fantasy and theatricality uncommon in American fashion. Her autumn/winter 2021–22 collection featured her signature combination of historical references and dramatic proportions. This dress is patchworked with remnants of varied silk weaves, colors, and patterns. Nineteenth-century-inspired gigot-like poufs interrupt its columnar silhouette at the right arm and left hip of the garment.

Puppets and Puppets (American, founded 2018)
Carly Mark (American, born 1988)
DRESS, AUTUMN/WINTER 2021–22
Pieced polychrome printed silk taffeta, satin, and shantung;
blue silk satin; polychrome silk jacquard; and polychrome silk velvet

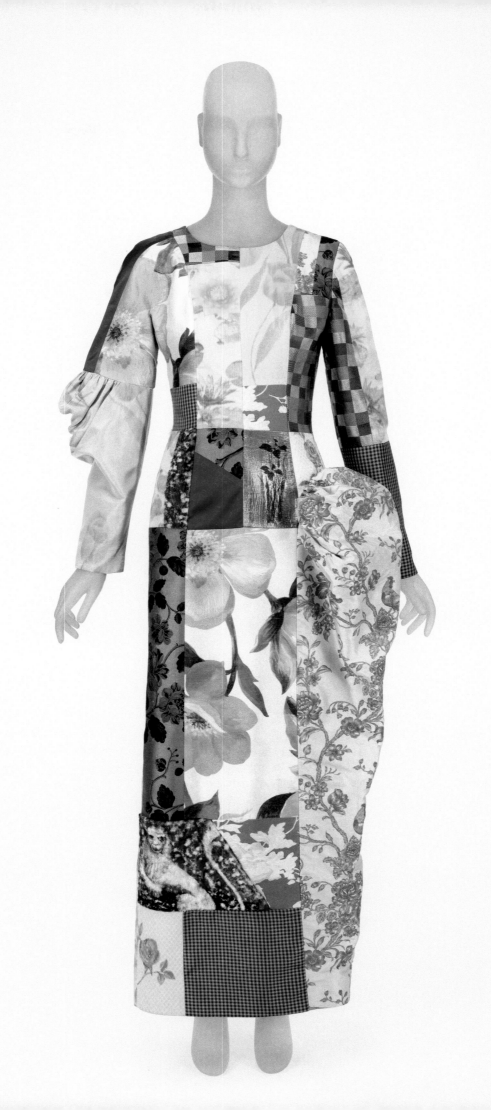

CONNECTION

—

The state of being joined or linked together

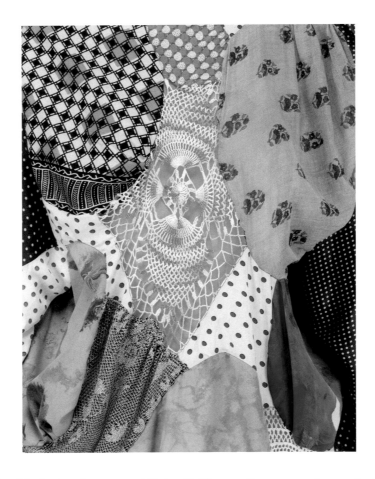

Designers Sophie Andes-Gascon and Claire McKinney of SC103 are known for their one-of-a-kind, handmade garments that are "meant to be touched, felt, held." Andes-Gascon and McKinney pieced together fragments of repurposed fabric in various prints, weaves, and weights to create this dress from their spring/summer 2020 collection. Sections of excess fabric gathered into circular seams create deflated bubbles that add dimension and texture to the surface.

SC103 (American, founded 2019)
Sophie Andes-Gascon (Canadian, born 1993)
Claire McKinney (American, born 1993)
DRESS, SPRING/SUMMER 2020
Pieced polychrome cotton poplin and jersey, polychrome silk crepe de chine,
and polychrome crochet cotton lace doilies

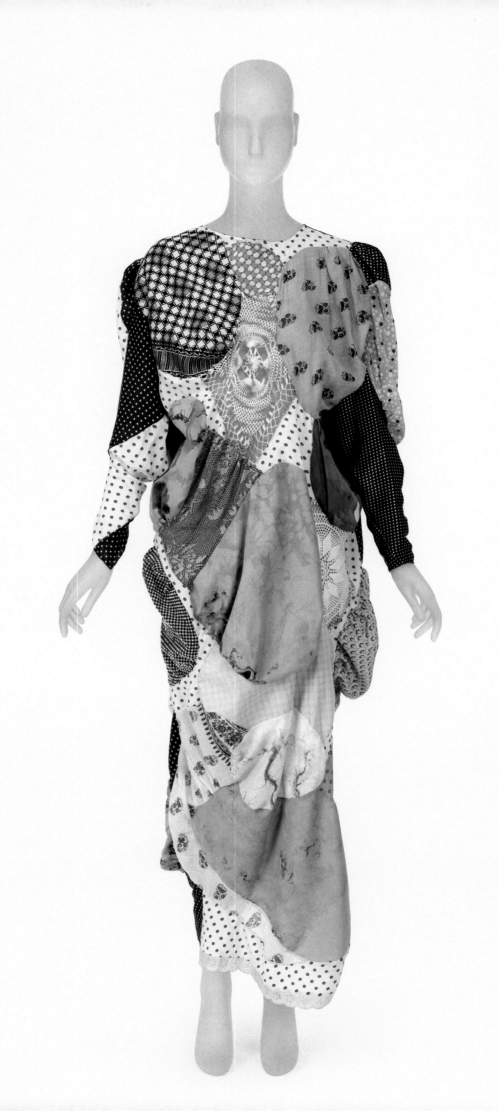

ATTACHMENT

—

1 — Affectionate regard
2 — A strong emotional bond

Eli Russell Linnetz's designs for his monogrammatic label, ERL, are informed by personal experiences and the aesthetics and customs of Venice Beach, California, where he lives and works. Linnetz's spring/summer 2022 "An American Tale" collection featured a cast of teenaged characters dressed in reimagined styles from the 1970s—sports uniforms and undergarments; handmade, hand-me-down play clothes; and denim customized with decorative florals and memorabilia. This wrap coat—the finale of the collection—was worn by rapper A$AP Rocky to The Met Gala in 2021 and is made of a puff quilt Linnetz found at a thrift store backed with fabric remnants of the designer's own boxer shorts and his father's bathrobe. The great-granddaughter of the quilt maker recognized it in coverage of the event and shared images of it in its original form on social media, connecting her with Linnetz. The histories and memories of both families are layered in the garment—a symbol of the comfort and intimacy of home.

ERL (American, founded 2018)
Eli Russell Linnetz (American, born 1990)
COAT, SPRING/SUMMER 2022
Polychrome cotton and synthetic flannel and plaid and printed cotton plain weave

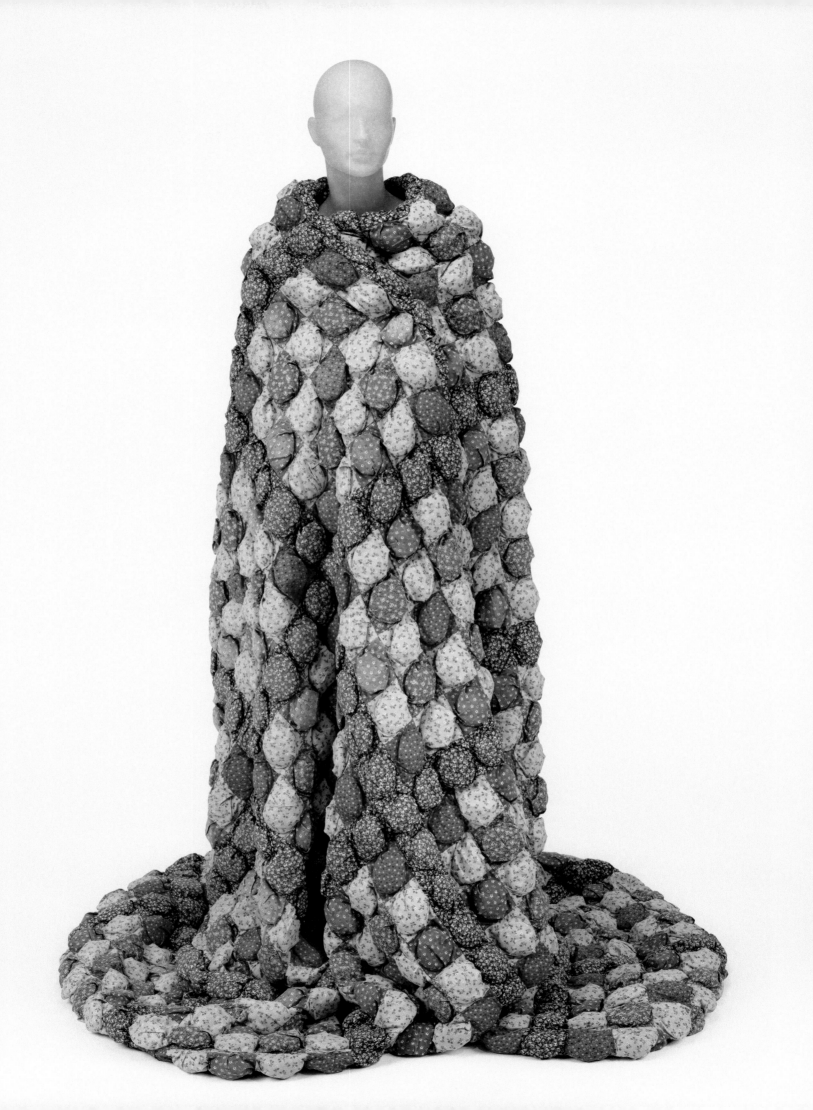

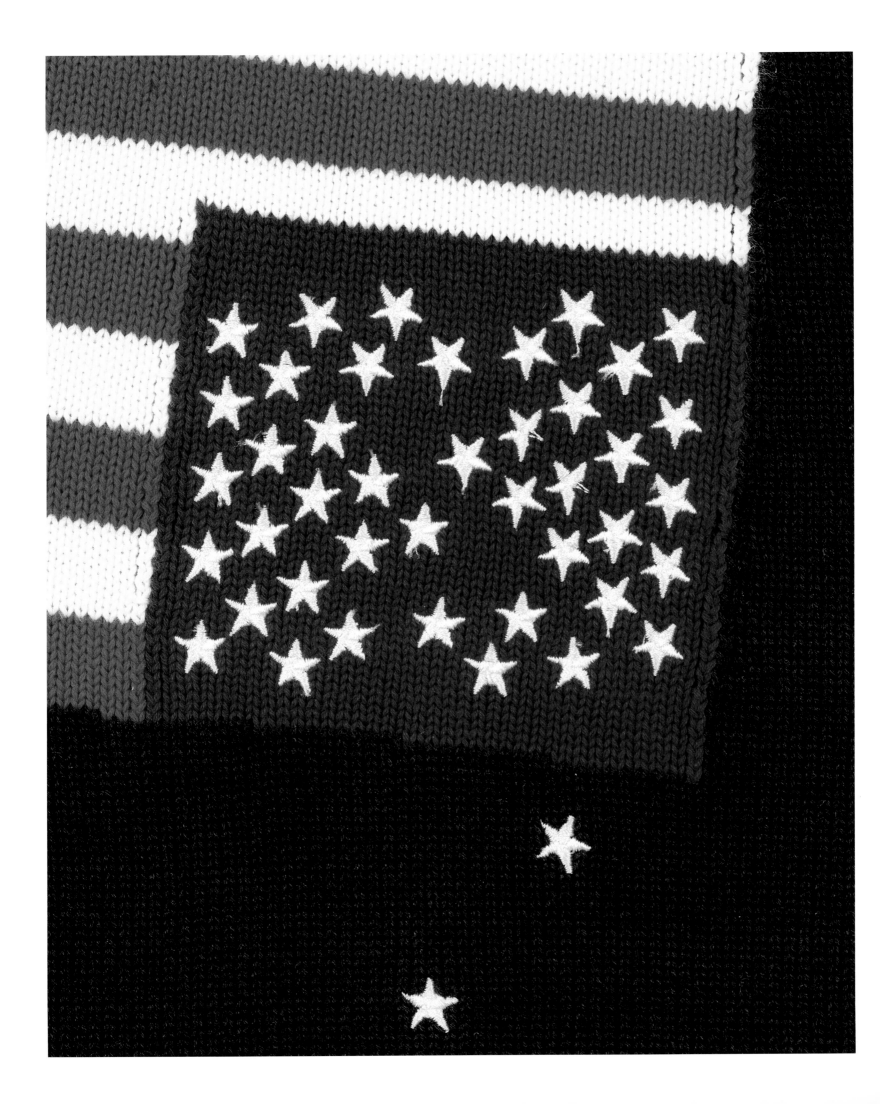

— BELONGING —

BELONGING

UNITY

IDEALISM

AFFIRMATION

SOLIDARITY

ISOLATION

BELONGING

—

1 — Close or intimate relationship; mutual loyalty
2 — [Belong] To become attached or bound (as to a person, group,
or organization) by birth, allegiance, or dependency

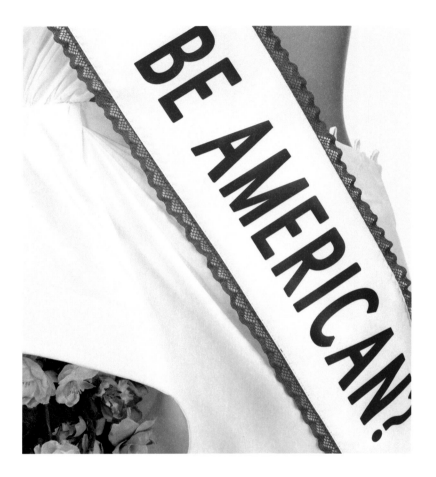

Prabal Gurung's spring/summer 2020 collection, which celebrated his eponymous label's
tenth anniversary, combined elements of American sportswear with features of traditional
Eastern dress. Here, the triangular cutout at the waist—a signature of Gurung's work—
references the wrapped construction of an Indian sari. The statement on the sash,
"Who Gets to Be American?," reflects the designer's activism on behalf of immigrants
as well as his own path to becoming an American citizen.

Prabal Gurung (American, born Singapore, 1979)
ENSEMBLE, SPRING/SUMMER 2020
Dress of white cotton poplin trimmed with polychrome synthetic flowers;
sash of polychrome printed synthetic satin

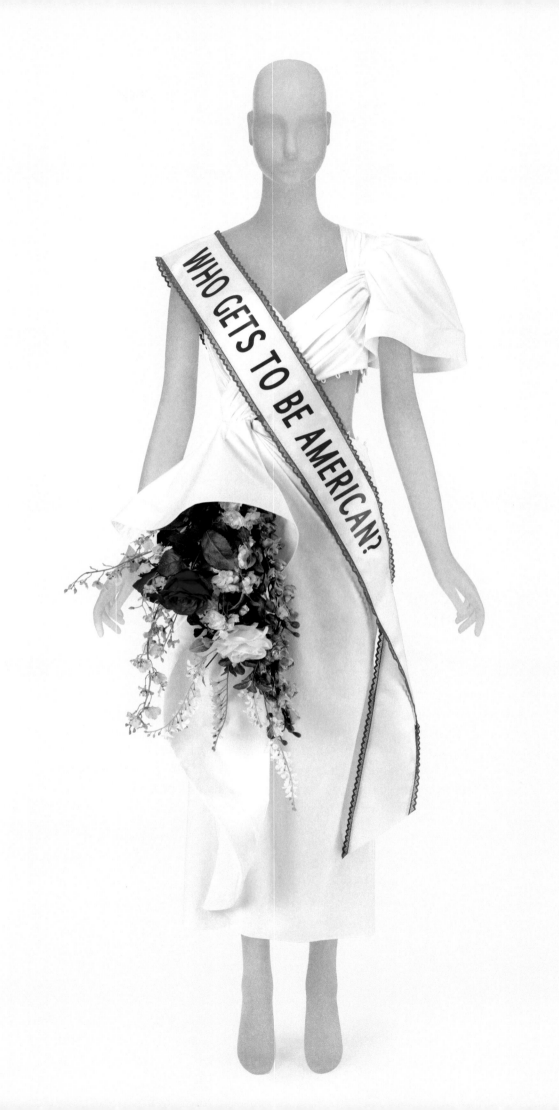

UNITY

—

*A condition of concordant harmony;
the state of full agreement; accord*

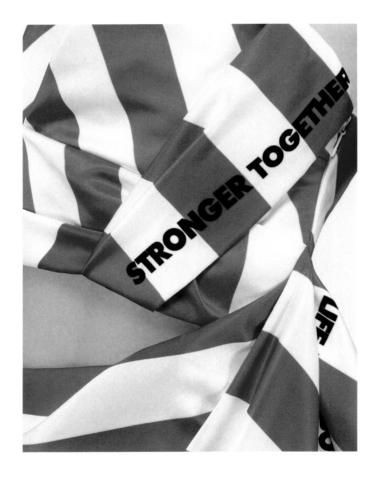

"Stronger Together" was the theme of Mexican American designer Raul Solís's spring/summer 2021 collection for LRS. The message was a call for unity and community in the midst of unprecedented division in American politics, turbulent social-justice demonstrations, and the devastation of the global COVID-19 pandemic. Titled "American Stripe," this dress from the collection is printed with the phrase in solid block letters along the left edge of the bodice. Its red-and-white fabric is draped around the figure like an uncut and unfinished flag.

LRS (American, founded 2014)
Raul Solís (American, born Mexico, 1984)
"AMERICAN STRIPE" DRESS, SPRING/SUMMER 2021
Polychrome printed synthetic satin

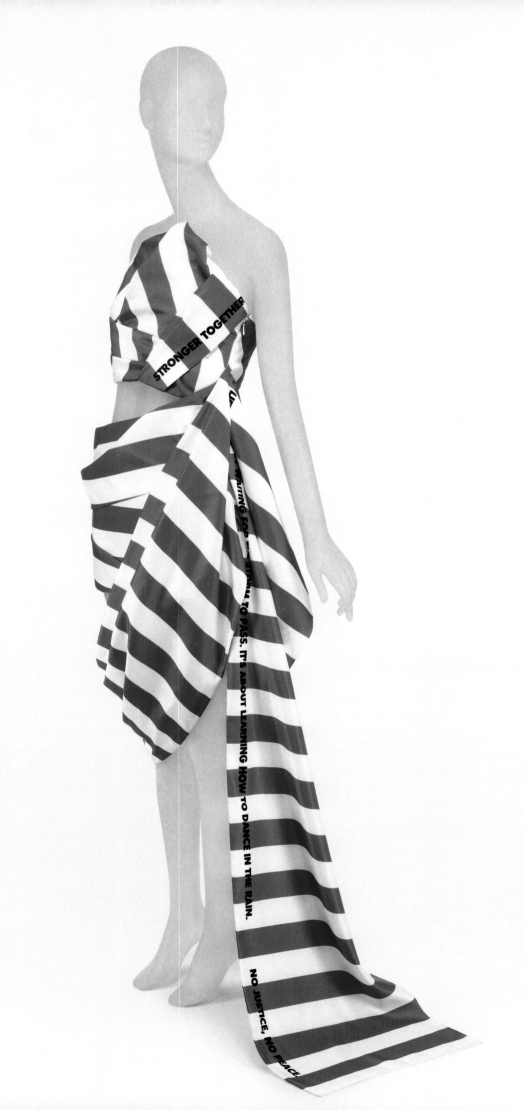

IDEALISM

The attitude of a person who believes that it is possible to live according to very high standards of behavior and honesty

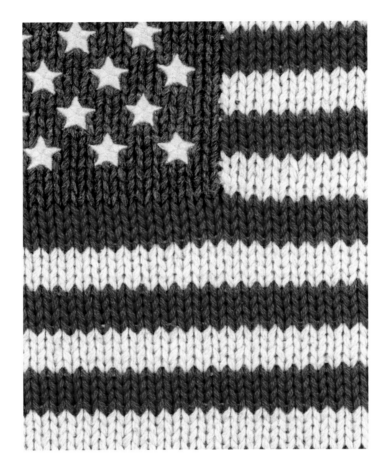

Ralph Lauren debuted the American-flag sweater in his autumn/winter 1989–90 womenswear collection. The garment features an 1820–22 version of the flag, with twenty-three stars representing the first twenty-three states in the union. For Lauren, the son of immigrants from Belarus, this flag represented the ideals of the newly independent nation. The sweater has become a hallmark of the brand and was worn by the designer himself at his spring 2002 presentation a week after the September 11 attacks.

Ralph Lauren (American, born 1939)

SWEATER, AUTUMN/WINTER 1989–90

Polychrome cotton intarsia knit

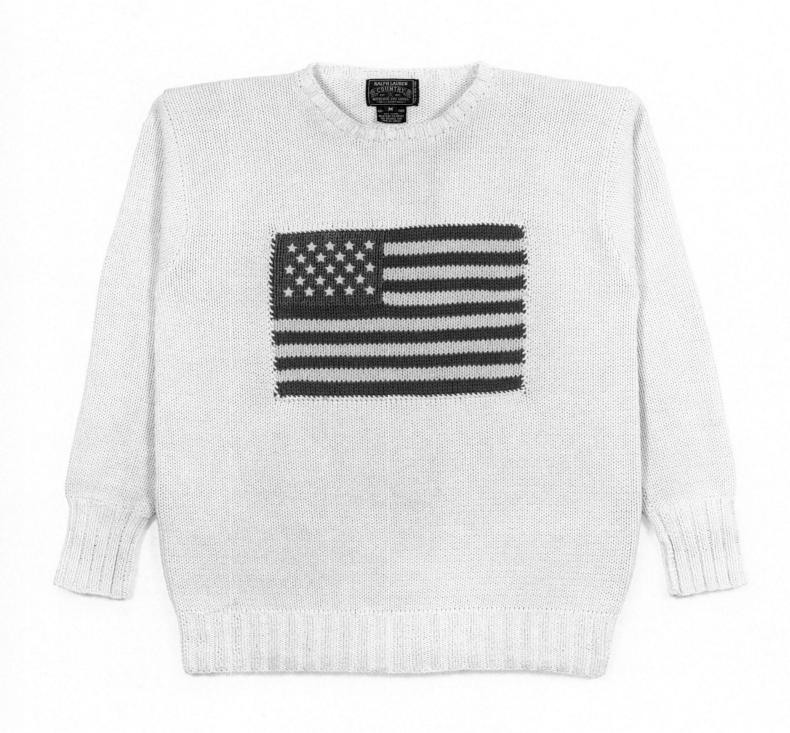

AFFIRMATION

—

*A solemn and often public declaration of the truth
or existence of something*

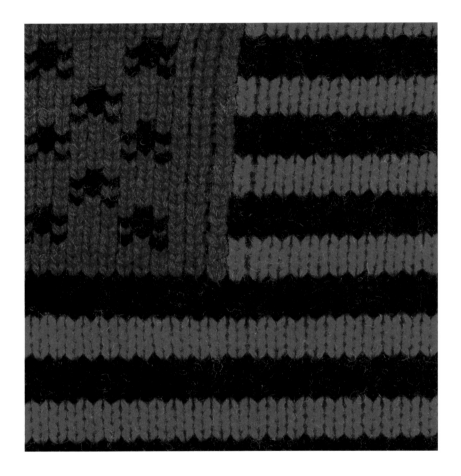

Tremaine Emory's designs for Denim Tears are inspired by the collective history and experience of Black Americans. This sweater, released in April 2021 and named after the black model Tyson Beckford, is a reinterpretation of Lauren's late 1980s design. By replacing the American flag with a version of Marcus Garvey's Pan-African flag and *African American Flag* by artist David Hammons, and by substituting the "RL" signature with the "DT" signature at the left hem of the garment, Emory transfers ownership of the design to the Black community.

Denim Tears (American, founded 2019)
Tremaine Emory (American, born 1981)
"TYSON BECKFORD" SWEATER, 2021
Polychrome wool intarsia knit

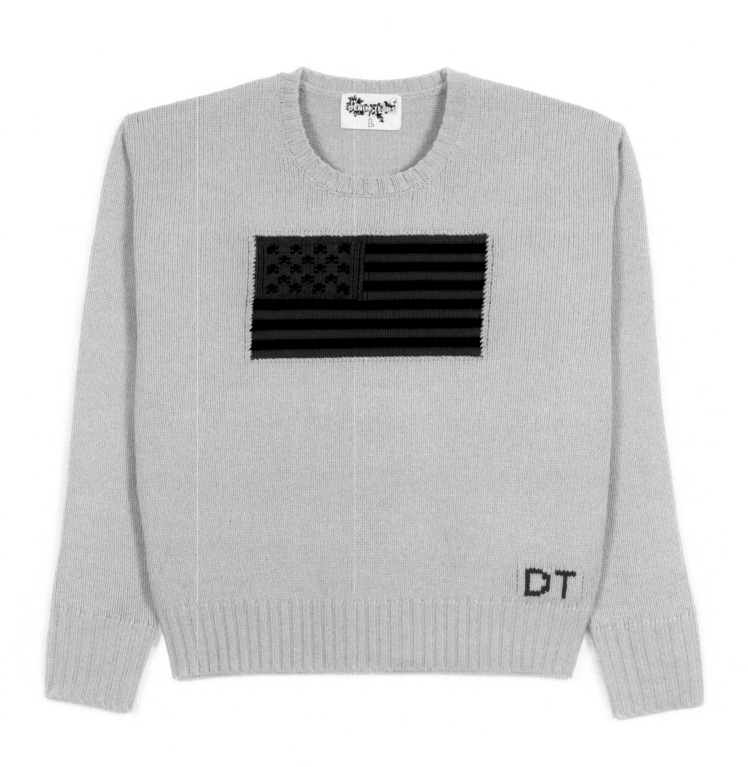

SOLIDARITY

—

*Unity (as of a group or class) that produces or is based on
a community of interests, objectives, and standards*

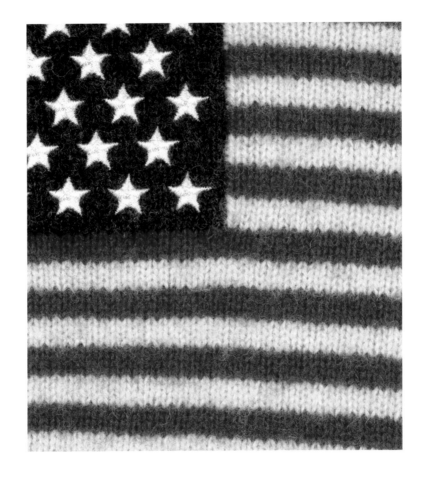

Tommy Hilfiger is well known for his egalitarian approach to fashion. He started his
career in the late 1960s with the People's Place boutique and launched his eponymous
label, inspired by the preppy aesthetic, in 1985. The broad popularity of his sportswear
collections, marked by a red, white, and blue palette and branded with an abstracted
American flag, reached its apex in the late 1990s. This sweater from that period is
emblematic of Hilfiger's career-long commitment to inclusion, recently expressed
through his designs for nonbinary people and adaptive garments.

Tommy Hilfiger (American, born 1951)
SWEATER, CA. 2000
Navy wool-cotton rib jersey pieced with polychrome wool-synthetic jersey
embroidered with white cotton thread

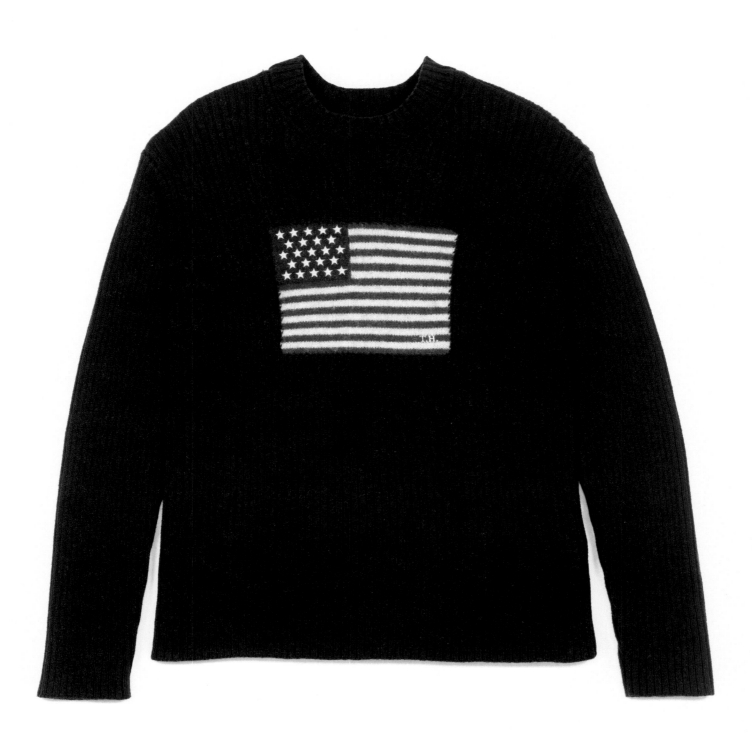

ISOLATION

—

The condition of being isolated
(placed or caused to be alone or apart; cut off)

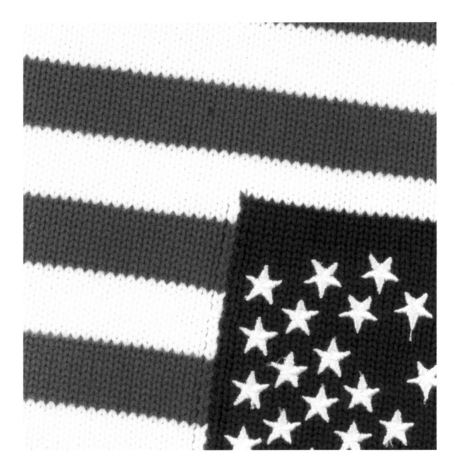

Mexican American designer Willy Chavarria's recent collections are a commentary
on immigration. Fashions embroidered with the phrases "No Human Being Is Illegal"
and "Authentic American" reflect the fear and alienation experienced by immigrants to
the United States. The "Falling Stars" motif on this sweater from the designer's spring/
summer 2019 collection presents a sense of hopelessness, a sharp contrast to the
optimism of Ralph Lauren's American-flag sweater.

Willy Chavarria (American, born 1967)
"FALLING STARS" SWEATER, SPRING/SUMMER 2019
Polychrome cotton intarsia knit embroidered with white cotton thread

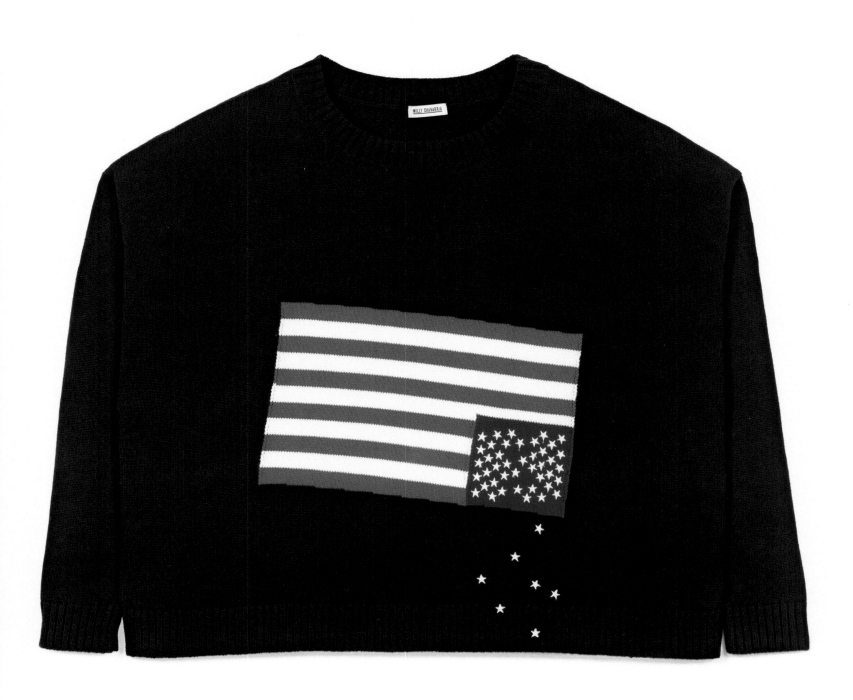

EXUBERANCE

EXUBERANCE

EBULLIENCE

DELIGHT

ESPRIT

ÉLAN

VITALITY

EXUBERANCE

—

*The quality or state of being exuberant
(joyously unrestrained and enthusiastic)*

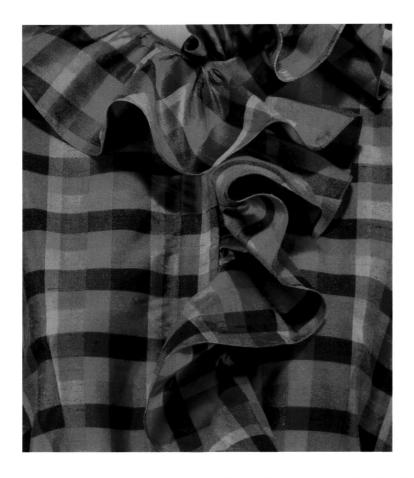

Christopher John Rogers has described his design philosophy as creating fashions that are both emotional and transformational, features that become tools for self-expression through vibrant color and dramatic volume. This dress from his autumn/winter 2020–21 collection exemplifies the expressive nature of his designs, conveying a sense of unrestrained enthusiasm with a vividly colored plaid silk and an expansive, nine-foot-wide skirt. The design amplifies the patterning, intense colors, and extravagant silhouettes of mid-nineteenth-century gowns for a more emphatic statement.

Christopher John Rogers (American, born 1993)

ENSEMBLE, AUTUMN/WINTER 2020–21

Polychrome plaid silk taffeta

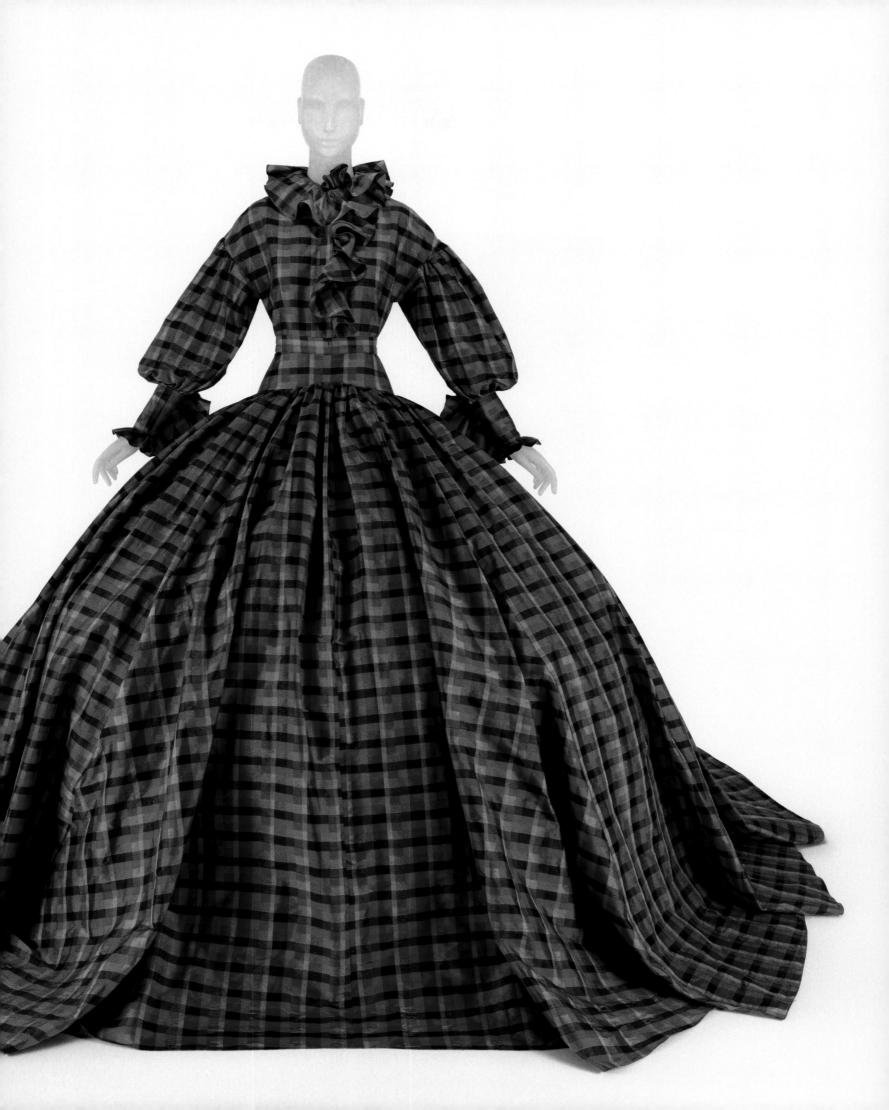

EBULLIENCE

*The quality of lively or animated expression
of thoughts or feelings; high spirits*

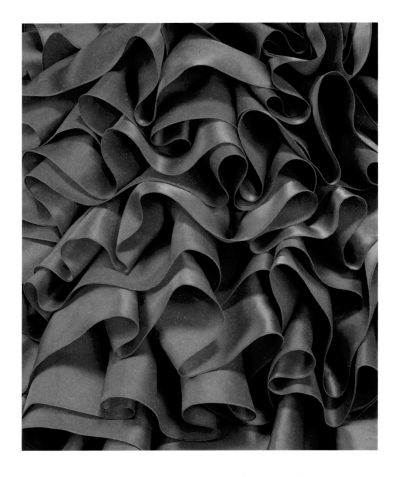

Musicals of Hollywood's Golden Age provided inspiration for Rodarte's autumn/winter
2019–20 collection, which featured designs that offer a fantastical counterpoint to
the costumes brought to life on screen by women such as Ginger Rogers. In this dress,
the designers created a sense of animation through their careful handling of the
fabric. Dense, cascading ruffles enveloping the skirt spring gently in tandem with
the wearer's movement, giving way to open, petal-like layers at the shoulders that
generate more buoyancy.

Rodarte (American, founded 2004)
Kate Mulleavy (American, born 1979)
Laura Mulleavy (American, born 1980)
DRESS, AUTUMN/WINTER 2019–20
Blue silk organza

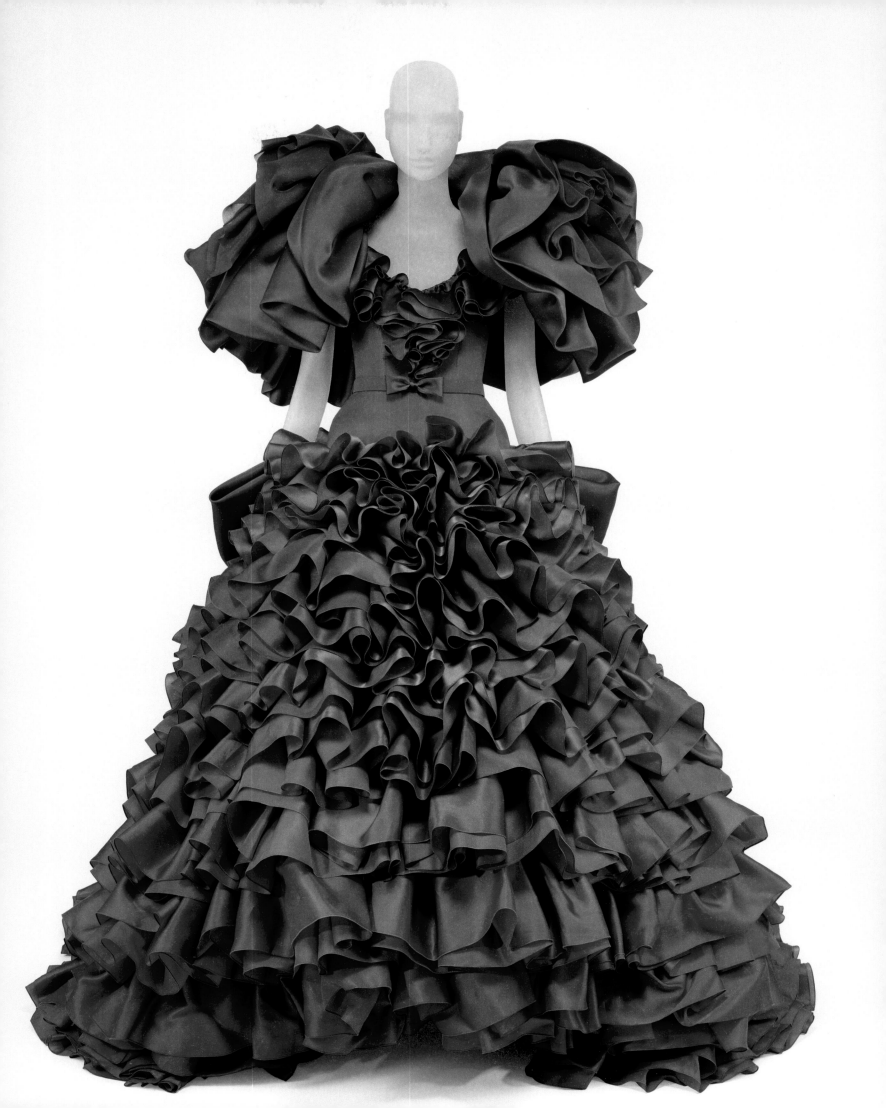

DELIGHT

—

A high degree of gratification of mind or sense;
lively pleasure

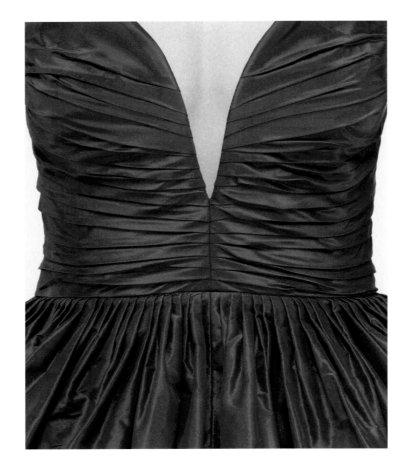

Throughout his decades-long career, Oscar de la Renta was renowned for his romantic
eveningwear characterized by sculptural shapes and saturated colors. Fernando Garcia
and Laura Kim, who were appointed co-creative directors of De la Renta's label in 2016,
have noted their desire to capture the joie de vivre expressed in the founder's designs.
In this dress, they convey a sense of vitality through their lively draping of jewel-toned silk
taffeta, which forms a dynamic shape reliant on the inherent quality of the textile.

Oscar de la Renta (American, founded 1965)
Fernando Garcia (American, born 1986)
Laura Kim (American, born Korea, 1982)
DRESS, AUTUMN/WINTER 2020–21

Blue silk taffeta

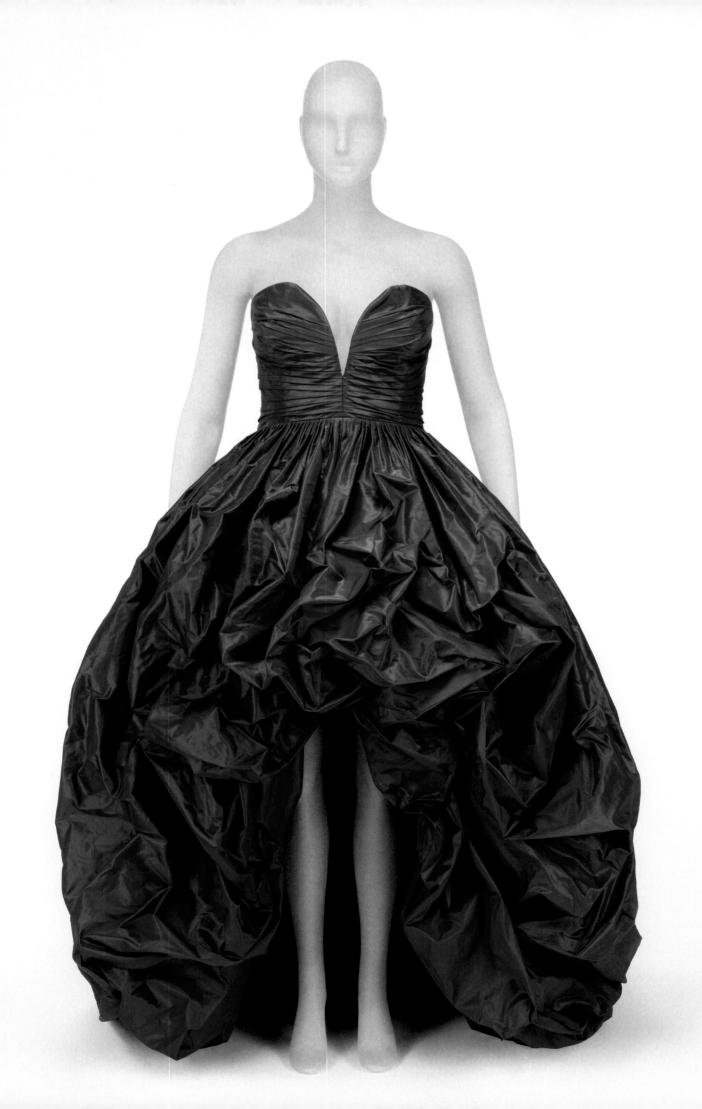

ESPRIT

Cleverness and vivacity as of spirit and mind; sprightly wit;
an inherent lively and colorful quality

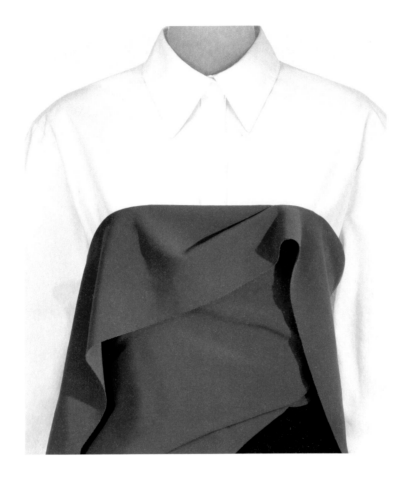

Carolina Herrera's designs are closely connected to her personal style, which is defined
by an image of effortless elegance and by her interpretations of classic garments, such as
the white button-down shirt. For Herrera, the appeal of this essential item is its ability to
transform from casual to formal. In this evening ensemble, a crisp white shirt is given
vibrancy through its pairing with a blue taffeta skirt, while the shirt itself lends a sense
of nonchalant ease. When Herrera retired in 2018, she named Wes Gordon creative
director of her label. In this ensemble from Gordon's second collection, he elaborates on
Herrera's clever combination of tailoring and draping. He pairs a plain white shirt with
slim black trousers and wraps them with a panel of blue silk crepe in the shape of an
unfinished evening gown.

Carolina Herrera (American, born Venezuela, 1939)
ENSEMBLE, AUTUMN/WINTER 2018–19
Shirt of white cotton poplin; skirt of blue silk taffeta

Carolina Herrera (American, founded 1981)
Wes Gordon (American, born 1987)
ENSEMBLE, AUTUMN/WINTER 2020–21
Shirt of white cotton twill; trousers of black wool;
bodice of blue silk crepe

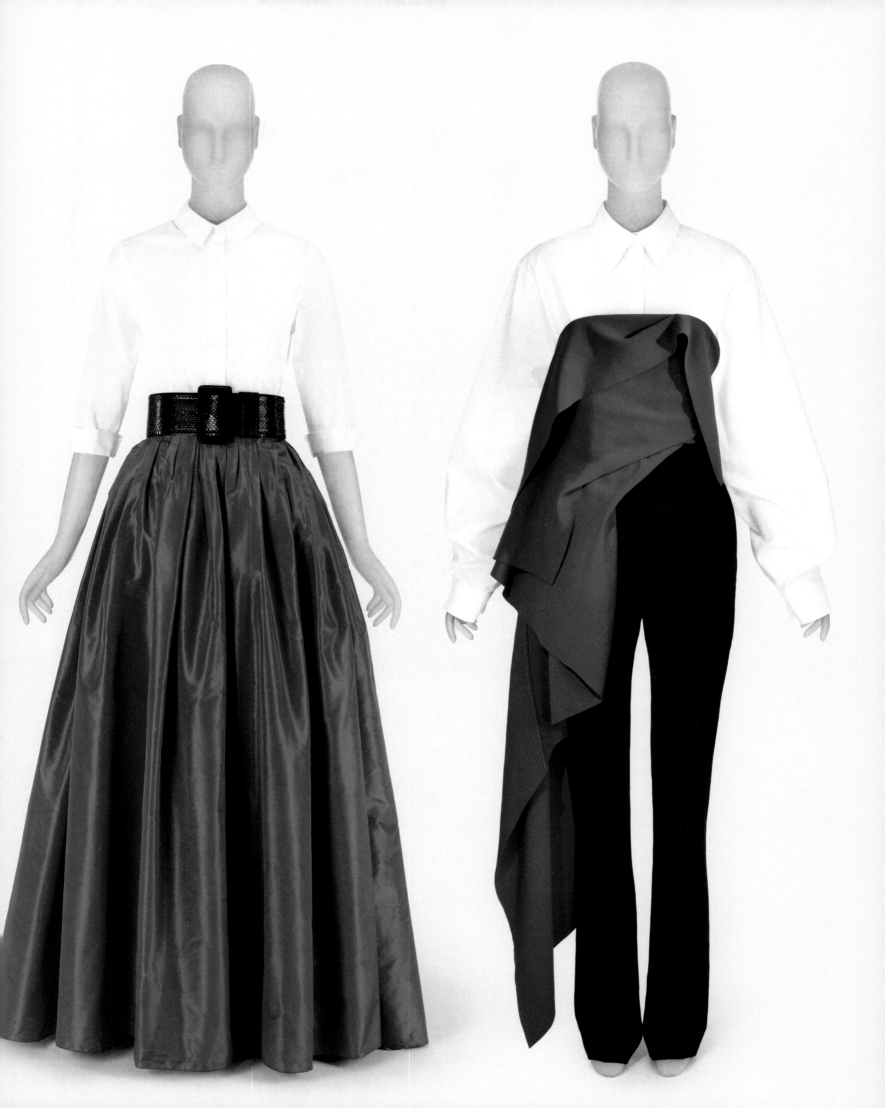

ÉLAN

Vigor, spirit, or enthusiasm
typically revealed by assurance of manner,
or liveliness of imagination

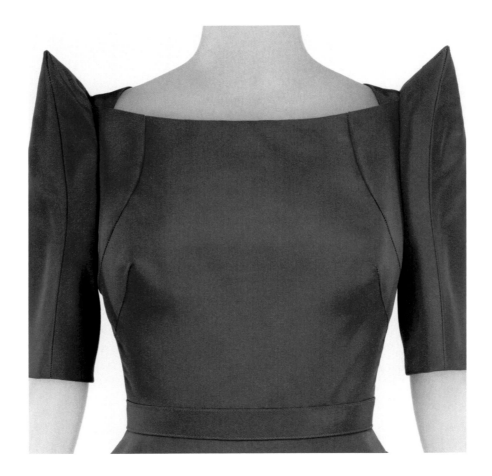

With this cobalt blue dress, Zac Posen recalls the sensuous and inventive designs of American couturier Charles James, who similarly experimented with silhouettes composed of a narrow sheath emerging from a fountain-like skirt. James's fashions often drew conspicuous attention to their complex construction through contrasting fabrics that highlighted seam lines and supporting understructure. While Posen's interpretation of this silhouette is also precisely constructed, he elides these details through his use of a single fabric, keeping the emphasis on the bold shape.

Zac Posen (American, born 1980)
DRESS, PRE-FALL 2012
Blue silk faille

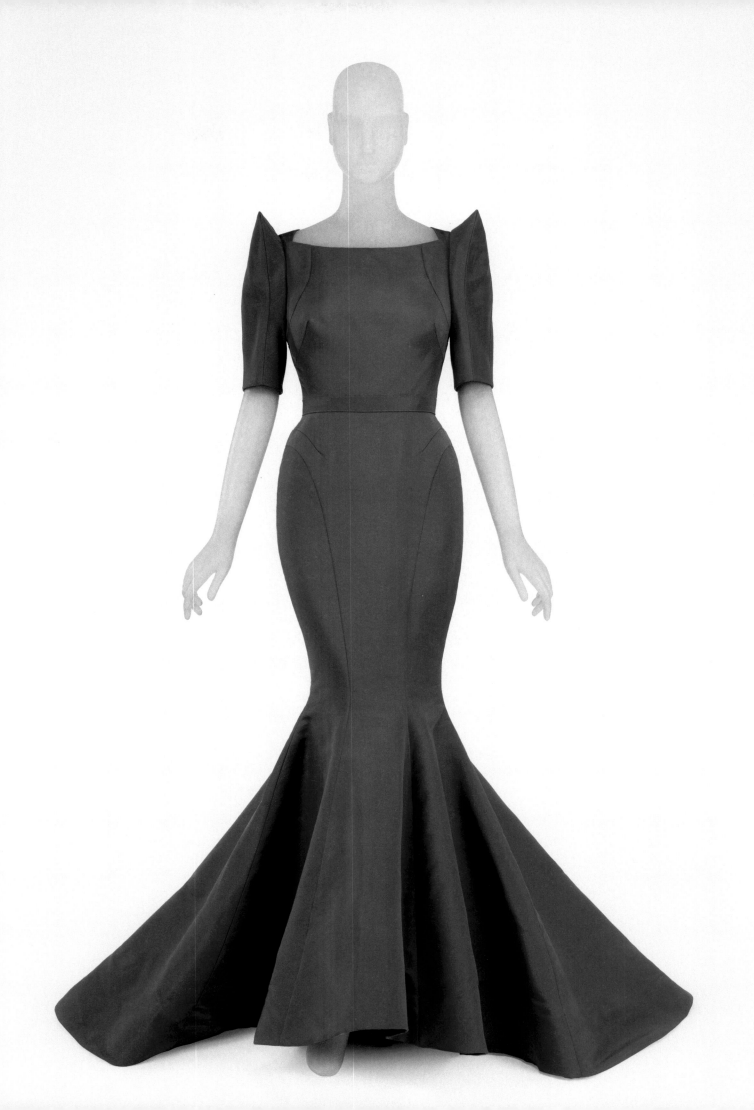

VITALITY

—

Lively and animated character

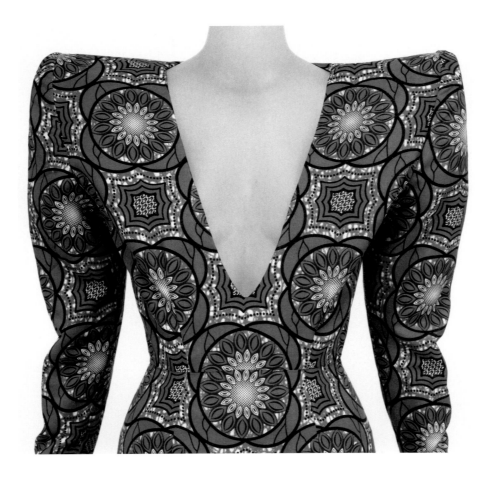

In her designs, Claude Kameni uses fabrics often referred to as African wax prints. These vividly colored and densely patterned textiles, which have an enduring history of popular use in West and Central Africa, were originally inspired by batik, or wax-resist, cloth from Indonesia. The dynamism of Kameni's work is indebted to the synergy she creates between these vibrant patterns, her strong silhouettes, and the body of the wearer. In this dress for Lavie by Claude Kameni, the pattern is arranged to complement the curves of the figure and accentuate the flowing tiers of the skirt.

Lavie by Claude Kameni (American, founded 2013)
Claude Kameni (Cameroonian, born 1994)
DRESS, 2021
Polychrome waxed cotton plain weave

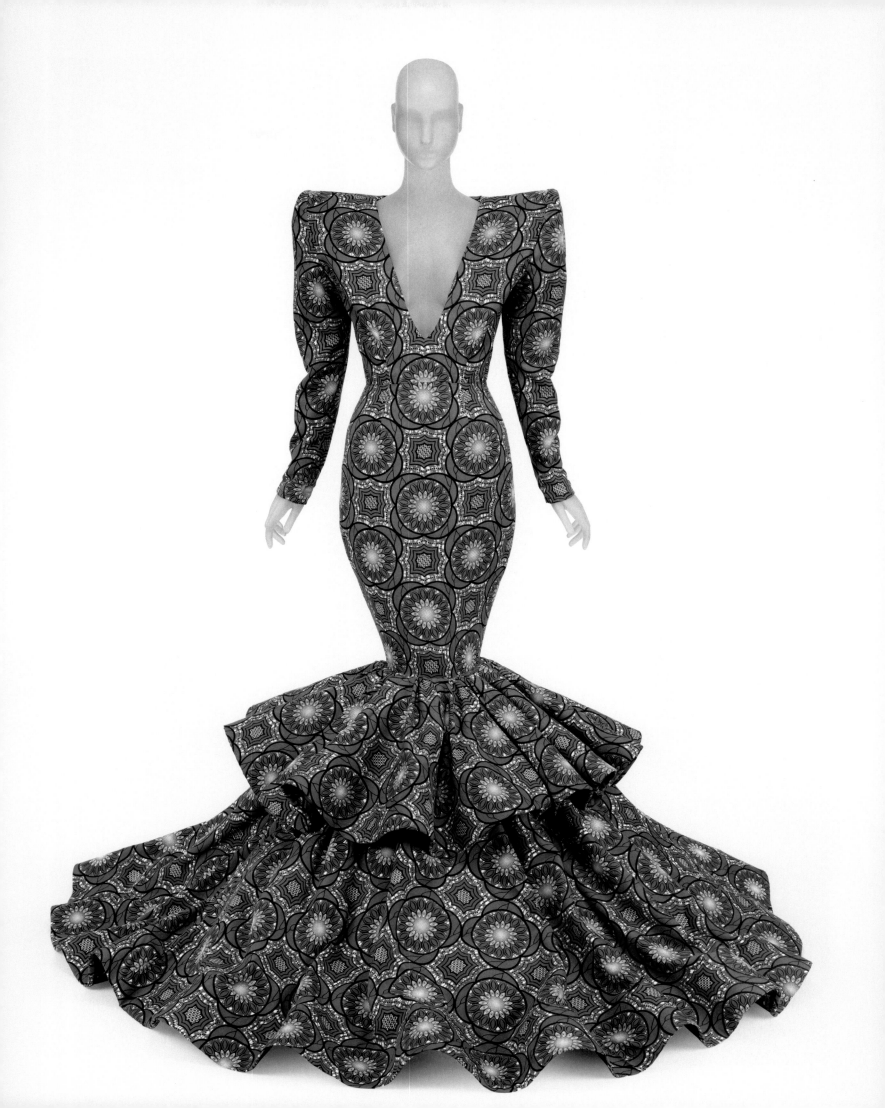

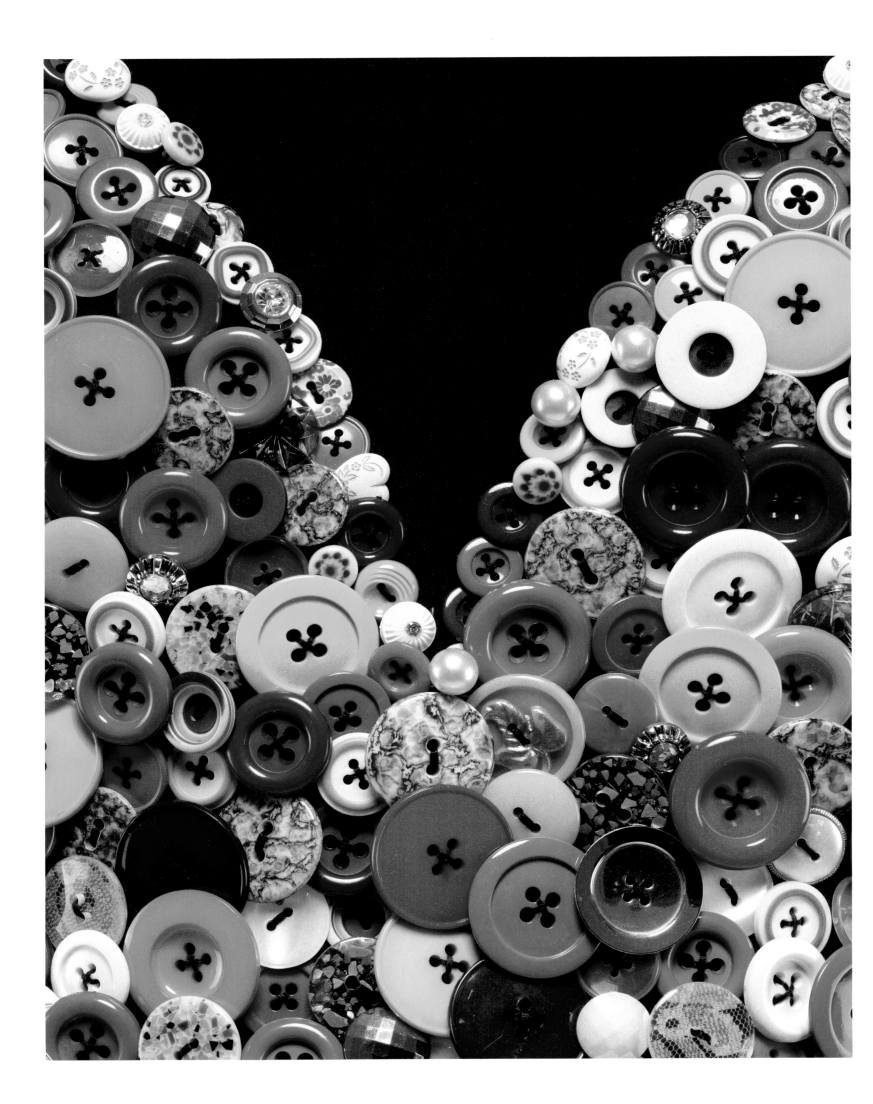

JOY

—

JOY

PLAYFULNESS

ENTHUSIASM

VIBRANCY

HUMOR

ARTFULNESS

IMPULSIVENESS

JOY

A state of happiness or felicity

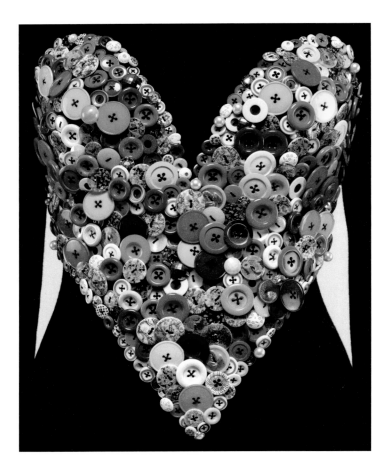

Patrick Kelly said of his designs, "I want my clothes to make you smile." In energetic
runway shows, he presented streamlined silhouettes that served as canvases for playful
ornamentation, such as the boldly colored plastic buttons embroidered in the shape
of a heart on this dress. Buttons appeared on his famed "Love List," which also included
pearls, bows, and his grandmother Ethel Rainey. Kelly often shared anecdotes about
Rainey adorning his mended childhood clothing with excess buttons to camouflage
that they mismatched, an improvisational approach that had an enduring influence
on the designer.

Patrick Kelly (American, 1954–1990)
DRESS, AUTUMN/WINTER 1986–87
Black wool jersey embroidered with polychrome plastic buttons

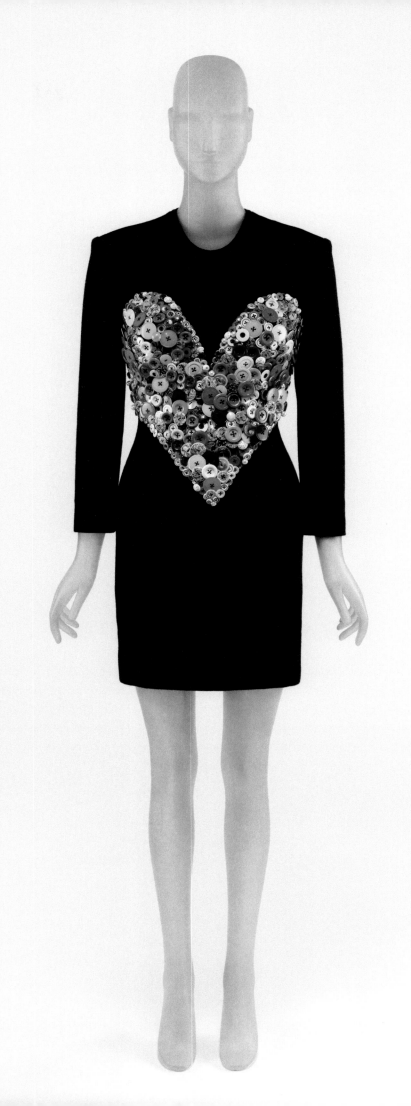

PLAYFULNESS

—

The quality of being lighthearted or full of fun

Jeremy Scott has said that for him "fashion is an emotion," describing his designs as led by his feelings and intended to evoke a sense of happiness. In this playful homage to Patrick Kelly's joyful fashions, Scott has exaggerated the designer's signature button motif, encrusting the wearer in a field of color. The bold but lighthearted embellishment seems to join both wearer and observer in a shared emotion elicited by the exuberant spirit of the design.

Jeremy Scott (American, born 1975)
TAILCOAT, AUTUMN/WINTER 2009–10
Black cotton sateen embroidered with polychrome plastic buttons

ENTHUSIASM

—

A strong excitement of feeling

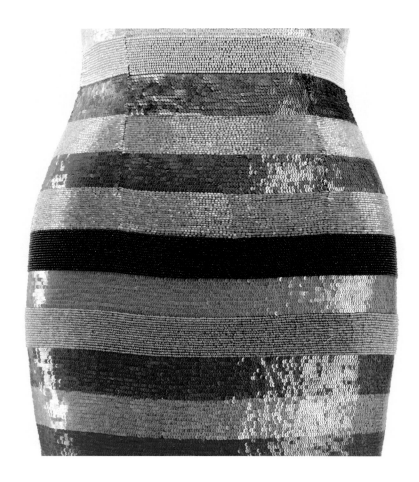

"I love stripes, and I've managed to use them in every collection," Todd Oldham proclaimed in *All of Everything*, RISD Museum's 2016 retrospective on the designer. This evening dress from the apex of his fashion career—which spanned a decade, from 1989 to 1999— epitomizes his maximalist aesthetic and joyful use of color, pattern, and embellishment. Embroidered with a rainbow of paillettes and lined in leopard-print silk, the slip dress clings to the body like a glistening second skin. The unusual combination of stripes and animal print reflect Oldham's bold, improvisational style.

Todd Oldham (American, born 1961)
EVENING DRESS, AUTUMN/WINTER 1994–95

Purple silk-synthetic plain weave embroidered with polychrome paillettes
and lined with leopard-print silk-synthetic plain weave

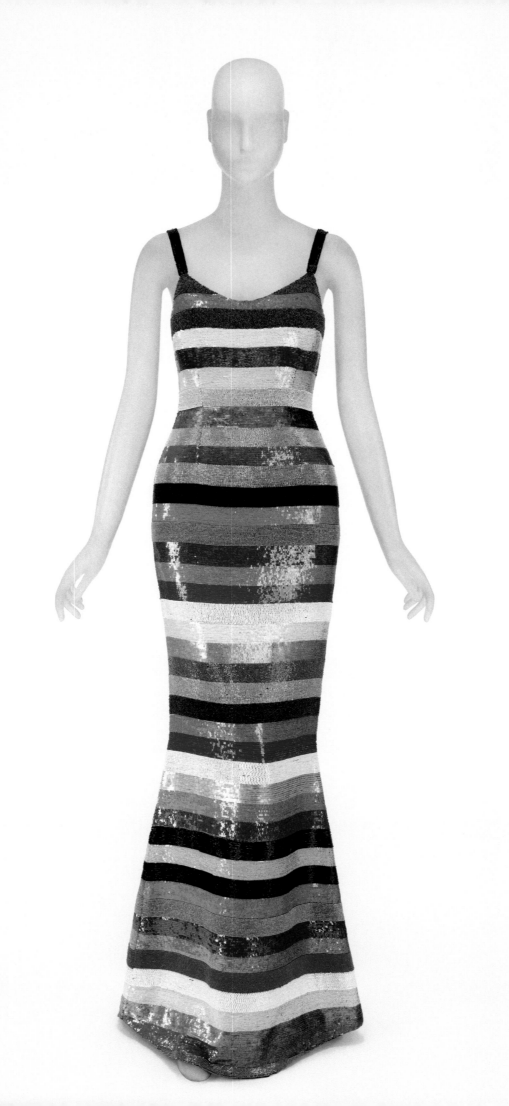

VIBRANCY

The quality or state of being vibrant or pulsating with life

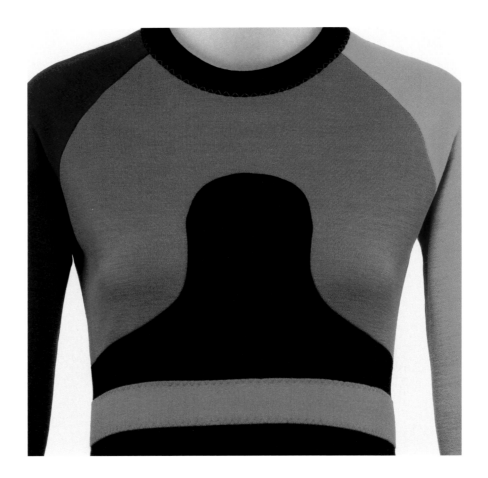

This dress exemplifies Stephen Burrows's conception of fashion as an art form for the body. Draped to move with the body and constructed without the hindrance of linings or understructure, his fashions are enlivened through a dynamic exchange between clothing and wearer, bringing vitality through vivid color and dynamic form. As Burrows explained, every design is intended to "make both the wearer and viewer aware of the body and its potential."

Stephen Burrows (American, born 1943)

DRESS, 1970–73

Pieced polychrome wool jersey

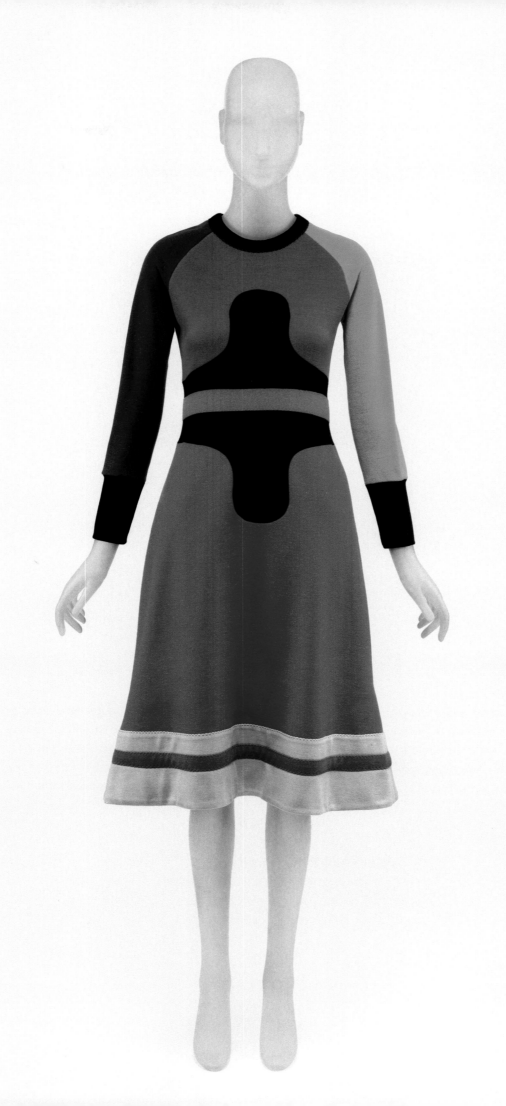

HUMOR

—

*That quality in an expression of ideas which appeals
to a sense of the ludicrous or absurdly incongruous;
a comic or amusing quality*

Christian Francis Roth brings both wit and flawless workmanship to his designs; as Roth
himself noted, without quality, the humor of his fashions would fall flat. This dress, one of
a series evoking brightly colored crayons, suggests the free hand of children's drawings
through squiggly lines of color. The intersecting pink and purple sections, whose shapes
recall the broad shading achieved with a crayon, are intricately cut, pieced, and stitched,
evidence of Roth's precise execution.

Christian Francis Roth (American, born 1969)

"CRAYON" DRESS, AUTUMN/WINTER 1990–91

Pieced polychrome wool jersey

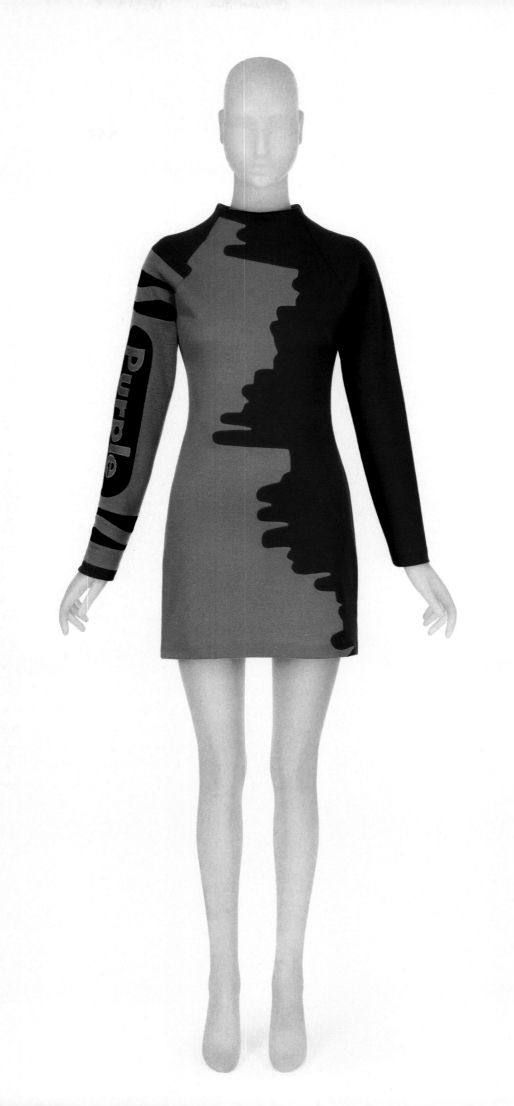

ARTFULNESS

—

The quality or state of being artful
or showing a noteworthy use of imagination and creativity

A piece of embroidery executed in his native Haiti and shared with him by his sister Brigitte inspired the first of Fabrice Simon's beaded designs. Beaded garments based on embroidery patterns he drafted himself would become his signature. As in this dress, they often retain the lively and spontaneous quality of a drawing. Previous experience as a textile designer likely honed his ability to create patterns that harmonize with the body in the finished garment.

Fabrice Simon (American, 1951–1998)

DRESS, 1980S

Pink silk georgette embroidered with black crystals and beads

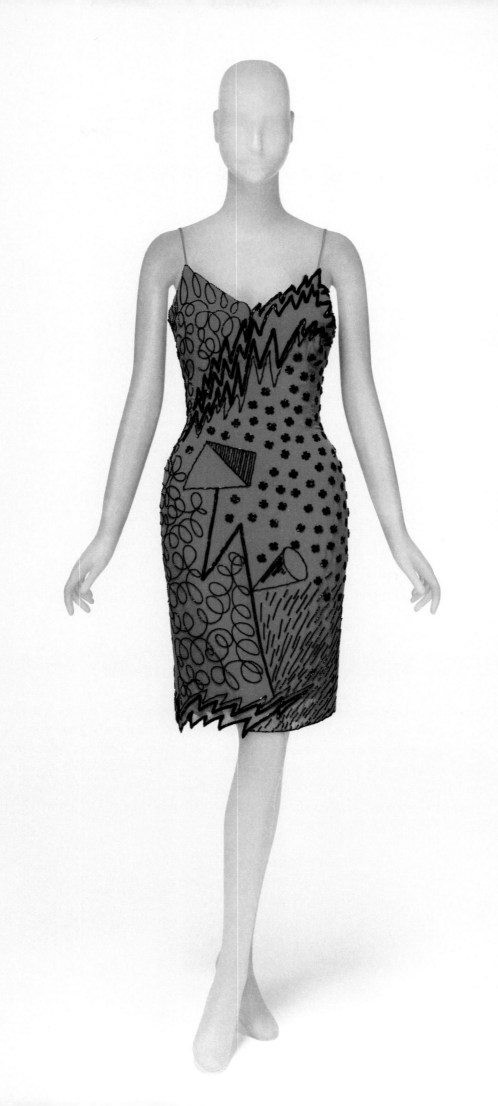

IMPULSIVENESS

—

1 — A sudden spontaneous inclination or incitement
to some usually unpremeditated action
2 — A propensity or natural tendency usually other than rational

Through vivid colors, eye-catching fabrics, and striking patterns often drawn in his own hand, Stephen Sprouse captured a sense of vibrant energy in each of his designs. In this dress, the simple sheath silhouette showcases a lively neon print with the free-form quality of graffiti. Typical of the designer's deft integration of youthful sensibility and luxurious materials, the pattern has been embroidered with a shimmering layer of transparent sequins, giving a patina of glamour to an otherwise playful garment.

Stephen Sprouse (American, 1953–2004)
DRESS, AUTUMN/WINTER 1983–84
Black and pink silk knit embroidered with clear paillettes

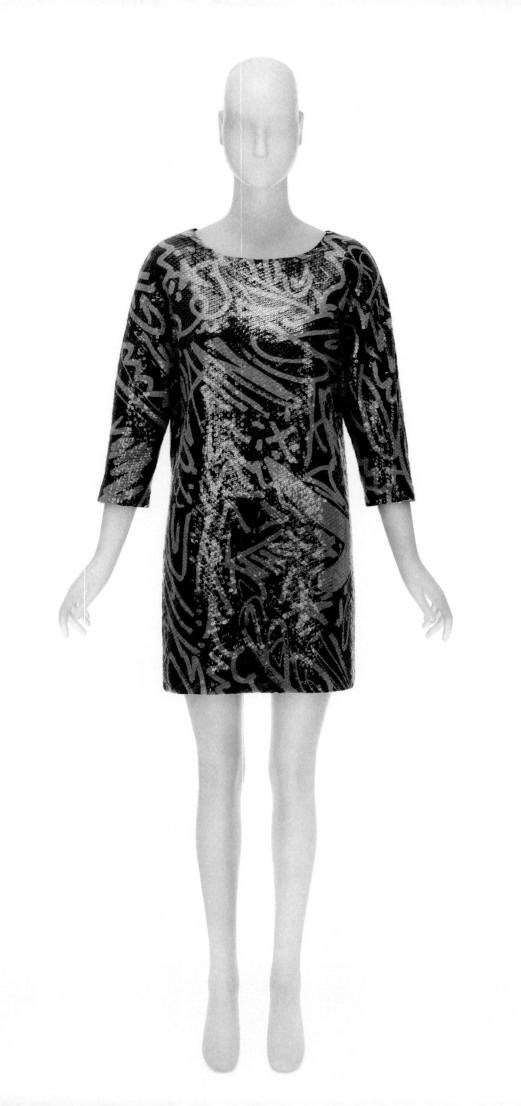

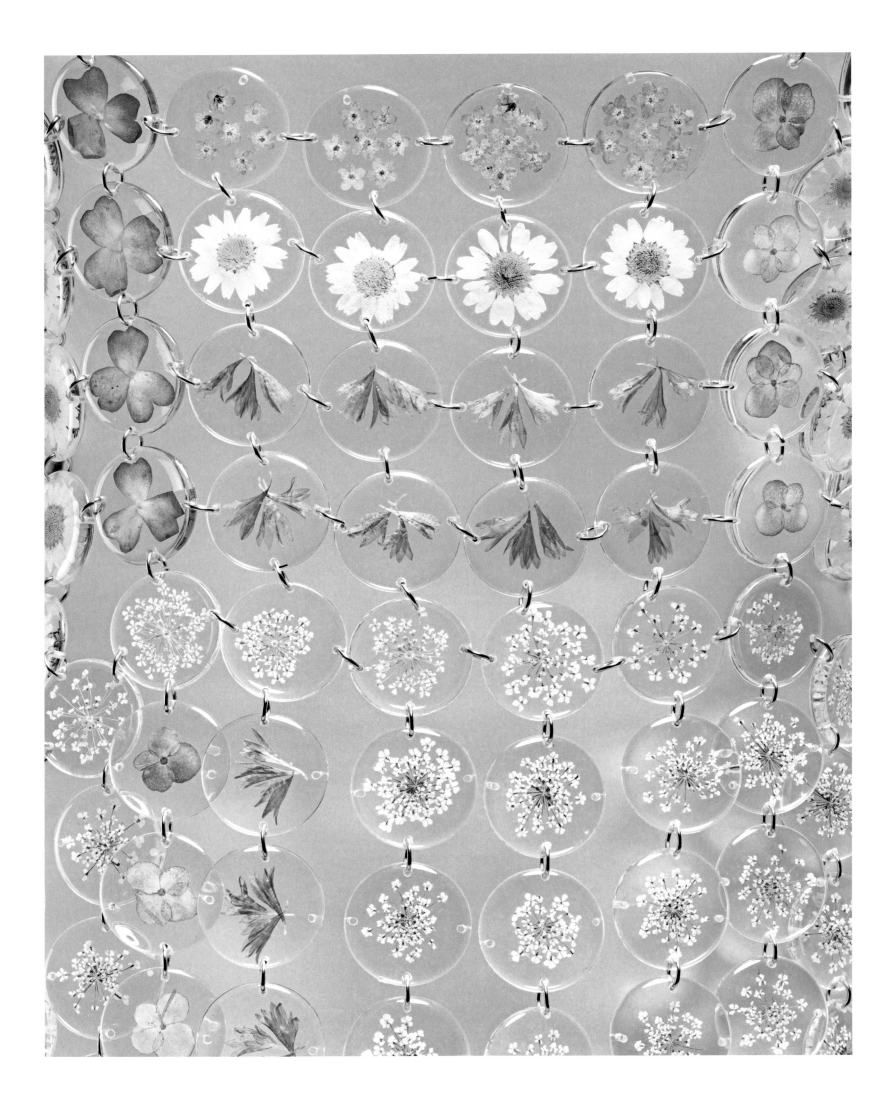

— SWEETNESS —

SWEETNESS

PRECOCIOUSNESS

INNOCENCE

IMPRESSIONABILITY

NAÏVETÉ

DREAMINESS

SNUGNESS

WONDER

SWEETNESS

—

*The quality or state of being sweet
(arousing agreeable or delightful emotions)*

Isaac Mizrahi employs signature design elements such as vivid colors and unexpected
juxtapositions to create his playful interpretations of American sportswear. Inspired by
the films *Nanook of the North* and *Call of the Wild*, Mizrahi's autumn/winter 1994–95
collection combined cold-weather wear with traditional midcentury silhouettes.
The baby-doll dress displayed here is rendered strapless, as if it were a shrunken 1950s
ball gown. The varying shades of pink—dubbed "poodle, pepto, powder and pez" by
WWD—lend charm to the weatherized design.

Isaac Mizrahi (American, born 1961)
DRESS, AUTUMN/WINTER 1994–95
Pink wool mohair, pink synthetic taffeta
embroidered with iridescent paillettes, and pink synthetic satin

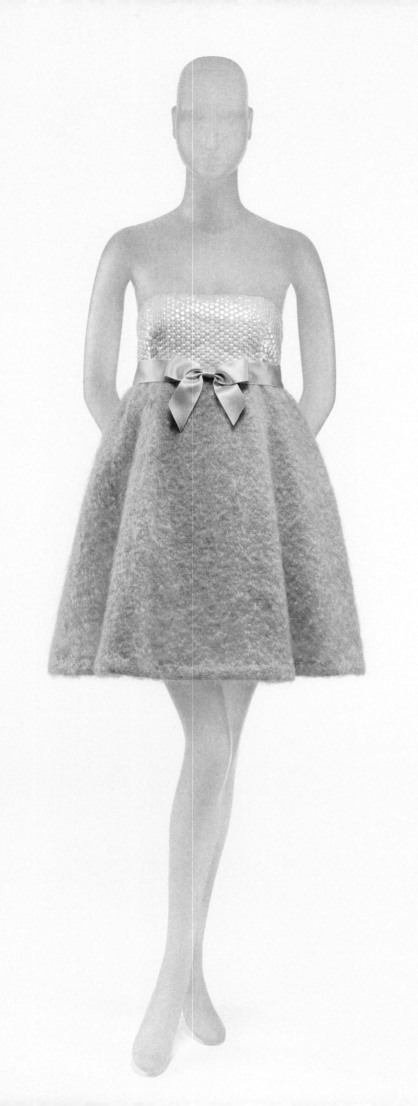

PRECOCIOUSNESS

—

Exhibiting mature qualities at an unusually early age

Anna Sui has often looked to music and youth culture as creative reference points. For her spring/summer 1994 collection, she drew inspiration from grunge, specifically the personal style of Nirvana's lead singer, Kurt Cobain. Citing Cobain's proclivity for wearing dresses belonging to his wife, Courtney Love, Sui presented her take on the baby-doll dress, a childlike style popularized by Love. With its thigh-high hemlines, flirtatious ruffles, and sugary embroidery, the example shown here is simultaneously alluring and innocent. Its exaggerated girlishness challenges gender stereotypes, a provocation that resonated with grunge musicians.

Anna Sui (American, born 1955)
ENSEMBLE, SPRING/SUMMER 1994
Dress of white synthetic organza embroidered with polychrome cotton thread
and clear iridescent paillettes; stole of pink synthetic plain weave with turkey down

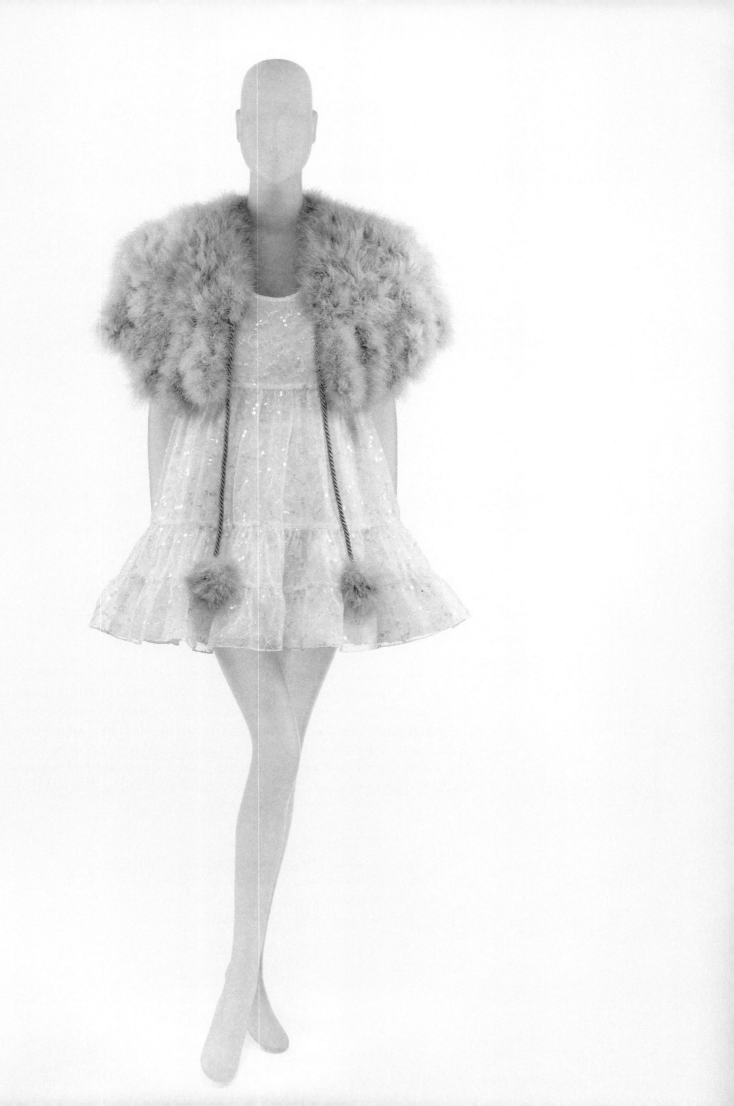

INNOCENCE

—

The quality or state of being simple and sincere

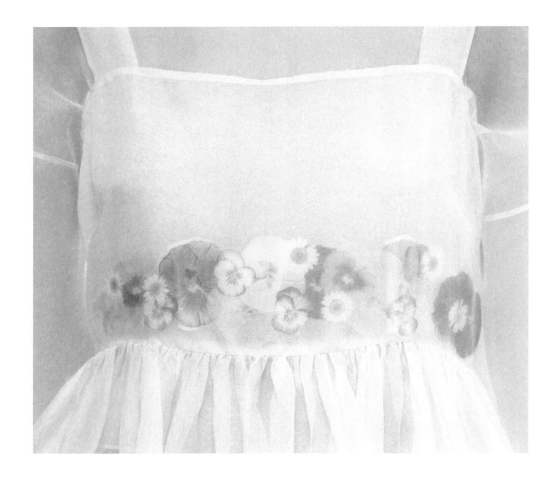

Olivia Cheng's deep-rooted respect for nature and appreciation for childhood delights inform the designs for her label, Dauphinette. The ensembles displayed here feature the self-taught designer's signature preserved botanicals, either encased in nontoxic resin disks or pressed between layers of silk organza. Sustainably sourced from local farms or locations with personal significance—including from the garden of Cheng's parents—the flowers visually announce Dauphinette's eco-conscious philosophy while simultaneously prompting a reconsideration of the ways in which we interact with nature.

Dauphinette (American, founded 2018)
Olivia Cheng (American, born 1998)
ENSEMBLES, SPRING/SUMMER 2020; AUTUMN/WINTER 2021–22
Blouse and skirt of white silk organza and polychrome flowers;
dress of pressed polychrome flowers, clear resin, and stainless steel

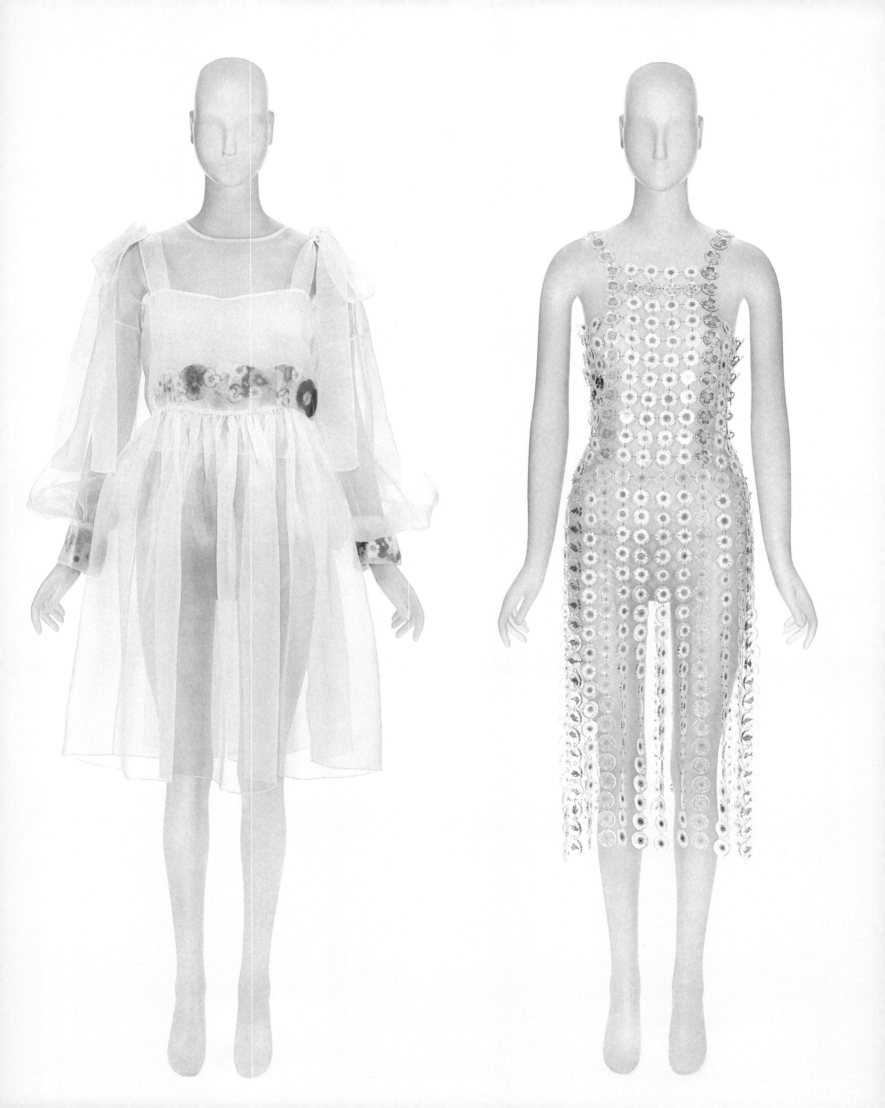

IMPRESSIONABILITY

—

*The quality or state of being impressionable
(liable to be easily influenced)*

Since the launch of her label in 2018, Caroline Hu has garnered acclaim for her ethereal, hand-smocked pieces, often constructed from discarded fabric. For her spring/summer 2021 collection, Hu drew inspiration from Saul Leiter's intimate photographs of women in their private interior spaces. Collaging together pieces of fabric, the designer produced a collection of garments with deflated protrusions reminiscent of seashells or popped bubbles. With its mix of delicate flounces and haphazard billows, this ensemble conveys a sense of comfort and vulnerability while also reflecting what Hu described as the "romantic uncertainty" of the collection's production process.

Caroline Hu (Chinese, born 1989)

ENSEMBLE, SPRING/SUMMER 2021

Pieced ivory cotton knit, plain weave, and silk satin

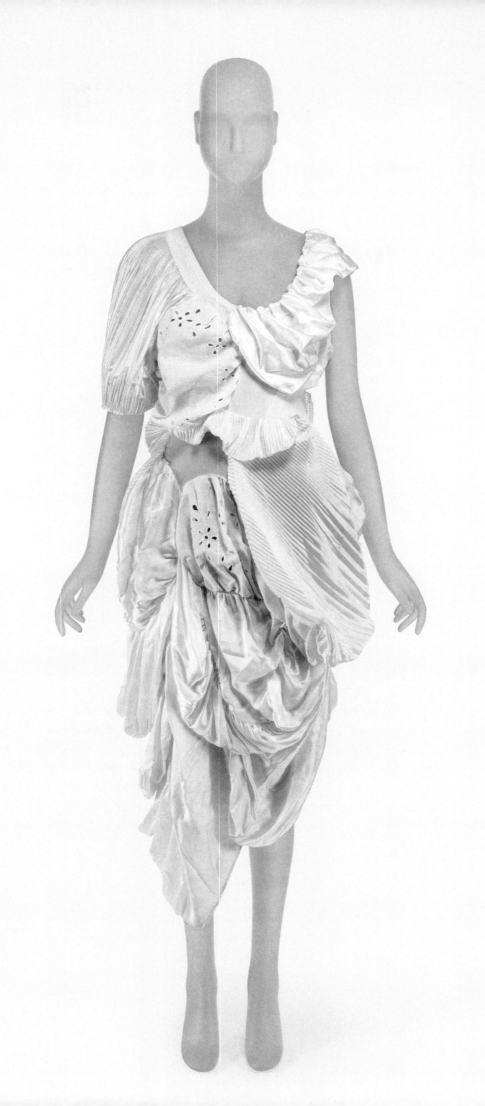

NAÏVETÉ

The quality or state of being naive
(showing candor, freshness, and spontaneity unchecked by convention,
social diffidence, or guile)

Titled "Nothing Is Forever," Vaquera's spring/summer 2021 collection explored the
potential of an "anything goes" approach to dressing in a postpandemic world. The design
trio—known for its campy sensibility and fashion-outsider status—played with the idea
of innerwear as everyday outerwear, incorporating lingerie and bedroom details
throughout the collection. This oversized boa boasts an exuberant jumble of jersey, tulle,
and lace, as if the wearer wrapped themselves in lingerie-strewn bedding and
unabashedly walked out the door.

Vaquera (American, founded 2016)
Patric DiCaprio (American, born 1990)
Claire Sullivan (American, born 1993)
Bryn Taubensee (American, born 1989)
BOA, SPRING/SUMMER 2021
White synthetic tulle, pink synthetic knit, and white synthetic lace

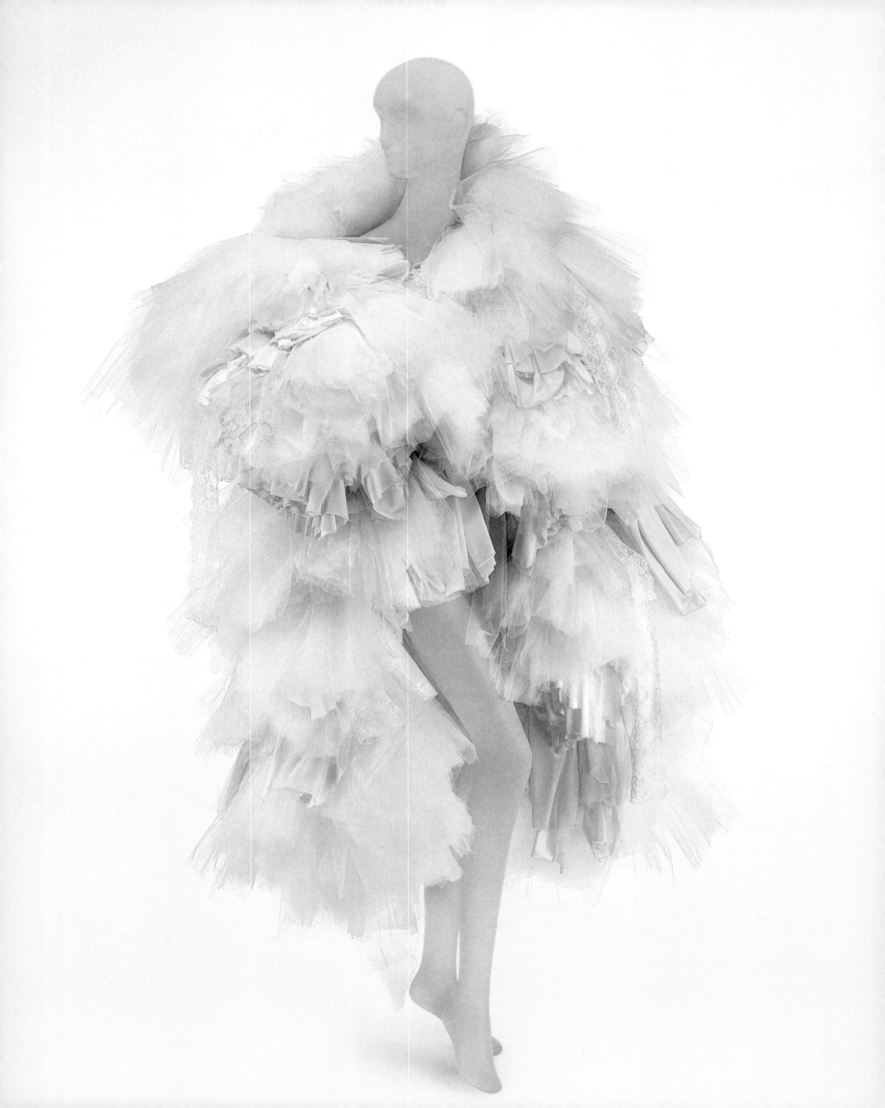

DREAMINESS

—

*The quality or state of being dreamy
(given to dreaming or fantasy)*

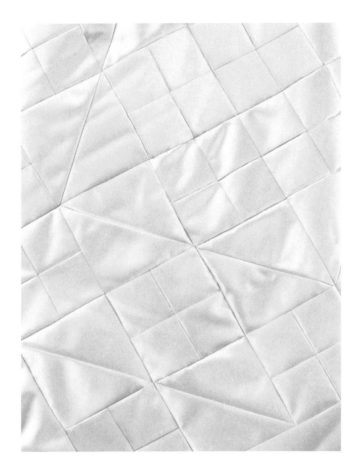

Since founding his eponymous label in 2015, Matthew Adams Dolan has sought to subvert
traditional signifiers of American sportswear. For his autumn/winter 2017–18 collection,
he recast utilitarian fabrics and silhouettes into ensembles evocative of at-home comfort.
This shirt and trousers are cut in Dolan's signature exaggerated proportions, suggesting
ill-fitting pajamas. A quilt strapped to the shoulder summons the coziness of bedtime.
Drawing inspiration from John Lennon and Yoko Ono's 1969 Vietnam protest movement,
"Bed-ins for Peace," Dolan cited a need for solace and hope during times of chaos.

Matthew Adams Dolan (American, born 1986)
ENSEMBLE, AUTUMN/WINTER 2017–18

Shirt and trousers of pink nylon plain weave; cape of quilted pink silk satin

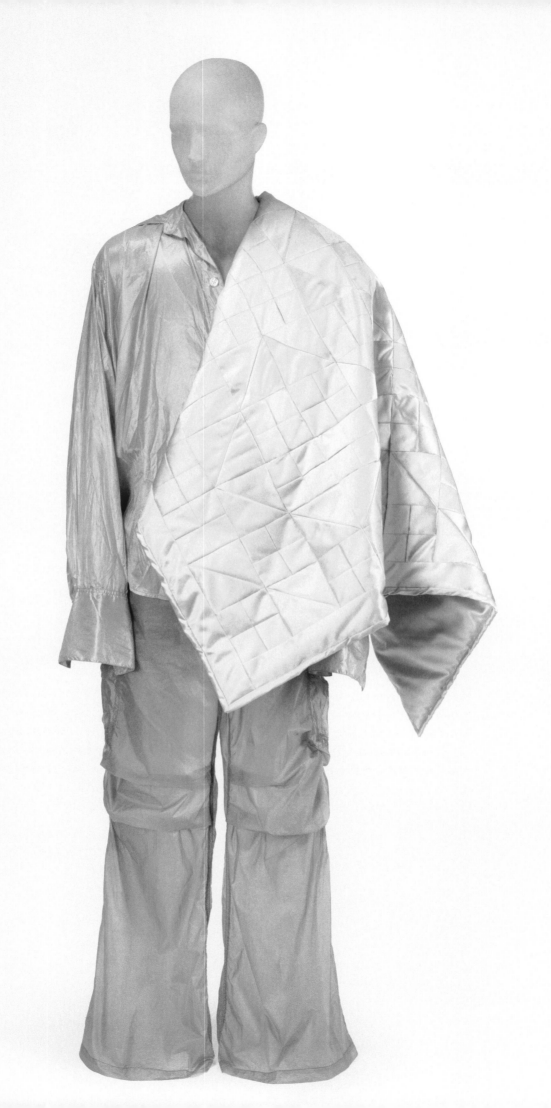

SNUGNESS

—

The quality or state of being snug
(at rest, warmly covered, and safe from the cold)

Conceived on a camping trip in 1973, Norma Kamali's "Sleeping Bag" coat remains
a signature of the designer's innovative adaptations of sports- and activewear. Originally
created from an actual sleeping bag, the garment evolved into this version, composed
of two polyester-filled nylon coats sewn together. The unique construction envelops the
body in a supple cocoon without overpowering it with excess structure. Its color evokes
a feeling of nurturing serenity.

Norma Kamali (American, born 1945)
COAT, AUTUMN/WINTER 2018–19
Pink synthetic plain weave

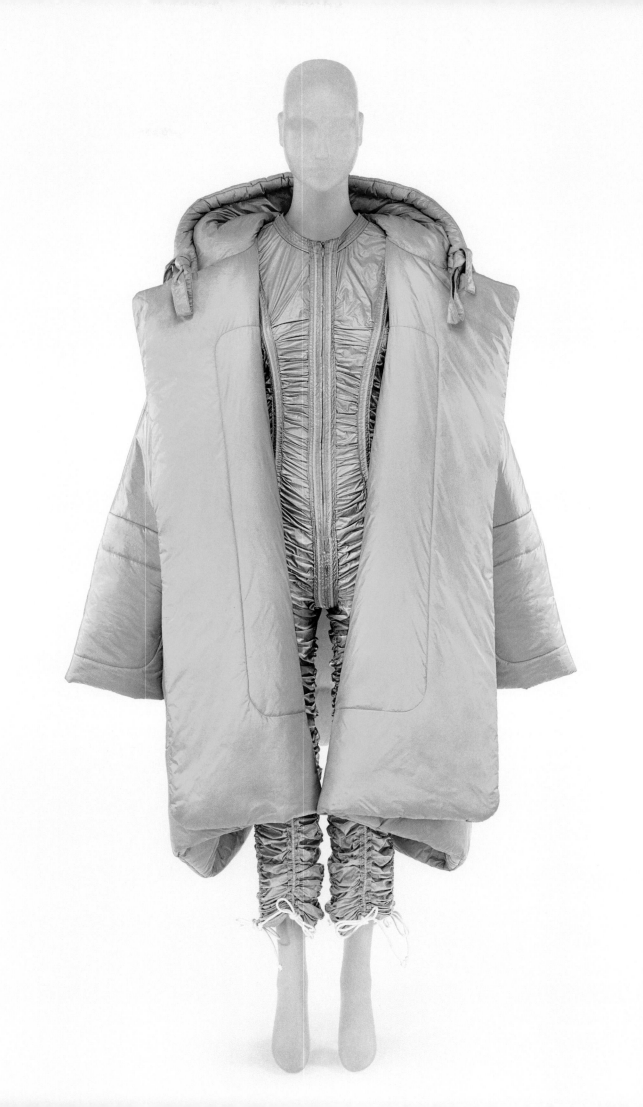

WONDER

—

*The rapt attention and deep emotion caused by the sight
of something extraordinary*

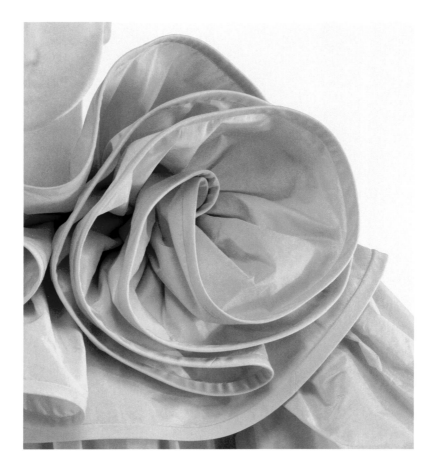

"If you're going to get dressed up, get dressed up," asserted Marc Jacobs of his spring/
summer 2019 collection, which was an ode to the haute couture and its excesses and
extravagances. Here, an oversize trapeze dress with flamboyant Pierrot collar and
pneumatic balloon sleeves suggests a child playing dress-up. Its cotton candy–pink hue,
informed by the cartoonlike paintings of Genieve Figgis, conveys an impression of sugary
sweetness that magnifies the garment's sense of childlike innocence.

Marc Jacobs (American, born 1963)

DRESS, SPRING/SUMMER 2019

Pink synthetic taffeta

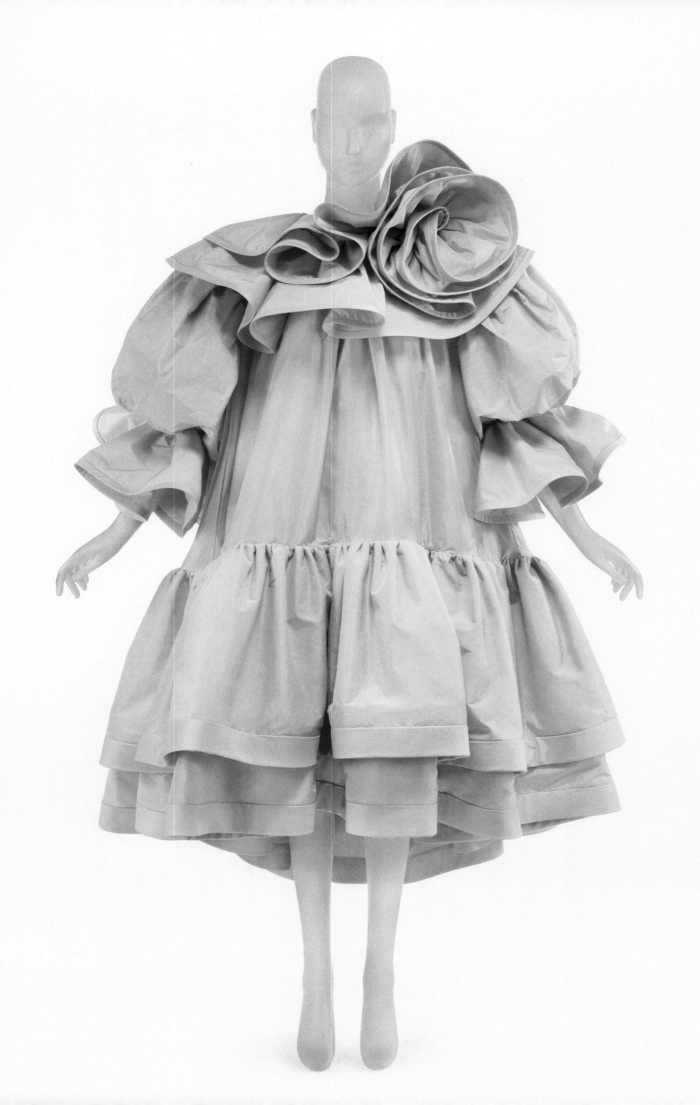

PROFESSIONAL
THE NEGRO
LEAGUES
BASEBALL
™

— FELLOWSHIP —

FELLOWSHIP

ASSOCIATION

KINSHIP

CAMARADERIE

CLOSENESS

SYMBIOSIS

AFFINITY

RECIPROCITY

FELLOWSHIP

—

A group of persons formally joined together for some common interest

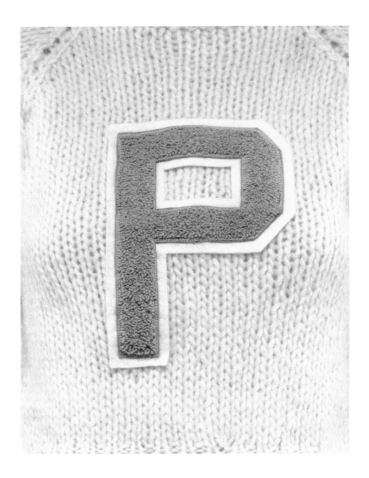

For his autumn/winter 1978–79 collection, Perry Ellis presented layered separates in
a high-octane show that included a team of Princeton cheerleaders. This ensemble is
directly inspired by the preppy insouciance of the cheerleading uniform and was part of
a series featuring monogrammed sweaters that spelled the designer's name. Its carefree
yet traditional sensibility reflects Ellis's overall approach to American sportswear,
described by the *New York Times* as a "look that should appeal to the college generation
as it sheds its blue jeans."

Perry Ellis (American, 1940–1986)

ENSEMBLE, AUTUMN/WINTER 1978–79

Sweater of ivory wool knit appliquéd with gray wool bouclé and white felt;

skirt of khaki wool gabardine

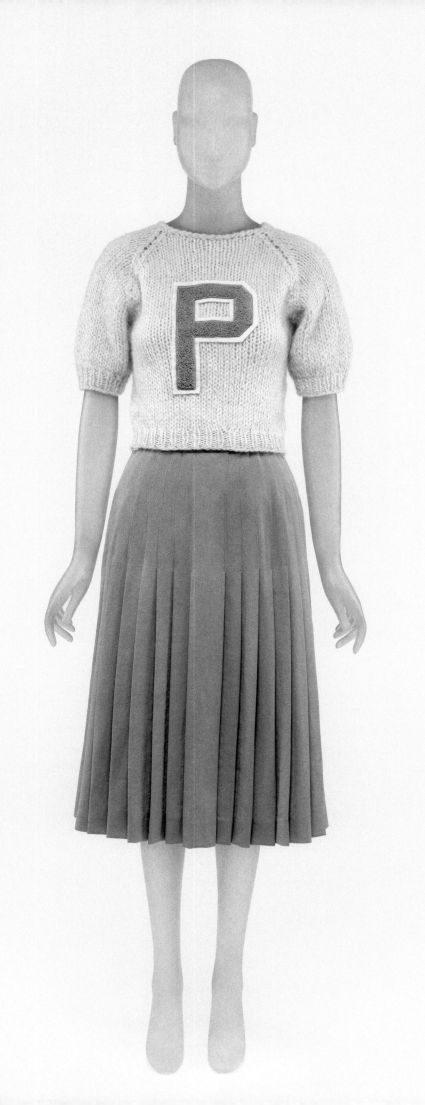

ASSOCIATION

—

The state of having shared interests or efforts

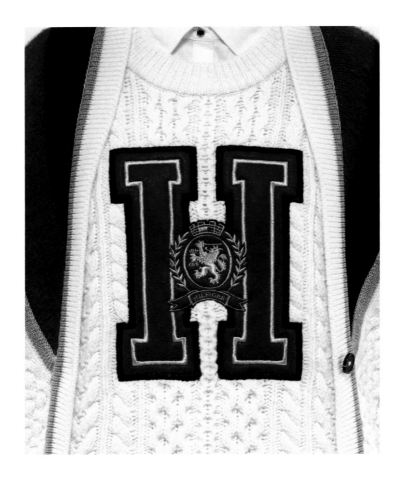

Tommy Hilfiger's populist take on Ivy League style is revealed in this ensemble. An outsize collegiate letterman sweater and cardigan each boast an emphatic "H"—the primary letter mark for Harvard University—to which the designer has aligned his surname. The branded Tommy Hilfiger crest was first introduced in 1985. Rendered in the label's signature red, white, and blue palette, the ensemble reflects the designer's distinctive "preppy with a twist" sensibility and democratizes a moniker that has historically been restricted to the elite.

Tommy Hilfiger (American, born 1951)

ENSEMBLE, AUTUMN/WINTER 2018–19

Cardigan of ivory, blue, red, and gold wool-cotton knit appliquéd with blue and gold felt;

sweater of white and gold wool-cotton knit appliquéd with red and blue felt;

dress of white cotton poplin; turtleneck of red wool knit

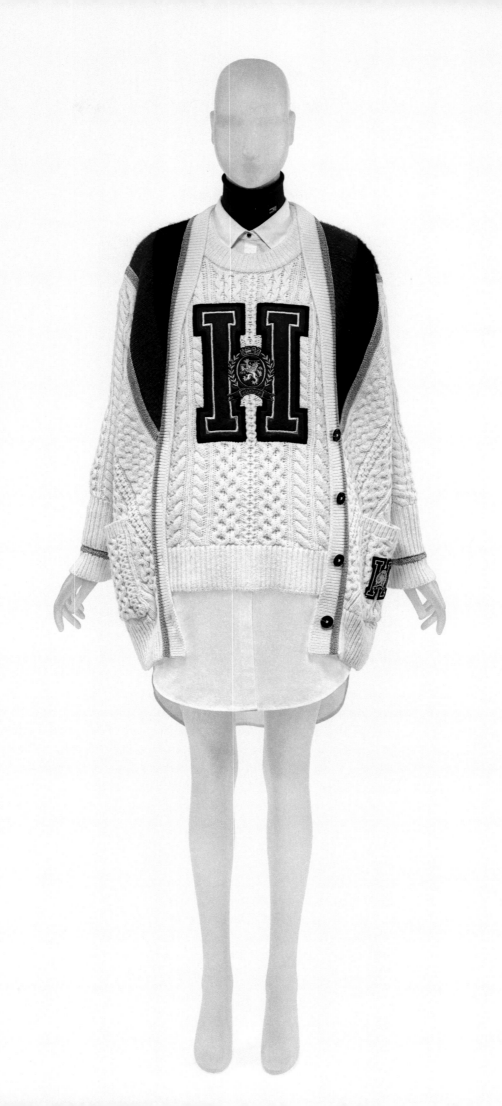

KINSHIP

—

1 — A likeness in character or qualities
2 — A community of interest, especially a sense of oneness

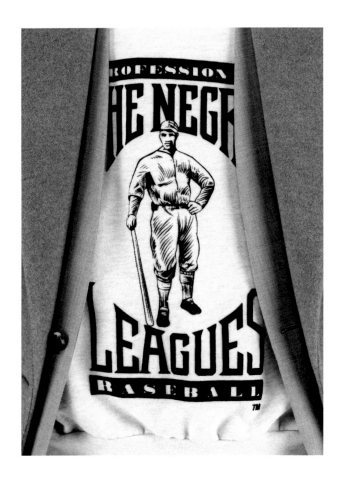

Fear of God's marriage of American sports- and urban wear is evident in this ensemble. A sweatshirt paired with a tailored jacket nods to Ivy League style, while an exposed hoodie suggests street insouciance. A collegiate sports emblem is supplanted by a graphic of the Negro Leagues, a segregated American professional baseball organization that marked its centennial in 2020. Of the graphic, designer Jerry Lorenzo, whose grandfather played in the Negro Leagues, observed, "[It] is a humble reminder of how far we've come and the responsibility we have to honor those before us who built the bridge we now cross."

Fear of God (American, founded 2013)
Jerry Lorenzo (American, born 1977)
ENSEMBLE, SPRING/SUMMER 2021
Coat of light brown cashmere broadcloth; jacket of light brown wool tweed;
sweatshirt of ivory cotton knit flocked with black synthetic velvet;
sweatshirt of ivory cotton knit; sweatpants of beige suede

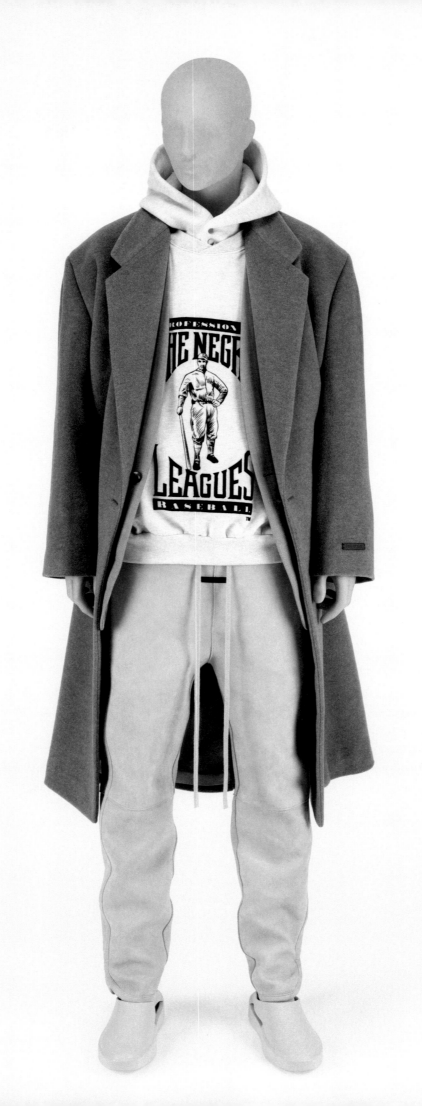

CAMARADERIE

—

*The spirit of friendly familiarity and goodwill
that exists between comrades*

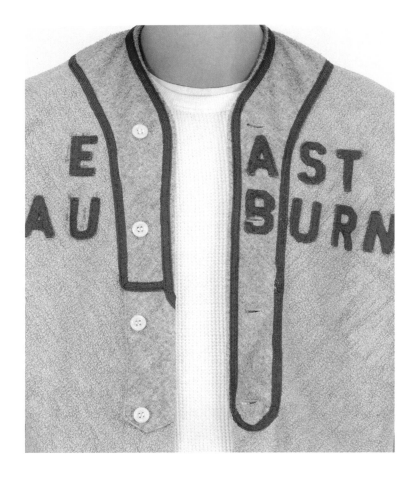

Eli Russell Linnetz founded ERL as a deeply personal take on American sportswear, filtered
through his carefree, easygoing Venice Beach lifestyle. Titled "The Final Frontier,"
his autumn/winter 2021–22 collection examined the relationship between self-discovery
and collective advancement through the lens of collegiate Americana. Here, a baseball-
inspired uniform conjures idyllic memories of boyhood friendship. While its sweat-stained
aesthetic alludes to the vitality of the ballpark, its state of undress is suggestive of
the locker room.

ERL (American, founded 2018)
Eli Russell Linnetz (American, born 1990)
ENSEMBLE, AUTUMN/WINTER 2021–22
Jersey of light gray cotton knit appliquéd with red cotton grosgrain and felt;
shirt of white cotton knit; shorts of gray nylon plain weave; pants of gray cotton knit

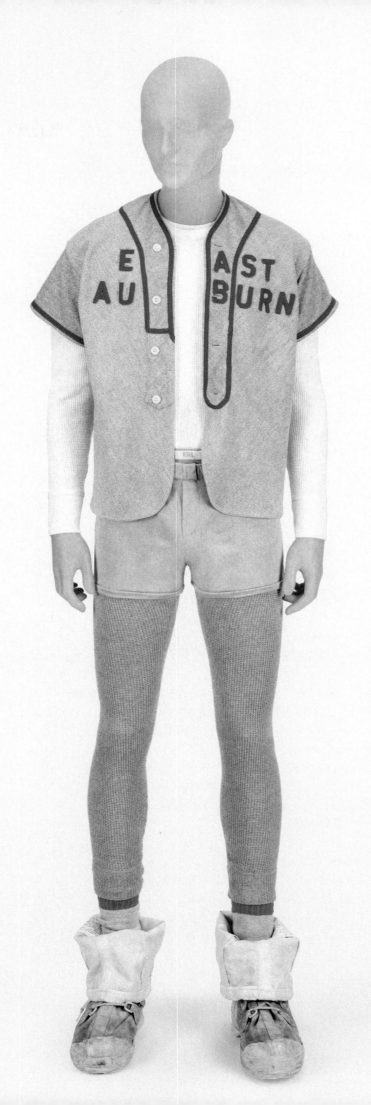

CLOSENESS

—

*The state of being in a very personal or private relationship;
the state or condition of being near*

Bstroy's subversive interpretations of American sportswear reflect designers
Dieter Grams and Brick Owens's futurist vision for a theoretical postapocalyptic
generation of "neo-natives." The double-hooded sweatshirt displayed here features
two neck holes with only one set of sleeves. Part of Bstroy's "Sweet Screams" collection,
it was presented on the runway on two models as if they were craving companionship.
Intended for an individual wearer, the garment's second hood effectively lies limp on the
shoulder, suggesting a dystopian future of loneliness and isolation.

Bstroy (American, founded 2013)
Dieter Grams (American, born 1991)
Brick Owens (American, born 1990)
ENSEMBLES, 2018
Sweatshirts of gray cotton knit; trousers of gray cotton knit

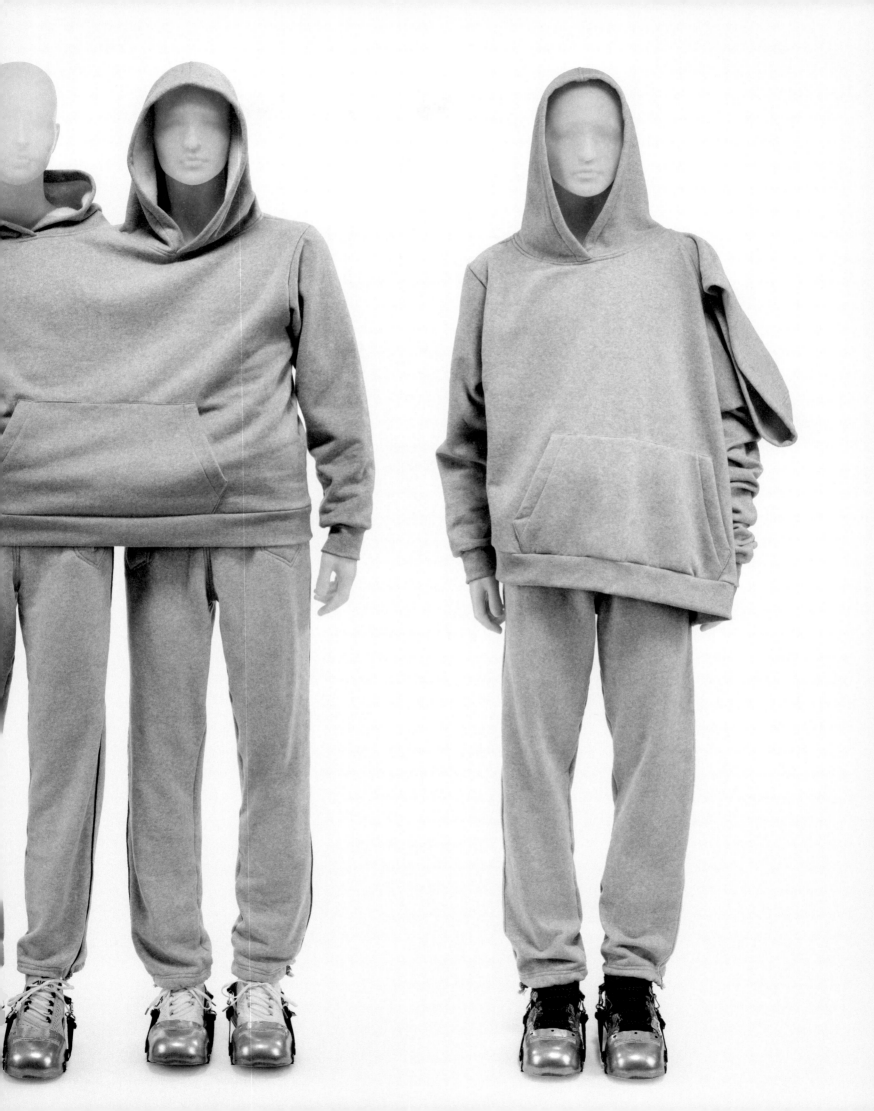

SYMBIOSIS

A mutually beneficial relationship

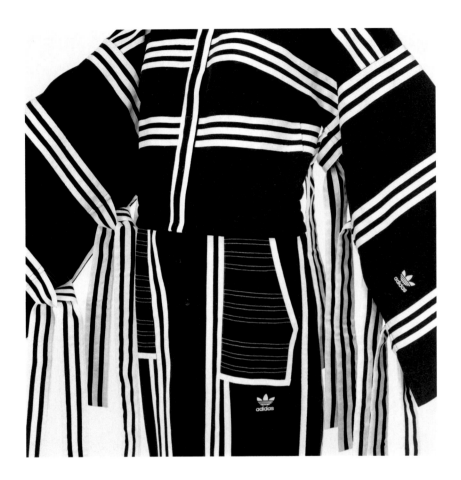

For Ji Won Choi's 2017 "Excessivism" collection—her final thesis project at Parsons School of Design—she combined the concept of modular dressing with formal elements of the *hanbok*, South Korea's national dress. Choi's outsize designs featured horizontal and vertical stripes of white and black trim with straps reminiscent of the hanbok's tie closures. In a collaboration with Adidas in 2019, the designer applied the same graphic lines to tracksuits and interchangeable separates using the sportswear company's 3-Stripe trademark.

Ji Won Choi (American)
Adidas (German, founded 1949)
ENSEMBLE, 2019
Black synthetic jersey trimmed with white synthetic

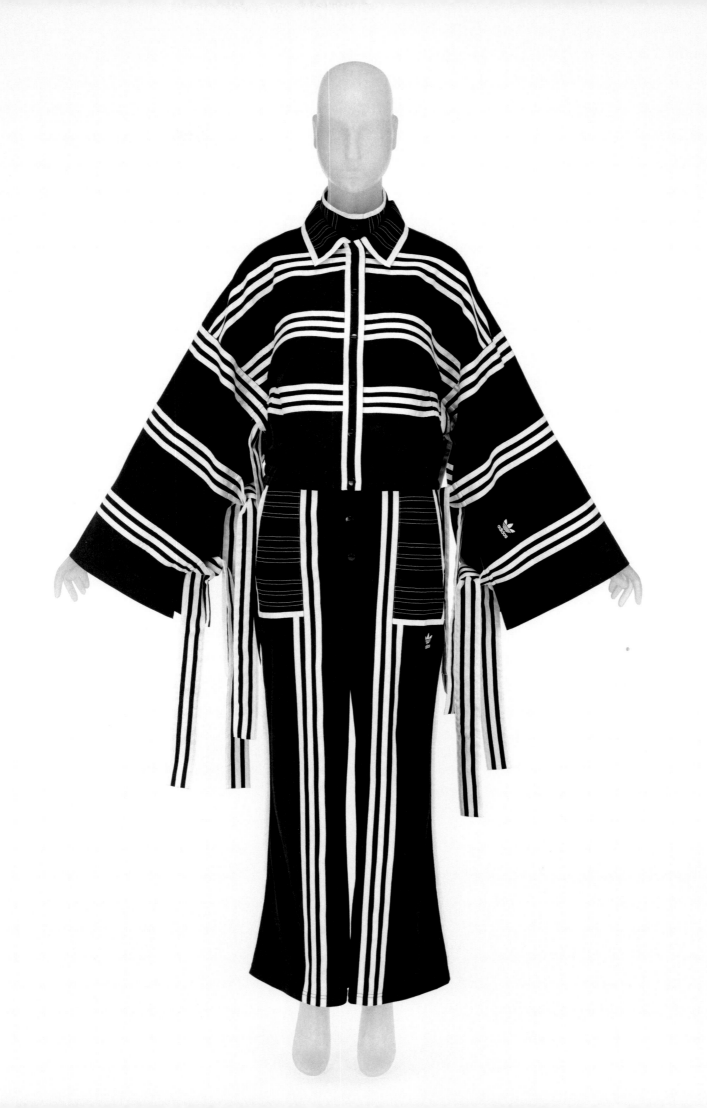

AFFINITY

—

Sympathy especially as marked by community of interest

For the second installment of "American Also," his three-part series of collections addressing Black narratives, Kerby Jean-Raymond of Pyer Moss explored "what the African-American experience would look like without the constant threat of racism." Presented in the historic Brooklyn neighborhood of Weeksville, founded by free African Americans, it included this choir robe–inspired dress, a collaboration with the streetwear label FUBU (For Us By Us). Of the partnership, Jean-Raymond explained: "We wanted to highlight designers that weren't seen. These companies grossed hundreds of millions in their prime, but weren't recognized . . . because they were considered urban, not fashion."

Pyer Moss (American, founded 2013)
Kerby Jean-Raymond (American, 1986)
FUBU (American, founded 1992)
DRESS, SPRING/SUMMER 2019
Black synthetic mesh trimmed with red and black rib knit
and appliquéd with red silk twill embroidered with white cotton thread

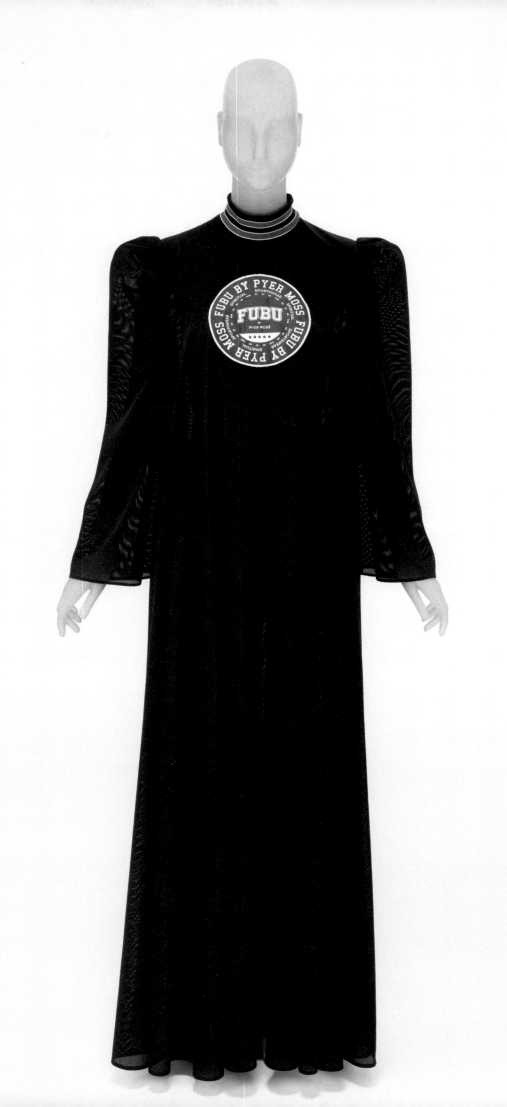

RECIPROCITY

—

The quality or state of being reciprocal
(mutual dependence, action, or influence)

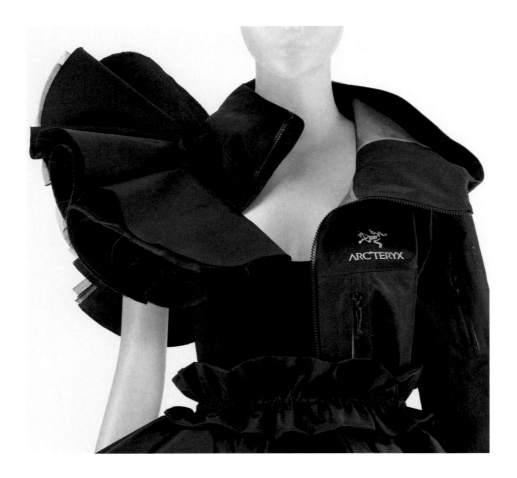

Virgil Abloh used the platform of his Off-White™ label to provoke and challenge the semiotics of fashion. Here, he combined the delicacy of tulle with the robustness of weather-resistant nylon in the form of an anorak by the Canadian label Arc'teryx—"the equal of haute couture in fashion," according to Abloh. The ensemble's embrace of symbolism that resides in both high fashion and activewear invites a broadening of creative possibility and collaboration.

Off-White™ c/o Virgil Abloh (Italian, founded 2013)
Virgil Abloh (American, 1980–2021)
ENSEMBLE, AUTUMN/WINTER 2020–21
Jacket of black nylon twill; ruffles of black nylon twill and black synthetic tulle;
bodysuit of black Lycra-jersey; skirt of black synthetic tulle

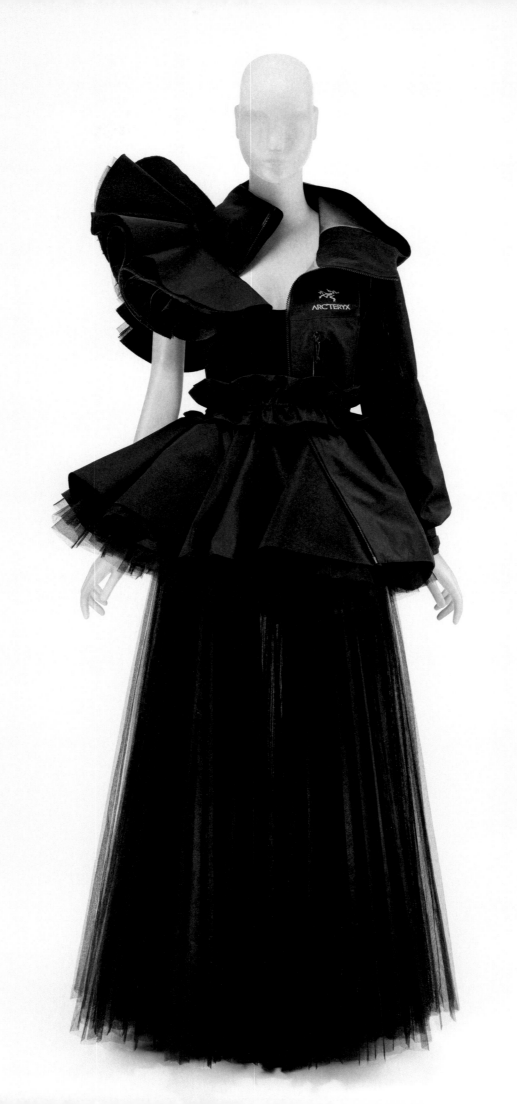

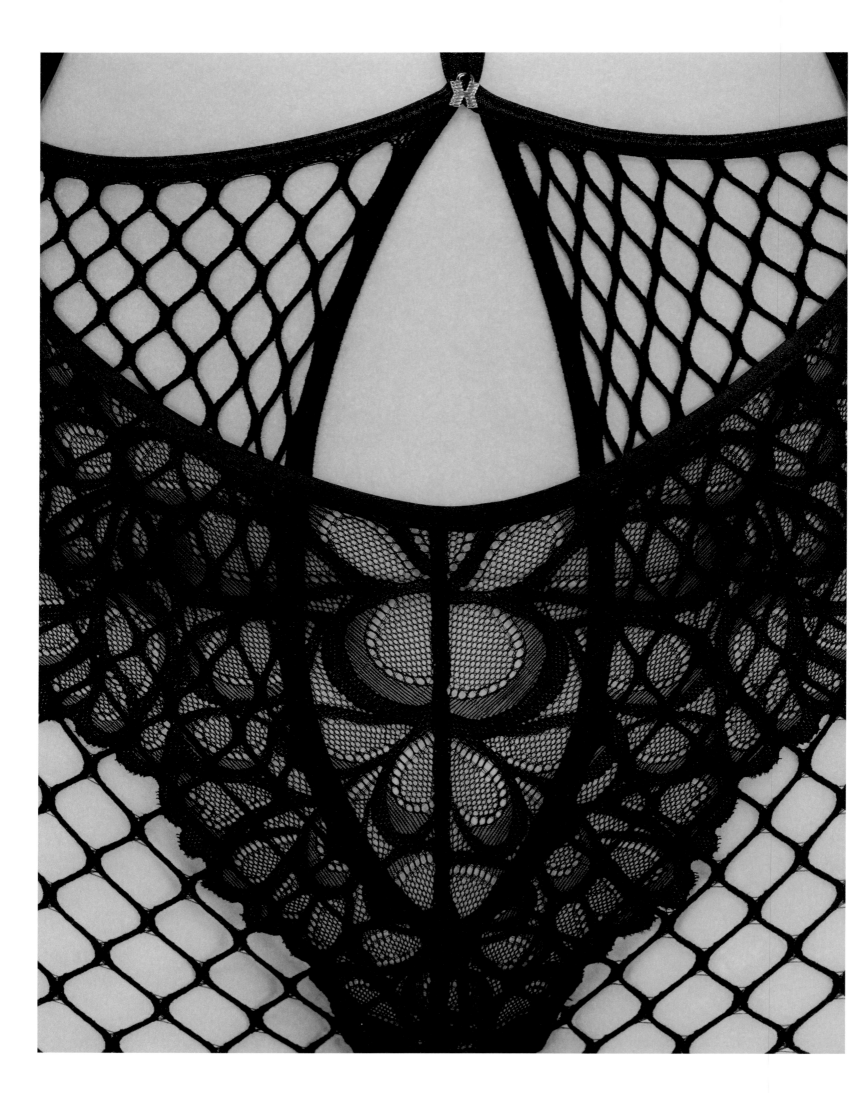

— OPTIMISM —

OPTIMISM

SELF-DETERMINATION

EMPOWERMENT

ASSERTION

CERTAINTY

APPRECIATION

CONFIDENCE

RECOGNITION

OPTIMISM

—

An inclination to anticipate the best possible outcome;
a cheerful and hopeful temperament

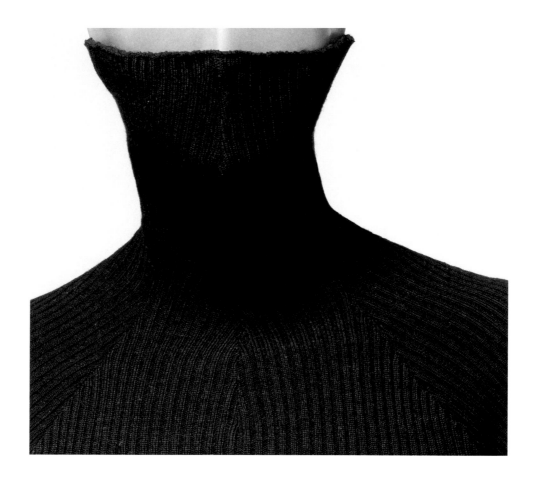

Designer Rudi Gernreich envisioned a future in which men and women could dress alike and nudity was stripped of its moral judgments. This ensemble from his unisex collection was conceived to free the figure from sartorial and cultural constraints by embracing the utility of a uniform, including optional thigh-high waterproof boots for winter. Paradoxically, Gernreich imagined the knit jumpsuit would enhance the wearer's individuality, despite disguising the lower half of the face and unifying the figure as a second skin to obfuscate gender signifiers.

Rudi Gernreich (American, born Austria, 1922–1985)

JUMPSUIT, 1970

Black wool-synthetic ribbed knit

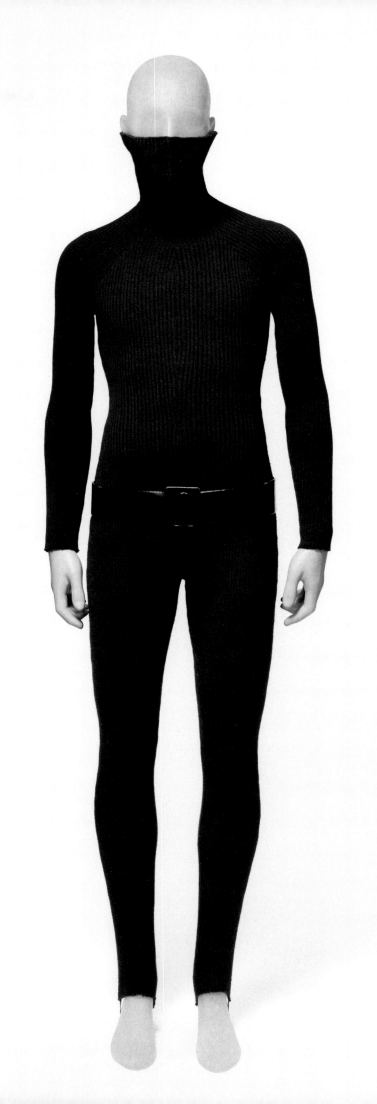

SELF-DETERMINATION

—

Determination of one's acts or states by oneself
without external compulsion

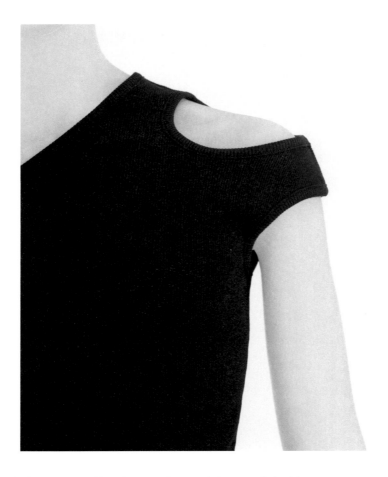

A self-taught designer, Telfar Clemens learned the art of clothing construction through disassembling and reconfiguring basic garments. This methodological approach is a fitting metaphor for his label, which deconstructs gender distinctions and recasts garment paradigms as a modern uniform for what Clemens has described as the "post-identity generation." The unisex line was devised with utopian ideals in mind, welcoming ambitions that are eloquently expressed through the label's tagline: "It's not for you—it's for everyone."

Telfar (American, founded 2005)
Telfar Clemens (American, born 1985)
ENSEMBLE, AUTUMN/WINTER 2017–18; SPRING/SUMMER 2019
Top of black cotton-synthetic knit;
trousers of black cotton twill and wool-cashmere knit

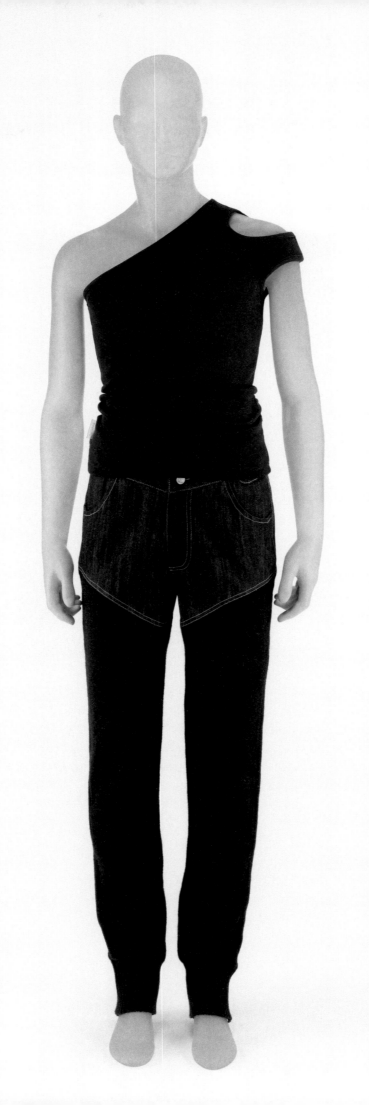

EMPOWERMENT

—

1 — To give faculties or abilities to enable
2 — To promote the self-actualization or influence of

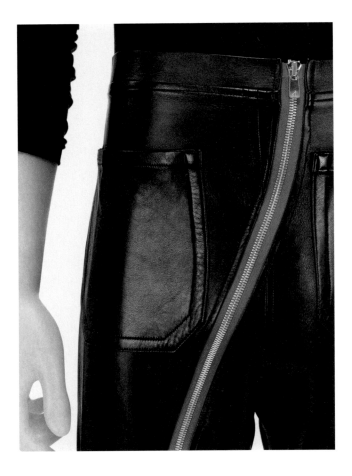

Neil Grotzinger's collections for Nihl subvert gender stereotypes, embracing an aesthetic that the designer has described as "masculine effeminacy." Grotzinger reclaims traditional symbols of masculinity, such as jockstraps and wrestling singlets, to promote an alternative queer message. This ensemble sheaths the figure within the reflective sheen of spandex and leather, punctuating a compression top with a circular cutout to expose the chest and interrupting high-waisted leather pants with a contrasting zipper that seductively snakes from the center torso down the leg.

Nihl (American, founded 2017)
Neil Grotzinger (American, born 1991)
ENSEMBLE, AUTUMN/WINTER 2019–20
Top of black cotton-spandex jersey; trousers of black leather
pieced with gold metal and red cotton twill zipper

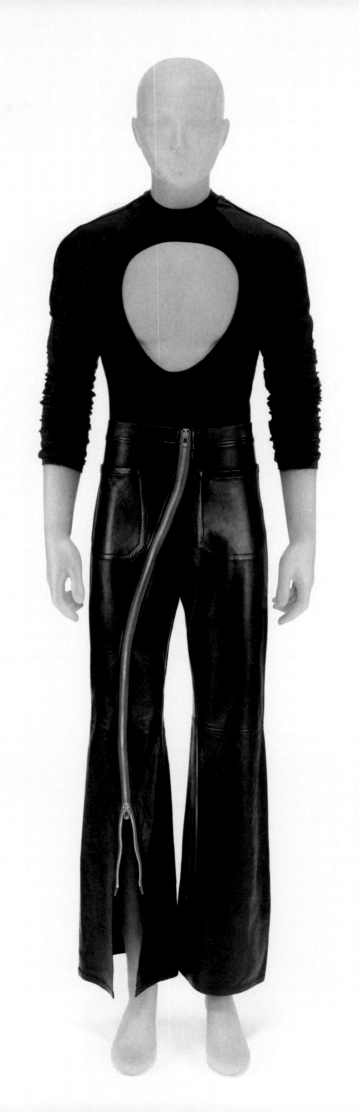

ASSERTION

—

*Insistent and positive affirming, maintaining,
or defending as of a right or attribute*

Shayne Oliver of Hood By Air champions the unconventional through his designs,
casting, and messaging. His spring/summer 2017 collection was an exercise in contrasts,
exemplified in this genderless dress birthed from the ravaged armature of a classic man's
suit. Its raw edges of slashed suiting and shirting that reveal windows of flesh contrast
starkly with the perfection of a factory-packed, pristine white shirt worn as a halter top.
The notion of deconstructing not only clothes but also societal traditions and institutions
epitomizes Oliver's transgressive egalitarianism.

Hood By Air (American, founded 2006)
Shayne Oliver (American, born 1988)
DRESS, SPRING/SUMMER 2017
Black wool gabardine, white cotton poplin, black silk satin,
and red and black printed plastic

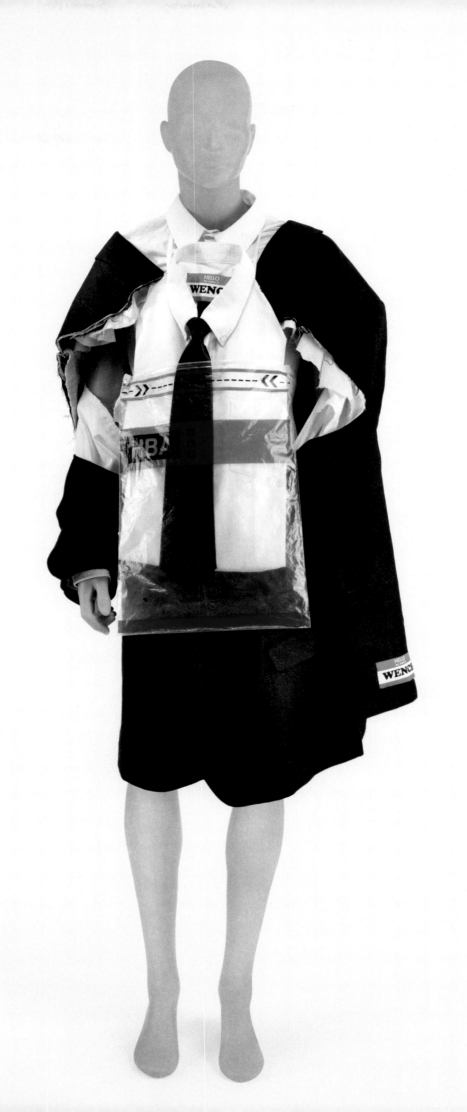

CERTAINTY

—

The quality or state of being certain
(given to or marked by complete assurance and conviction)

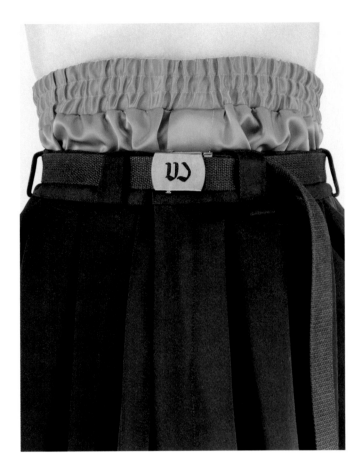

In his work, Willy Chavarria often draws inspiration from Chicano and gay subcultural styles. He challenges normative conventions of masculinity by combining the outsize and body-altering proportions of streetwear with emotional and political themes related to family, community, and sexuality. His spring/summer 2021 "Cut Deep" collection was staged in a New York City barbershop—a site devoted to male beauty and fellowship. This ensemble is part of a series of floor-length, billowing trousers worn shirtless with silk satin boxer shorts. Its high, cinched waist and pleated fullness mimic the elegant silhouette of a woman's evening gown.

Willy Chavarria (American, born 1967)

ENSEMBLE, SPRING/SUMMER 2021

Black wool gabardine and green silk satin

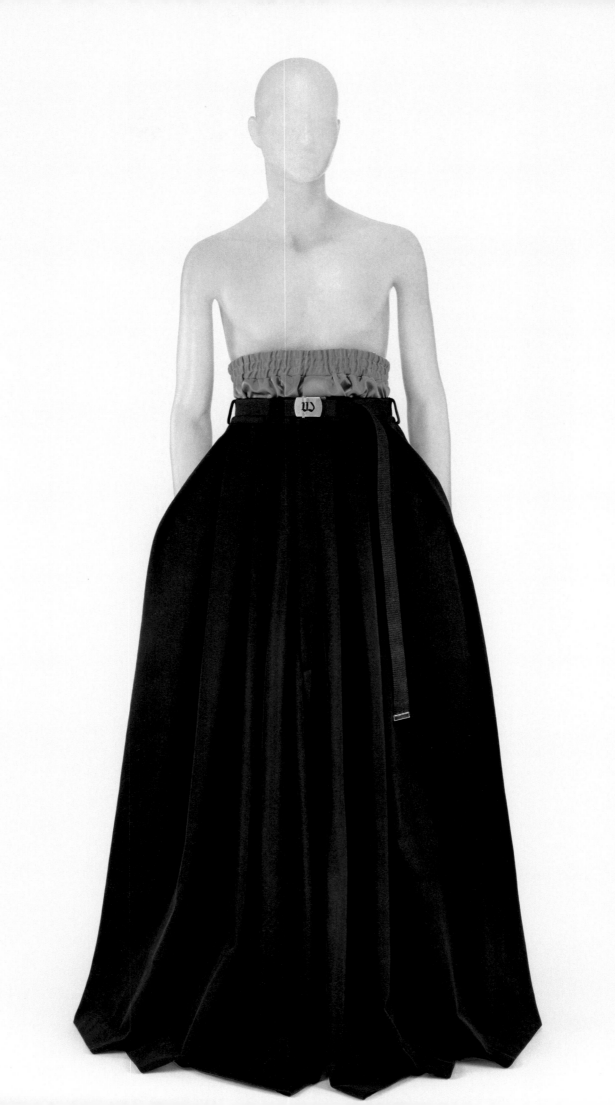

APPRECIATION

—

*Expression of gratification and approval, gratitude,
or aesthetic satisfaction*

Christian Siriano closed his spring/summer 2018 runway presentation with seven models wearing versions of a single dress. Transcending body and gender stereotypes, this modern, inclusive group exemplified Siriano's democratic fashion and beauty philosophy: "There is no correct size, shape, color, or age. As a creator of fashion, I celebrate the body that wears my work. What an honor to be chosen, to be appreciated, and to be seen. That honor extends in both directions."

Christian Siriano (American, born 1985)

DRESSES, SPRING/SUMMER 2018

Black silk satin

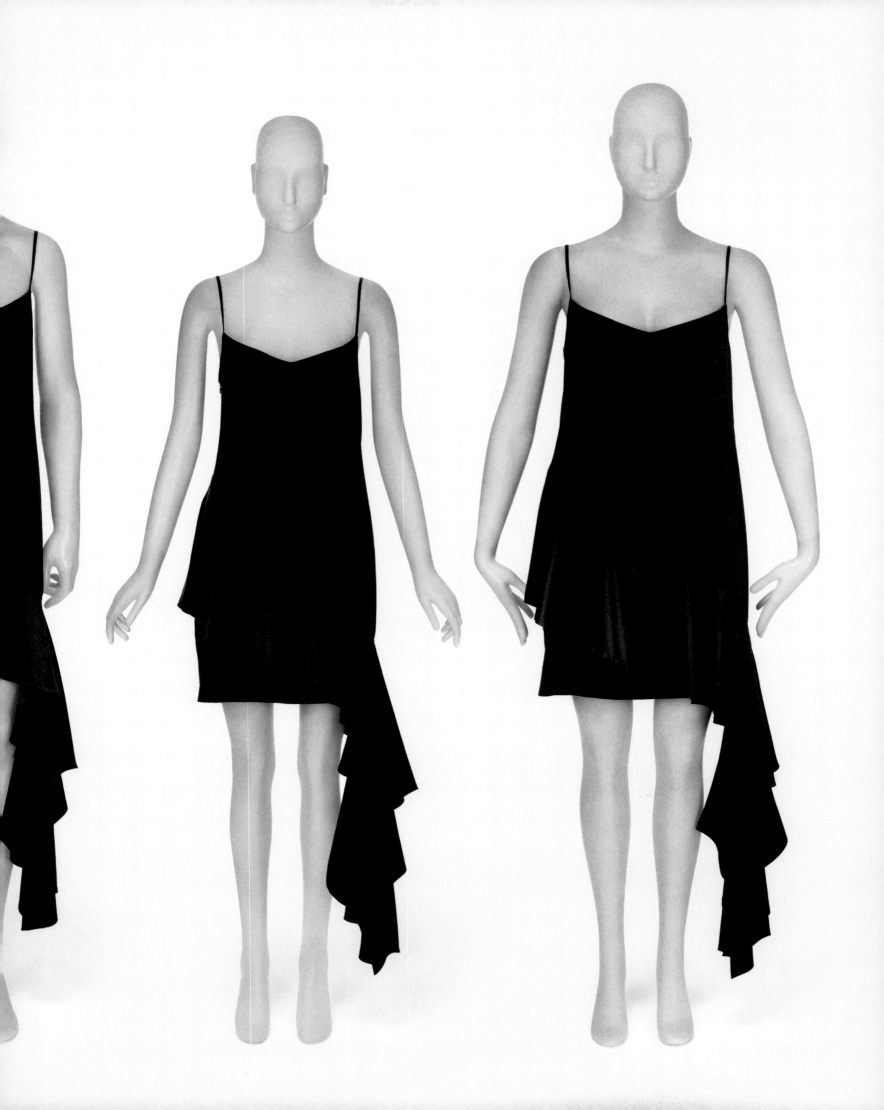

CONFIDENCE

—

1 — Feeling or consciousness of reliance on oneself or one's circumstances
2 — The state of feeling sure

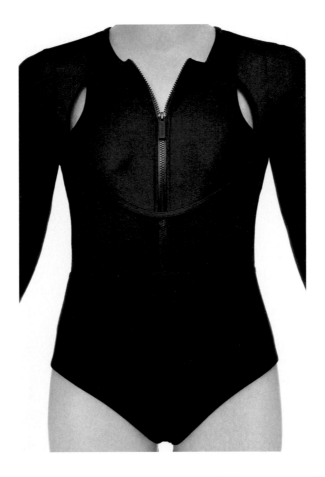

Becca McCharen-Tran's collections for Chromat celebrate a range of body types.
Invariably, she takes the figure as her focal point, utilizing inventive cuts, striking color
combinations, and eco-friendly materials to create attractive activewear that meets
aesthetic, ethical, and comfort-based concerns. This unapologetic emphasis on the body
has led to such innovations as the antichafing thigh bands featured here (presented
in collaboration with Bandelettes), which seamlessly fuse novelty and functionality,
prioritizing the experience of the wearer above all else.

Chromat (American, founded 2010)
Becca McCharen-Tran (American, born 1985)
"SIGOURNEY" SUIT, AUTUMN/WINTER 2016–17

Black synthetic knit and black synthetic mesh

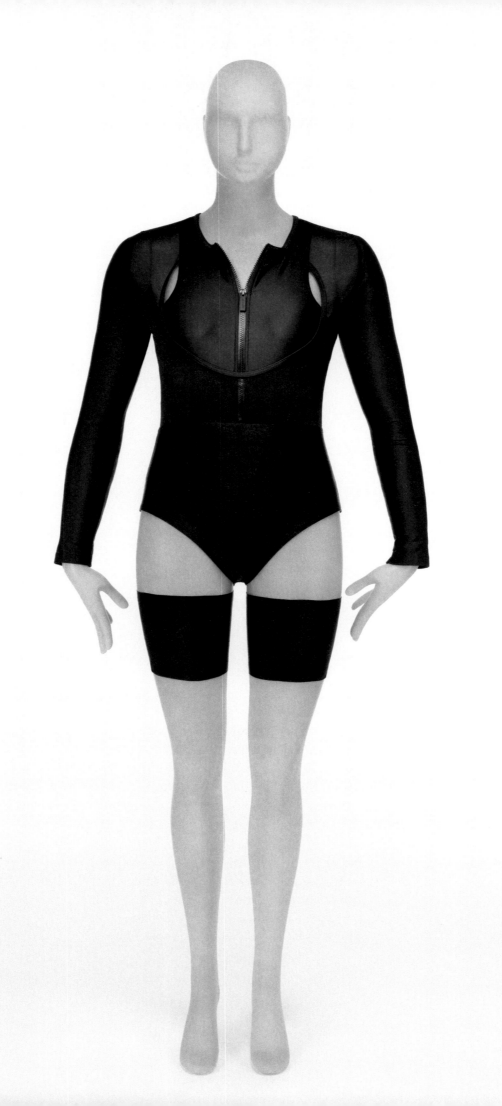

RECOGNITION

—

*Acceptance of an individual as being entitled
to consideration or attention*

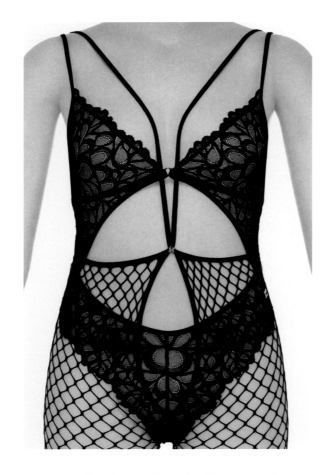

Rihanna's Savage x Fenty collection was launched in 2018 with an acute awareness of the diverse identities that compose contemporary society. The lingerie line promotes principles of community and inclusivity, aiming to avoid the elitism of high fashion. With these goals in mind, it is presented through accessible and highly choreographed runway performances that interweave dance and music. The "Savage Not Sorry" bodysuit and "Commitment Issues" suspender body stocking featured here are part of Rihanna's second collection, which was described as a "celebration of individuality and self-expression."

Savage x Fenty (American, founded 2018)
Robyn Rihanna Fenty (Barbadian, born 1988)
ENSEMBLE, 2020
Bodysuit of black synthetic lace; stocking of black synthetic net

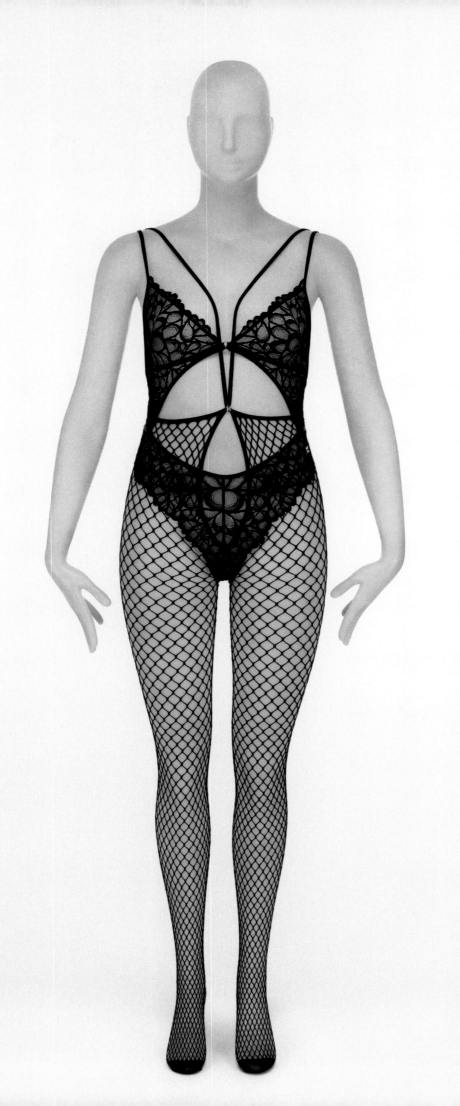

—

STRENGTH

—

STRENGTH

COMMAND

RESOLVE

DISCIPLINE

SERVICE

CAPABILITY

ACCOMPLISHMENT

RESPONSIBILITY

STRENGTH

—

1 — Ability to produce an effect
2 — A source of power or influence

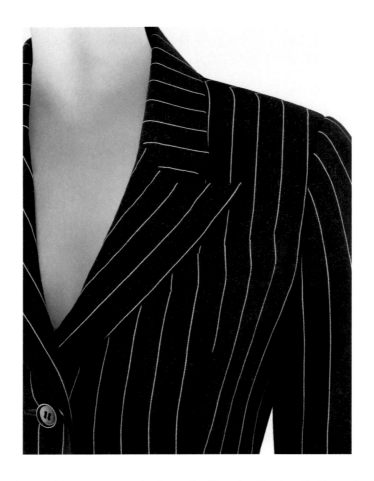

Bill Blass began his career as a designer for Maurice Rentner in the 1960s before establishing his own label in 1970. He quickly earned a reputation for tailored suits woven with bold stripes, checks, and plaids. This suit of navy wool twill features pinstripes in assertive vertical lines from the collar to the hem. The continuation of stripes through the jacket's welt and flap pockets exemplifies Blass's skill as a tailor and his conception of the suit as a seamless whole.

Bill Blass (American, 1922–2002)

SUIT, 1980S

Navy wool twill with white pinstripes

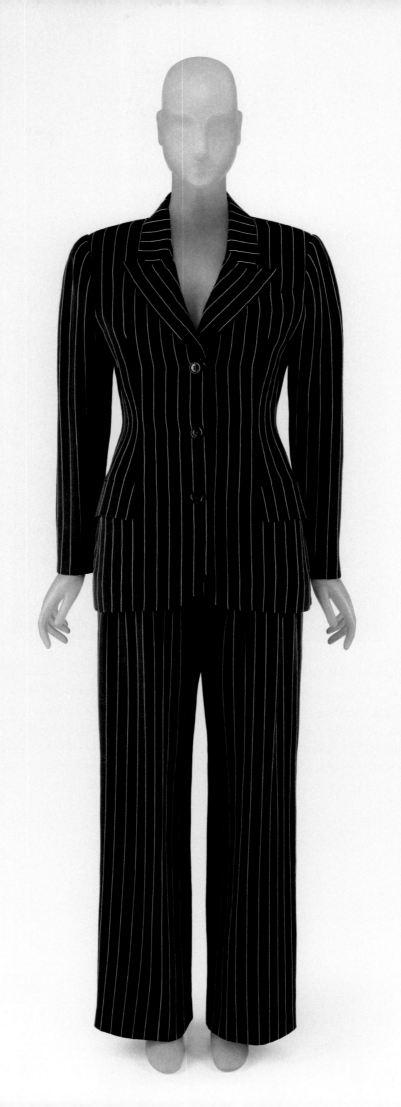

COMMAND

—

The ability to control; mastery

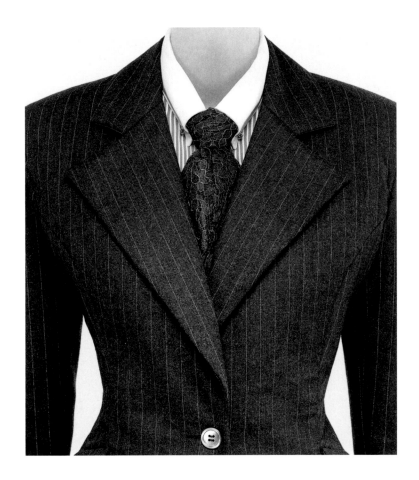

Before founding his own sportswear line in 1986, Carmelo Pomodoro studied fashion at Parsons School of Design and worked for New York–based designers, including Ralph Lauren and Bill Haire. Lauren's influence is evident here in the skillful translation of classic menswear suiting into charismatic womenswear. Pomodoro appreciated the "emotional involvement" of fashion, understanding it as driven by how it makes the wearer feel. Combining the authoritative presence of traditional suiting with the sensuality of a contoured and closely tailored silhouette, this suit confers an alluring sense of strength.

Carmelo Pomodoro (American, 1955–1992)

SUIT, CA. 1989

Jacket and skirt of gray pinstripe wool plain weave;
shirt of gray striped silk georgette and white cotton poplin;
necktie of black cotton lace embroidered with silver silk and metal thread

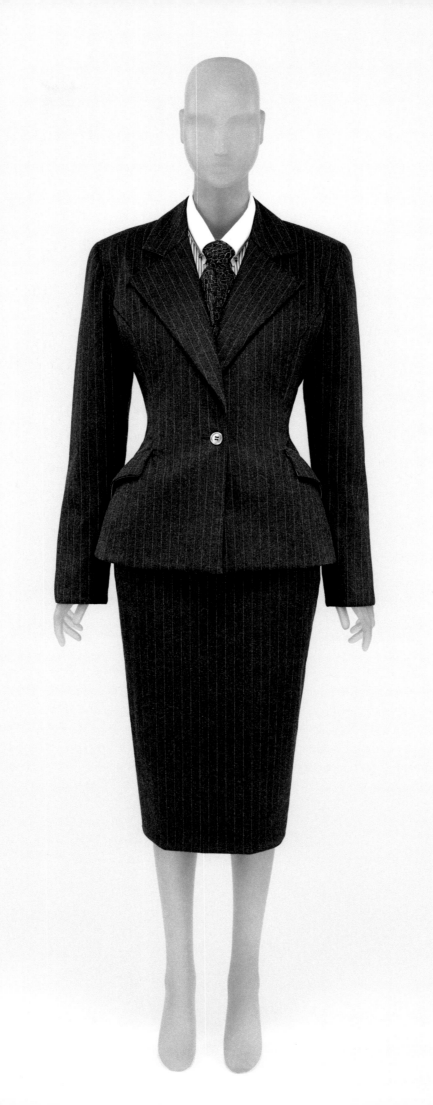

—

RESOLVE

—

Fixity of purpose; resoluteness

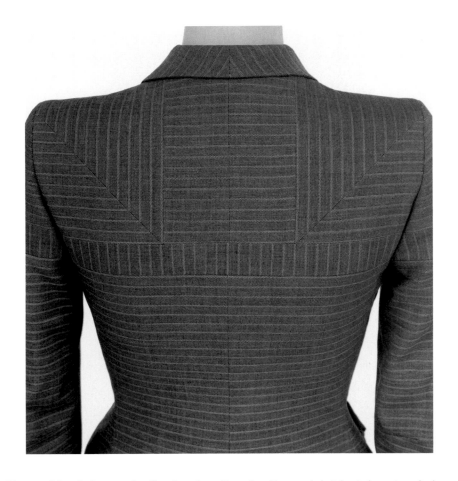

Gilbert Adrian is known for flawlessly tailored suits, each intricately cut and pieced
to create a superb fit and subtle ornamentation. His suiting is equally defined by its
distinctive silhouette: slim, with a firm, accentuated shoulder. Following World War II, the
fashion industry embraced an exaggerated hourglass shape requiring heavy layers and
restrictive undergarments. Yet Adrian remained steadfast in the belief that his more
streamlined forms were a perennially appealing and universally flattering choice,
continuing to show his trim, square-shouldered line until he retired in 1952.

Gilbert Adrian (American, 1903–1959)

SUIT, 1948

Gray pinstripe wool twill

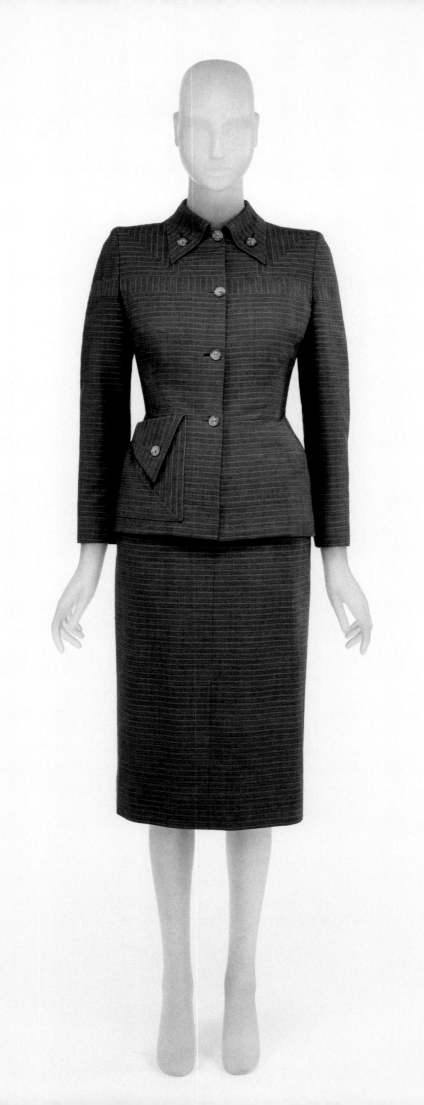

DISCIPLINE

—

An orderly or regular pattern of behavior

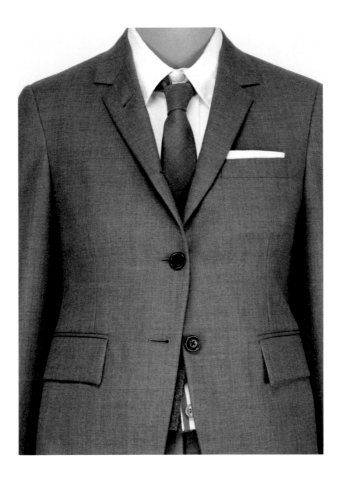

Thom Browne's designs are rooted in the inventive adaptation of classic forms.
He has proposed interpretations of the mid-twentieth-century man's suit, composed
of traditional materials in varied shades of gray, as a universal modern uniform.
In Browne's conception, however, the uniform's regularity is not delimiting. Instead,
its varied permutations allow a sense of individuality to be conveyed through subtle
but distinctive details—shifted proportions, the intermingling of conventionally
masculine and feminine codes of dress, and the precision of cut, construction, and
fabric selection that defines his work.

Thom Browne (American, born 1965)
ENSEMBLES, 2018

Jackets, skirt, and trousers of gray wool twill; shirts of white cotton oxford;
cardigans of gray cashmere knit; neckties of gray wool twill

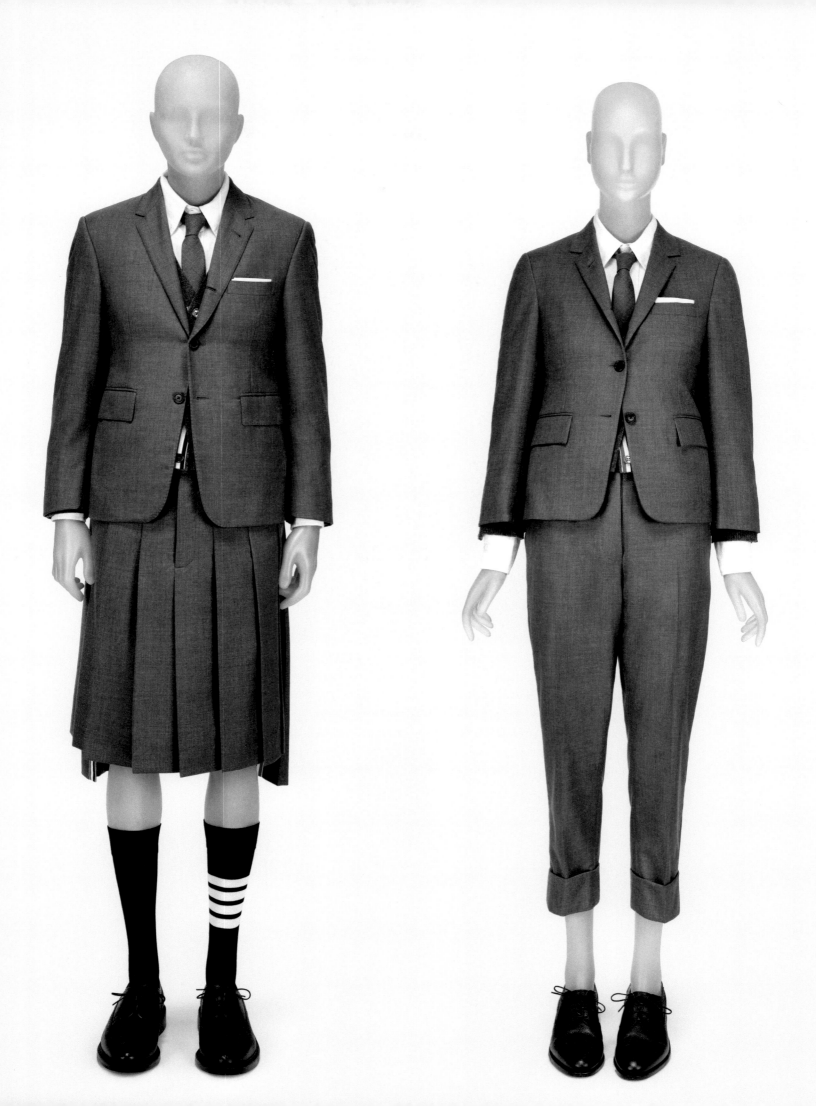

SERVICE

The capacity for being useful for some purpose

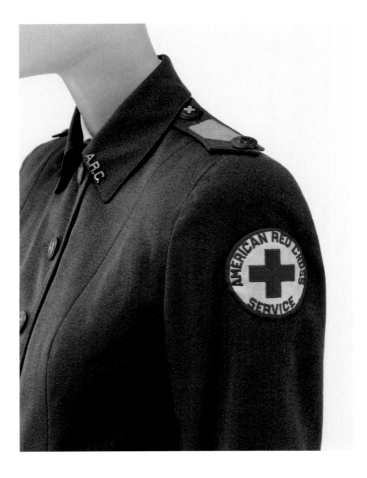

The United States entered the Second World War in December 1941. At this time, the American Red Cross commissioned New York–based couturière Elizabeth Hawes to design an updated uniform, one of a series of collaborations between well-established fashion designers and military and volunteer organizations. Hawes's boxy suit of sturdy blue-gray gabardine with metal buttons, which has the neatness and serviceability of a military uniform, was an expression of the wearer's desire to support the war effort and her willingness to do so.

Elizabeth Hawes (American, 1903–1971)

UNIFORM, 1941–42

Blue-gray wool gabardine with metal buttons

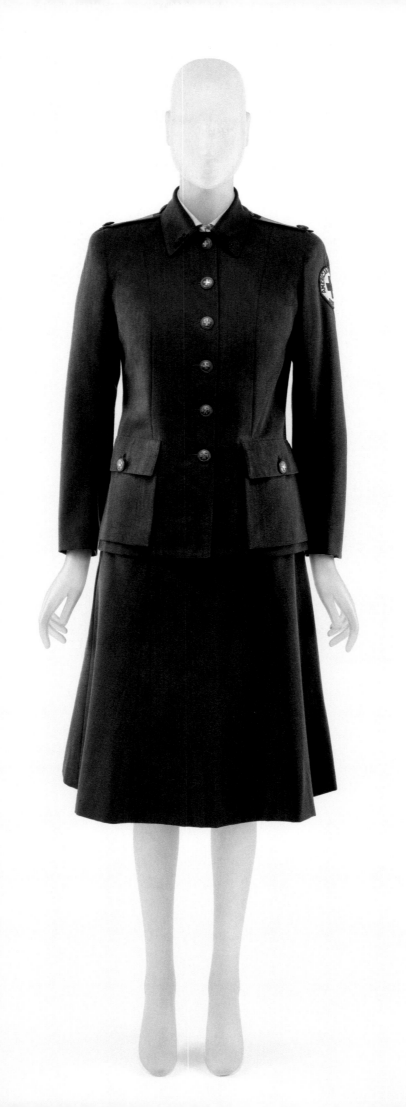

CAPABILITY

—

*The quality or state of being capable
(having or showing general efficiency and ability)*

Mainbocher designed this uniform in 1942 for the Women Accepted for Volunteer
Emergency Service (WAVES), a branch of the US Naval Reserve. Intended to be
comfortable and unrestrictive, the fitted jacket and gently flared skirt also reflected
the elegant lines of contemporary fashion. As one servicewoman declared, "[We] all have
the same aim—to do a man-sized job in a man's field and to try to retain a touch of
femininity as well." The ensemble was becoming without sacrificing functionality,
conveying an image of ready capability.

Mainbocher (American, 1890–1976)
UNIFORM, 1942
Jacket of navy wool twill embroidered with blue silk cord
and blue and gold silk thread; skirt of navy wool twill;
shirt of white cotton poplin

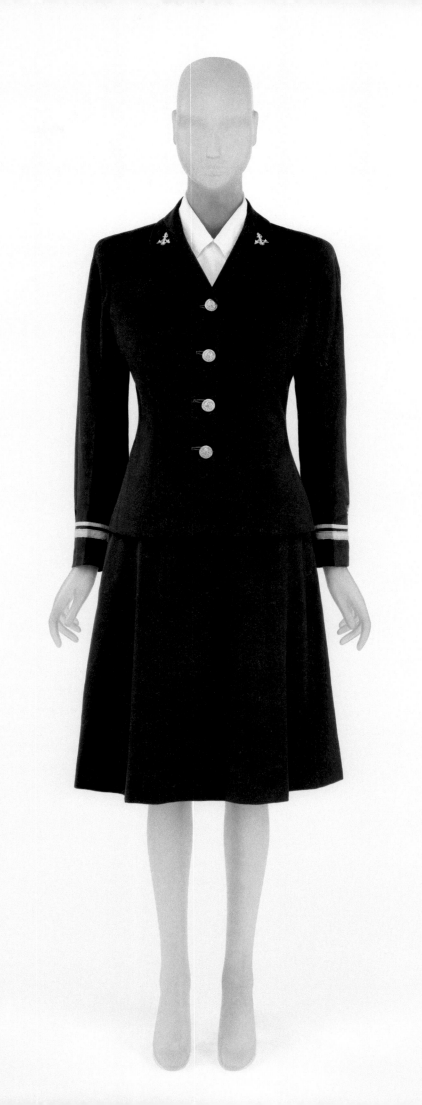

ACCOMPLISHMENT

—

A quality or ability that equips one for society

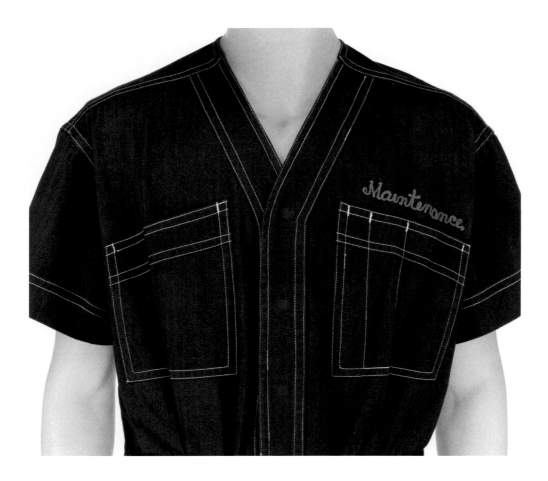

These coveralls are part of a series of work uniforms designed by Helen Cookman for Reeves Brothers Inc., a textile manufacturer specializing in hard-wearing cotton fabrics. Cookman, who was known for her well-tailored coats and suits, introduced details that were both attractive and functional—seams outlined in white topstitching, generous slanted patch pockets, and an integral belt with contrasting red tabs. Her uniforms were intended to align with the demands of the wearer's job while also boosting morale through appealing design and lasting quality.

Helen Cookman (American, 1894–1973)

UNIFORM, 1948

Blue herringbone twill and red cotton plain weave

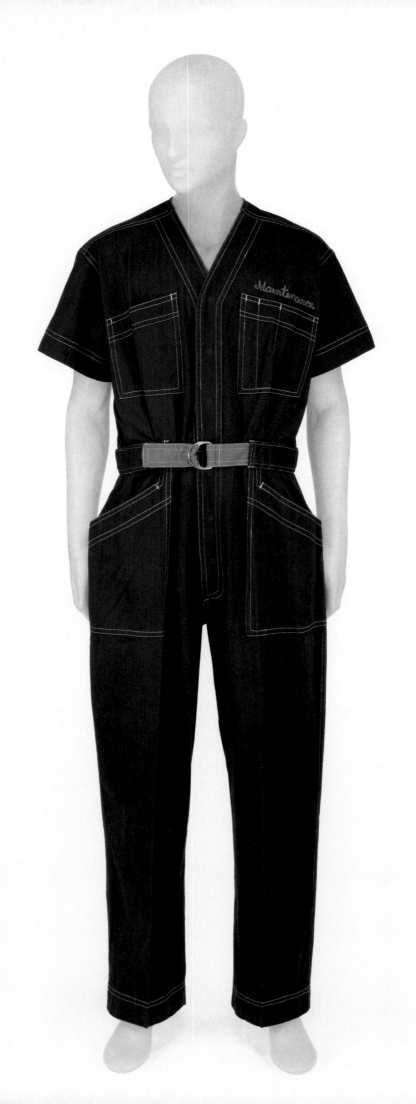

RESPONSIBILITY

—

The quality or state of being responsible;
accountability, reliability, trustworthiness

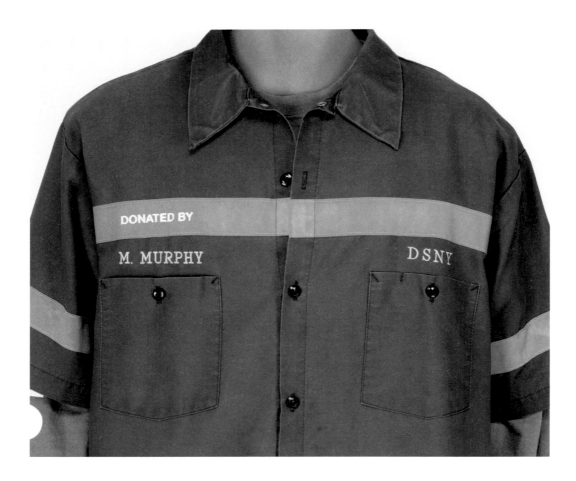

This ensemble is part of Heron Preston's "UNIFORM" collection, developed in collaboration with New York City's Department of Sanitation. Preston was inspired to create thoughtfully designed work wear that would bring attention to the city's zero-waste goals, highlight the contribution of the apparel industry to landfill waste, and celebrate the often underappreciated but essential role of sanitation workers in city life. His redesigned uniforms, made from thrift-store finds and decommissioned sanitation-worker garments, feature DSNY and Heron Preston logos that he screen printed by hand.

Heron Preston (American, born 1983)

ENSEMBLE, 2016

Shirt of green nylon plain weave appliquéd with silver synthetic;
shirt of green cotton knit; trousers of green nylon twill

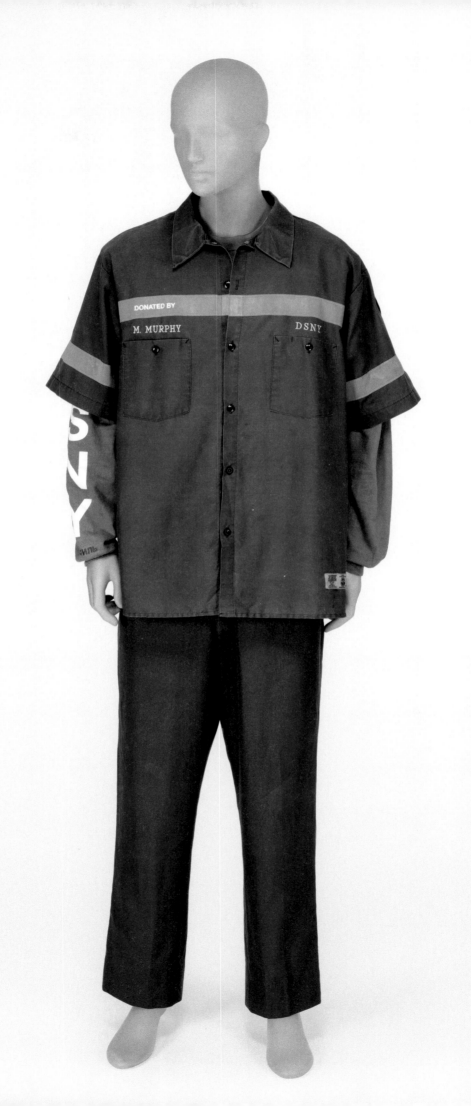

DESIRE

DESIRE

SEDUCTIVENESS

DEVOTION

ENCHANTMENT

ROMANCE

INTIMACY

APPEAL

MAGNETISM

SENSUALITY

ALLURE

GRACE

PASSION

DESIRE

—

A striving after in intent;
a deliberate choice or preference

Through his virtuosic manipulations of fabric, Charles James produced garments that
could cleave to and subtly enhance the curves of the wearer's body. Here, black silk crepe
is worked into horizontal tucks that traverse the center front of the dress and release into
softly draped folds that accentuate the bust and hips, forming an attenuated column
below the knees. This style was called "La Sirène" for its alluring shape, after the mythical
Greek sirens whose seductive singing was said to lure sailors to shipwreck.

Charles James (American, born Great Britain, 1906–1978)

"LA SIRÈNE" DRESS, 1941

Black silk crepe

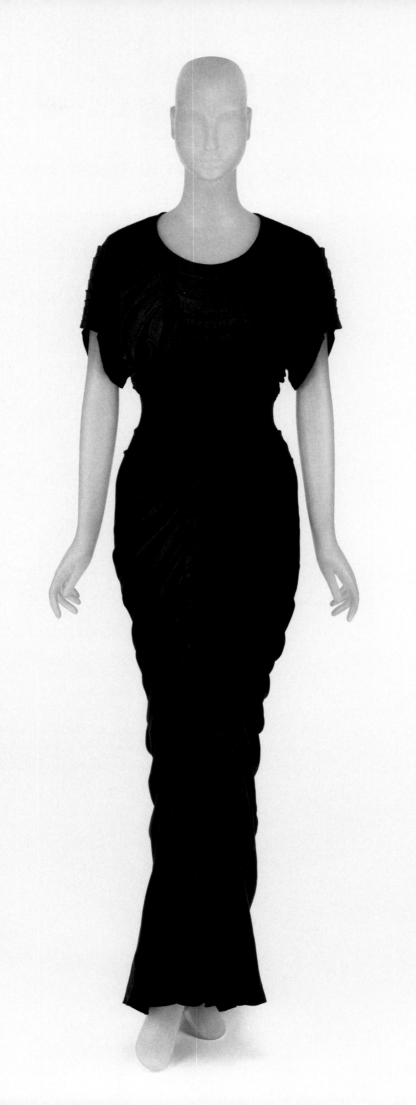

SEDUCTIVENESS

The power of irresistible attraction

Tom Ford is well known for the overt sex appeal of his designs, which reveal and accentuate the body with fluid fabrics and body-conscious silhouettes. Ford's spring/ summer 2018 collection borrowed from the sharp lines of his men's suits. This evening dress is constructed of tightly ruched black net wrapped over the broad, padded shoulders and around the upper arms, mimicking the square shape of a man's jacket. From the waist to the hem, the net is loosely draped in sheer folds, revealing the hips and legs beneath.

Tom Ford (American, born 1961)

DRESS, SPRING/SUMMER 2018

Black rayon jersey and black synthetic net

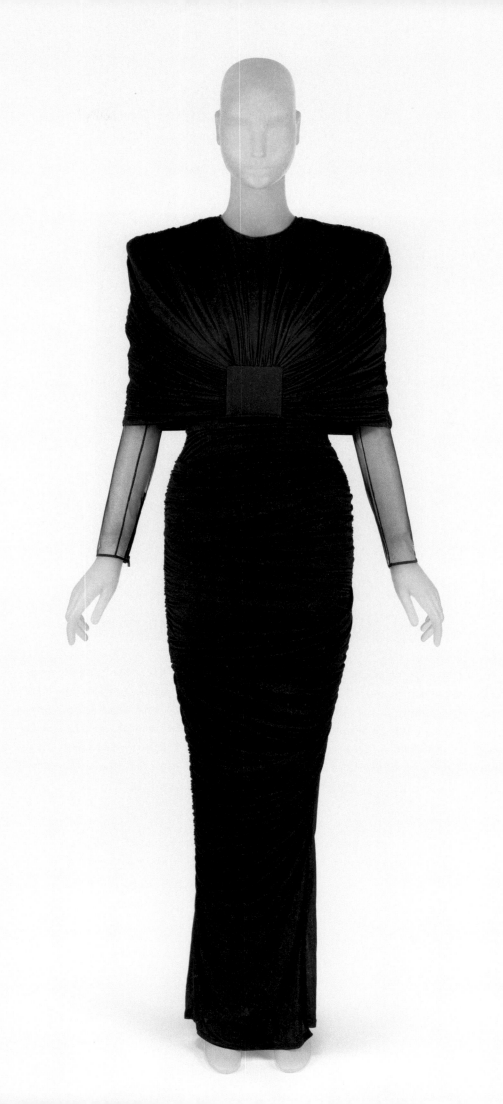

DEVOTION

Ardent love or affection

Isabel Toledo described her work as "dressing emotions," acknowledging the power fashion has to both express the wearer's emotions and change how they feel. She matched this consideration with masterful technical knowledge—an intimate understanding of the way fabric could be draped, folded, or stitched to achieve a desired effect. Toledo's devotion to her craft, through constant hands-on experimentation, yielded garments with unique structures, like this dress composed of tubes of rayon jersey that gently embrace the body, enclosing it in soft folds.

Isabel Toledo (American, born Cuba, 1961–2019)
"HALF MOONS BLOSSOM INTO A CORNFLOWER" DRESS, AUTUMN/WINTER 1998–99
Black rayon jersey

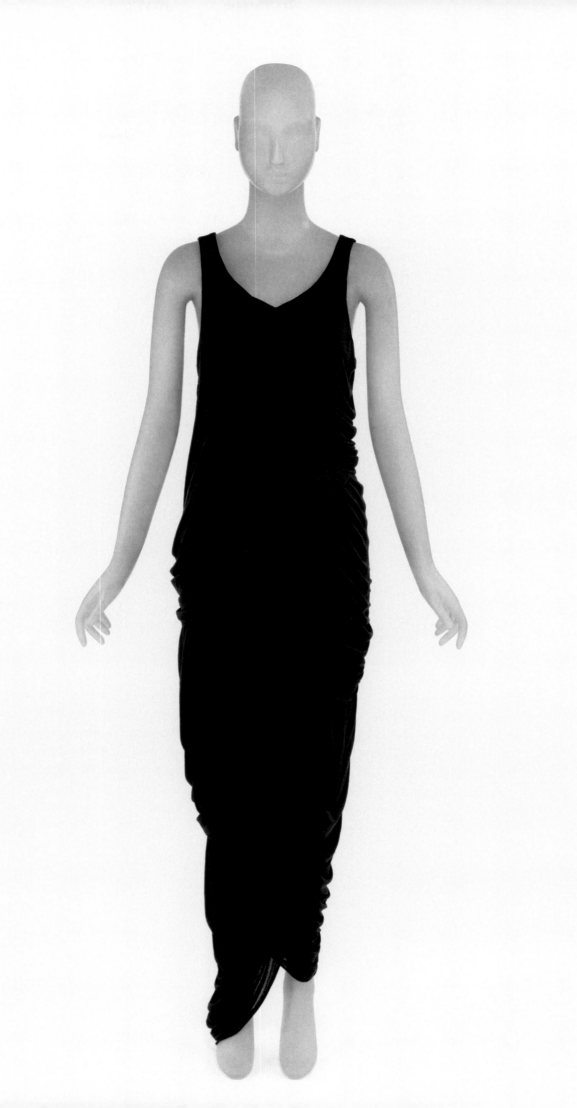

ENCHANTMENT

*The quality or state of being enchanted
(placed under or as if under a magic spell)*

For his autumn/winter 2019–20 collection, Rick Owens referenced designers who inspire him, including the American couturier Charles James, whose disciplined approach to dressmaking parallels Owens's controlled and deliberate methods. James often conveyed a feeling of sumptuousness through dramatic, body-altering silhouettes, and in this ensemble Owens achieves a similar sensibility through complex draping that wraps asymmetrically around the body. The designer offers a modern perspective on glamour, based on the dynamic appeal of asymmetry and irregularity rather than the sinuous lines of mid-twentieth-century fashion.

Rick Owens (American, born 1961)
ENSEMBLE, AUTUMN/WINTER 2019–20
Black silk-cotton jersey

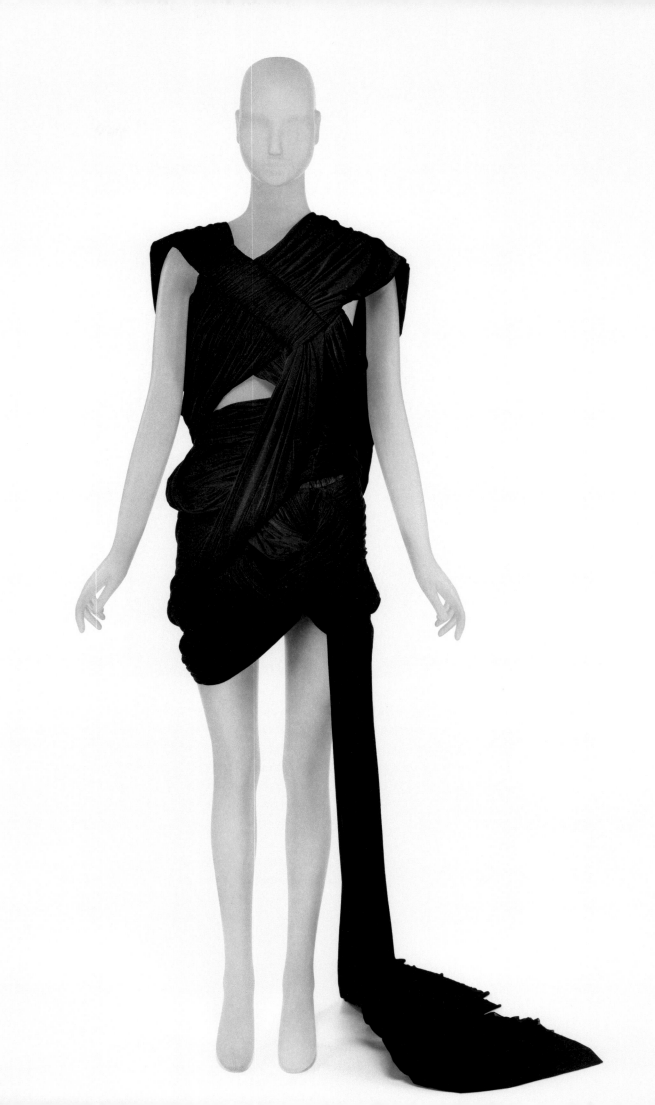

ROMANCE

—

The quality or state of being romantic
(marked by freedom, spontaneity, or freedom of conception
and expression)

Vera Wang engages with fashion both "cerebrally and emotionally," studying its history and giving thought to how her clothing will make the wearer feel. Her designs are carefully draped to flatter the body and to provide a sensation of ease. In this ensemble, a sense of spontaneity is also introduced through the arrangement of the silk georgette, which is gathered to form seam lines that arc organically around the body and extend into loosely falling panels.

Vera Wang (American, born 1949)
ENSEMBLE, AUTUMN/WINTER 2019–20
Dress of black silk georgette trimmed with beige cotton tulle;
shorts of black wool twill; bra of black silk charmeuse

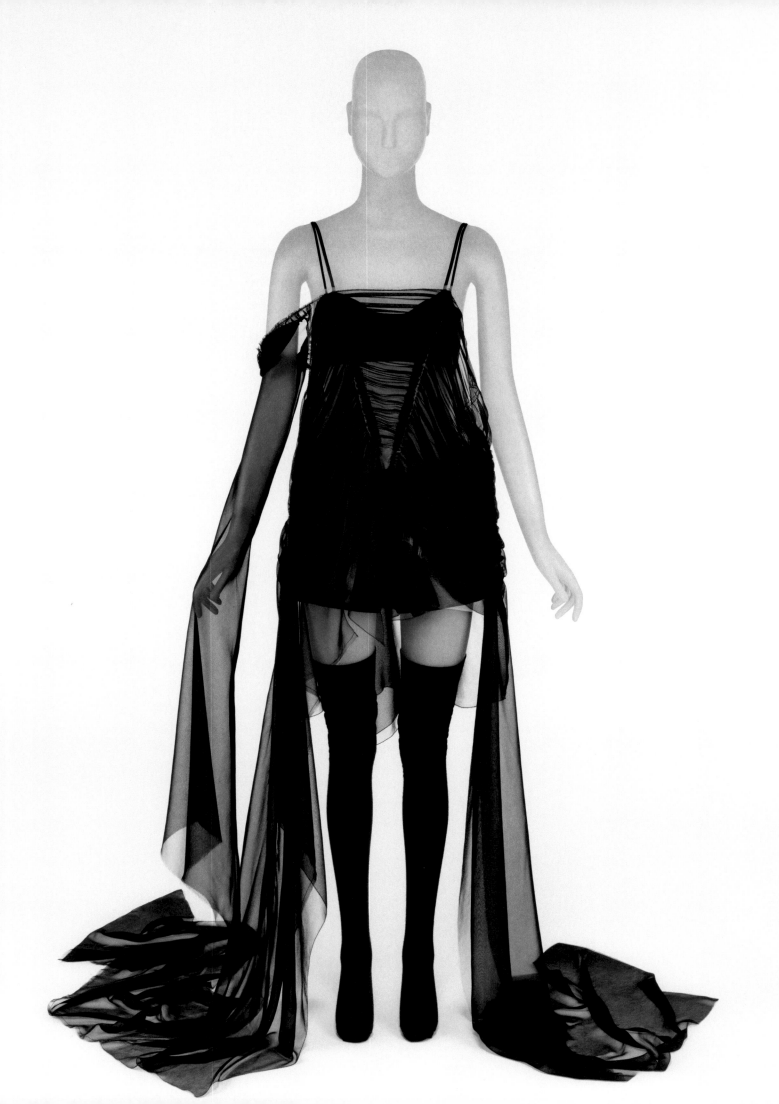

INTIMACY

*The state of being intimate, such as a close association
or connection or a relationship marked by depth of knowledge
or broadness of information*

Jean Yu's approach relies on exacting construction and a deep understanding of the
distinct properties of her materials. Exemplifying the timeless quality of her designs,
this dress eschews embellishment in favor of "soft architecture," as the designer has
referred to her ethereal creations. Delicate silk georgette is suspended from grosgrain
ribbon, forming an intimate connection between body and cloth in which the body
is revealed or concealed through precise draping that creates varying degrees
of transparency.

Jean Yu (American, born Korea, 1968)

ENSEMBLE, CA. 2005

Black silk georgette and black silk grosgrain

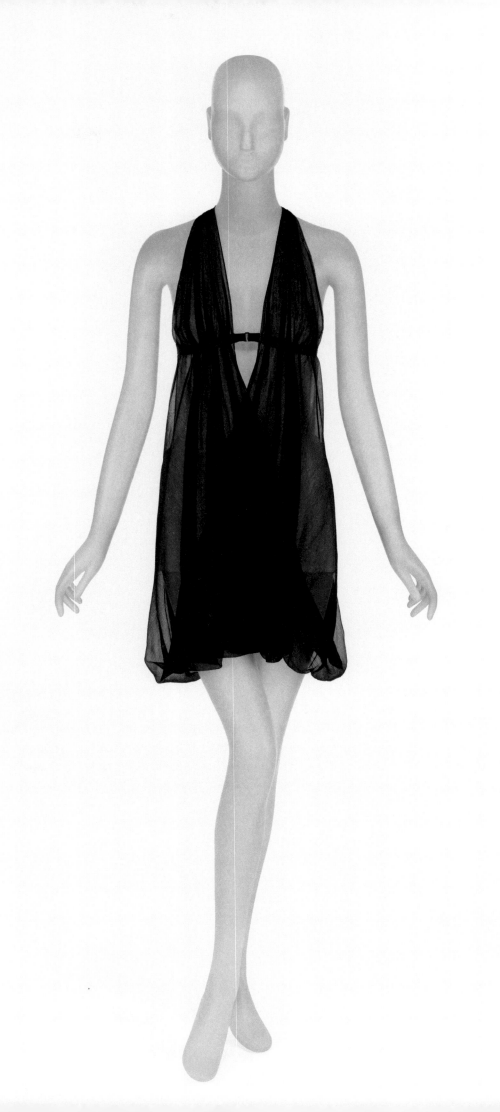

APPEAL

—

The power of irresistible attraction

At the outset of his career, Giorgio di Sant'Angelo was known for his intuitive and experimental approach to draping fabric on the body. As his skills evolved, he explored the arresting potential of stretch fabrics, which he used to highlight the figure. This sheath dress, designed by Martin Price for the Sant'Angelo label after the founder's death, follows this body-conscious sensibility. A panel of opaque stretch velvet below the waist at the front and back and a transparent panel of black mesh reveal the sides and back of the body, creating the illusion of nudity.

Giorgio di Sant'Angelo (American, born Italy, 1933–1989)
Martin Price (American, born 1956)
DRESS, SPRING/SUMMER 1991
Black synthetic-Lycra velvet and net

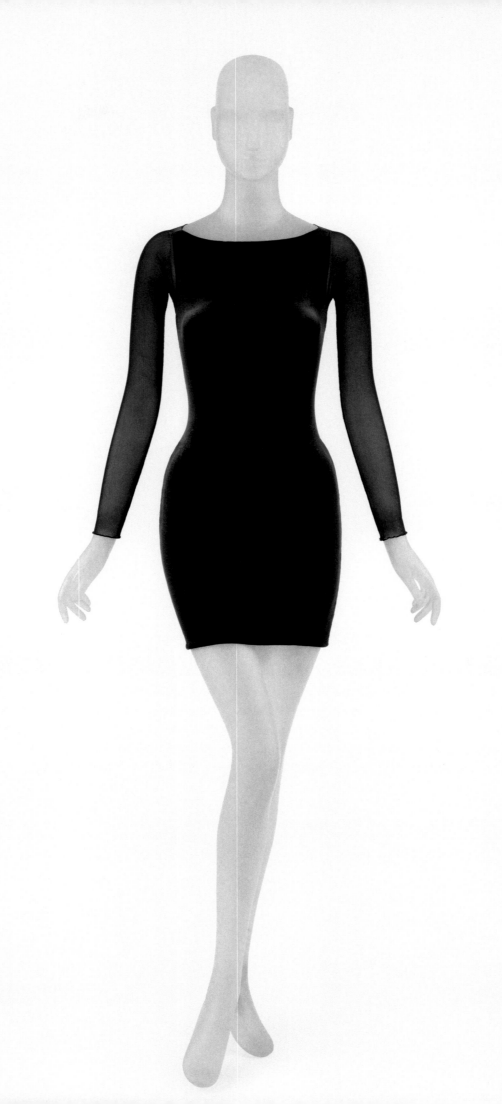

MAGNETISM

—

An ability to attract or charm

Like Giorgio di Sant'Angelo, LaQuan Smith plays with stretch fabrics, cutouts, and transparency to emphasize and amplify the contours of the body, not limited to the supermodel physique of the 1990s. Smith designed this dress, constructed of black mesh appliquéd with black velvet panels at the front and back, for a plus-sized figure. The mesh foundation reveals the body beyond the velvet silhouette, defying the boundaries of the hourglass shape and presenting an alternate model of sensuality and desirability.

LaQuan Smith (American, born 1988)

DRESS, AUTUMN/WINTER 2020–21

Black synthetic mesh and velvet

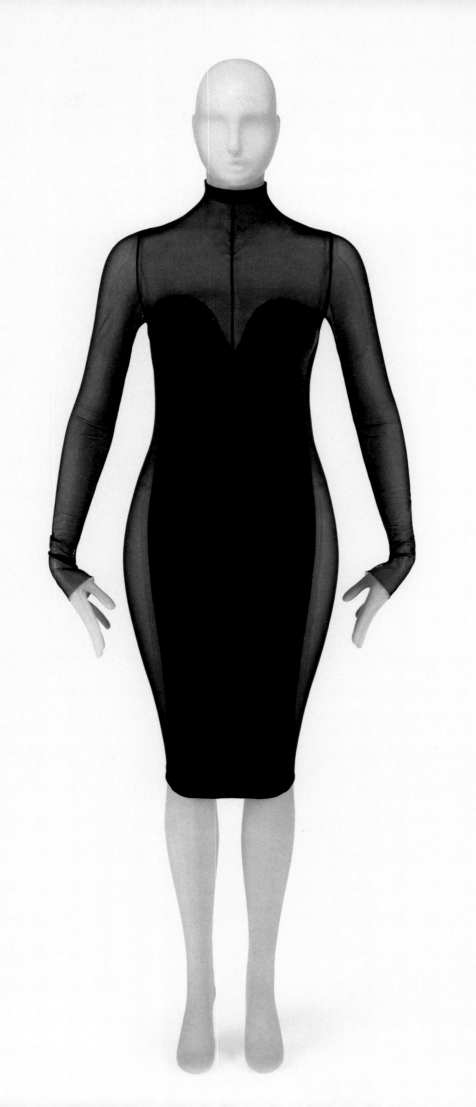

SENSUALITY

—

The quality or state of being sensual
(sensory; of or relating to sensation or to the senses)

The essence of Calvin Klein's minimalism is revealed in this dress of airy matte jersey
that demurely covers the front and reveals an asymmetrical slice of the back. In paring
his design down to the essentials of line, color, and form, Klein emphasizes the physicality
of the body, the luxuriousness of the textile, and the sensuality of the interaction between
body and dress.

Calvin Klein (American, born 1942)

DRESS, AUTUMN/WINTER 1996–97

Black rayon jersey

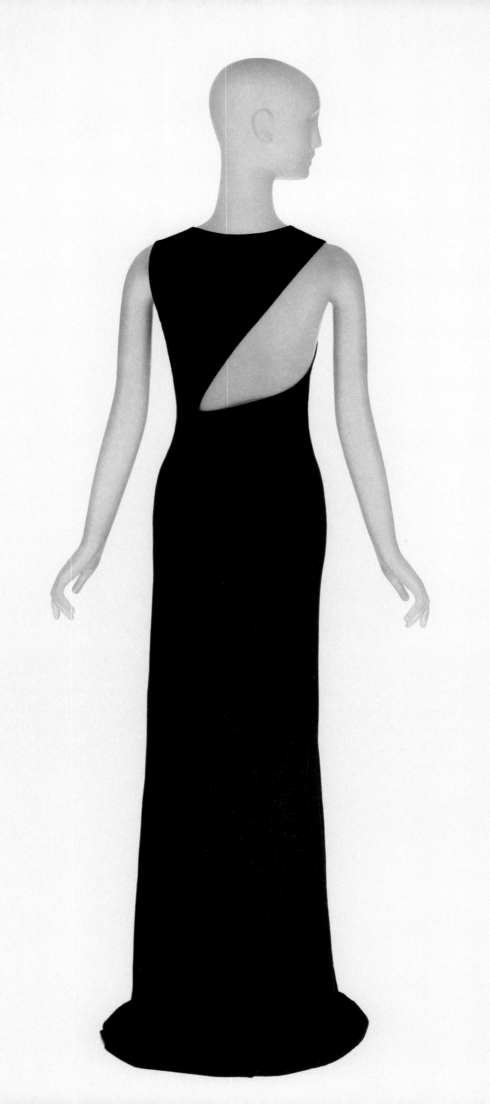

ALLURE

—

A power of attraction or fascination

Narciso Rodriguez's understated designs are defined by fluid fabric and a precise cut
and fit that seem to sculpt the body. Here, carefully placed seams punctuate the wearer's
curves and eliminate the need for shaping darts that would interrupt the line. The focal
point of this dress—the deep cut that bares the upper back and shoulder—tapers to
a narrow vee just below the waist, enhancing the body's inherent allure.

Narciso Rodriguez (American, born 1961)
DRESS, AUTUMN/WINTER 2001–2
Black silk jersey

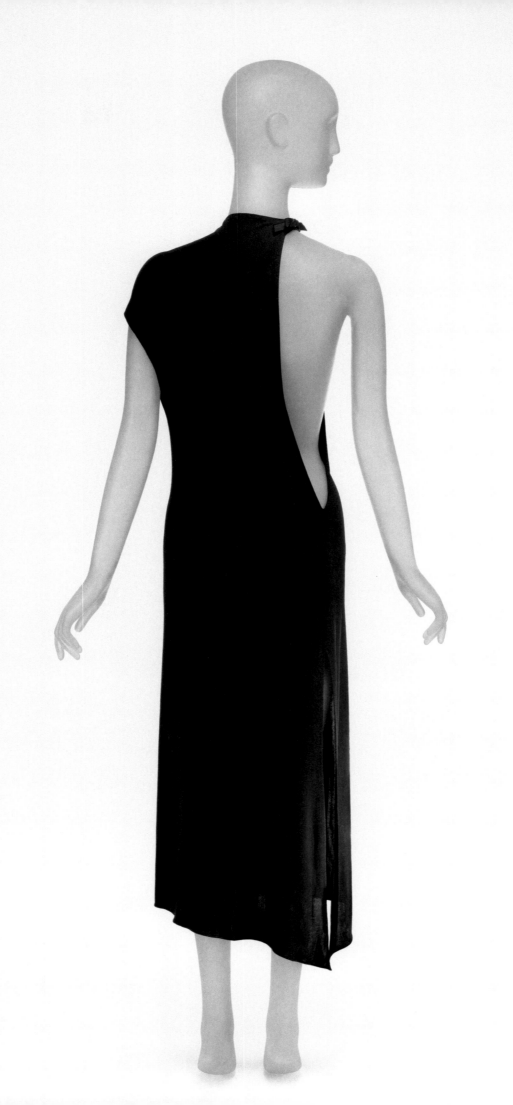

GRACE

*Attractiveness, charm, especially the pleasing quality
associated with a special and refined fitness of proportion
combined with an ease and beauty of movement*

Geoffrey Beene talked about clothing as a language that linked creator and wearer. His
designs combine the sensuality of eveningwear with the ease and fluidity of sportswear,
employing supple fabrics and pared-down construction to emphasize the lines of the body
and articulate its gracefulness. This dress, cut modestly at the front, has curved seams
and tulle insets at the back that reveal and outline the torso and hips.

Geoffrey Beene (American, 1927–2004)

DRESS, AUTUMN/WINTER 1989–90

Black wool-Lycra jersey pieced with nude silk chiffon

and edged with black silk satin

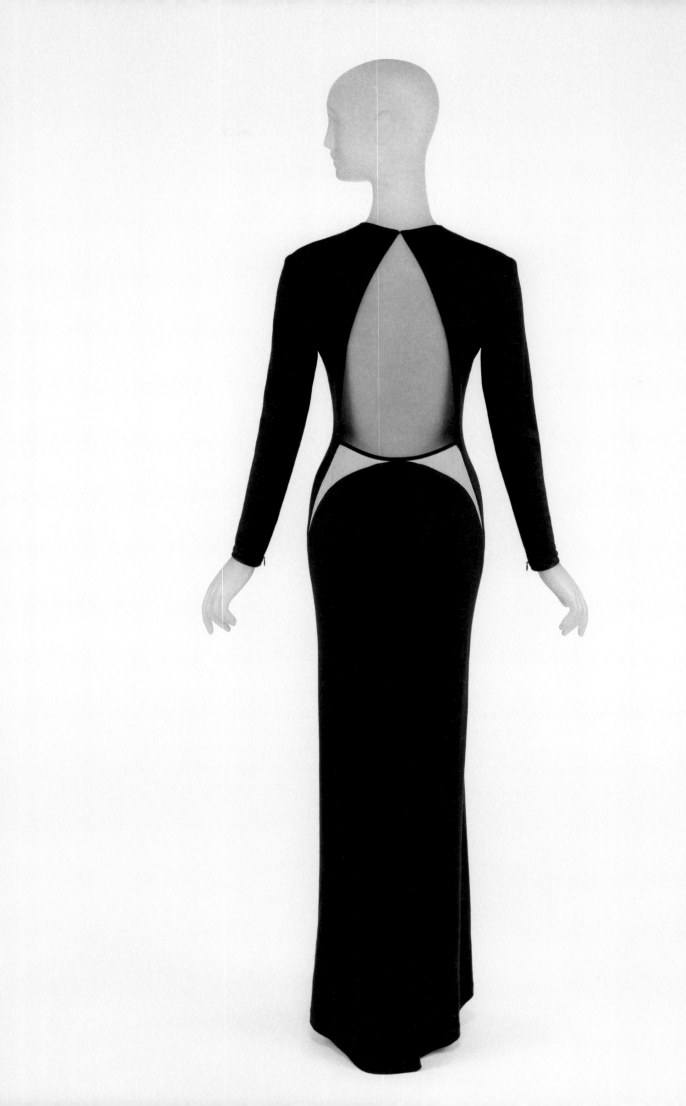

PASSION

*A strong devotion to some activity,
object, or concept*

Ralph Rucci's rigorous technical skill and fundamental respect for the body are both rooted in his devotion to evolving the art of dressmaking. The design of this dress is biomorphic: it does not simply follow the superficial outlines of the body but responds to its internal structure. Precisely cut center-back panels evoke the vertebrae beneath, while cords that join the back and front sections echo the rib cage and the bands of muscle wrapping the torso. The effect accentuates the body while seamlessly integrating structure and ornament.

Ralph Rucci (American, born 1957)
"VERTEBRAE" DRESS, AUTUMN/WINTER 2004–5

Black wool crepe

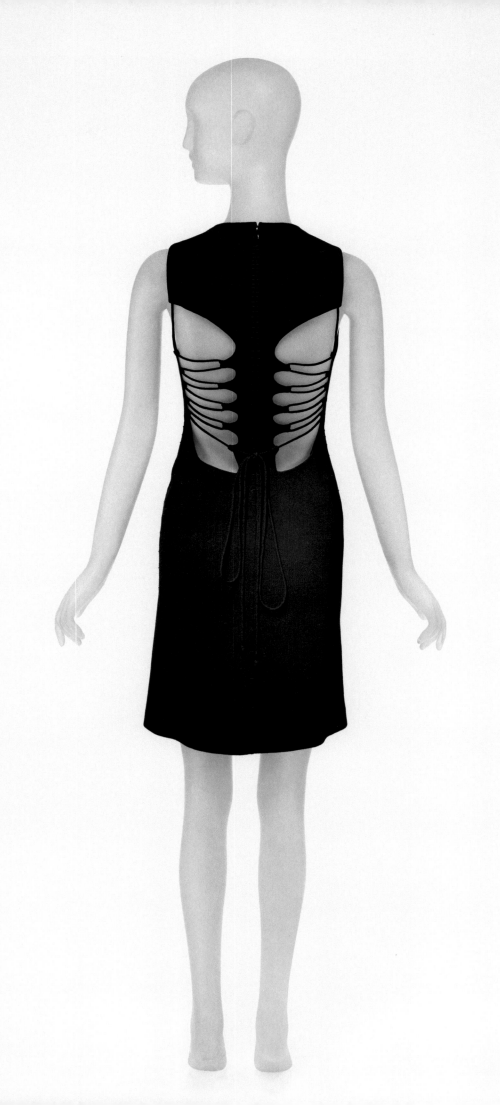

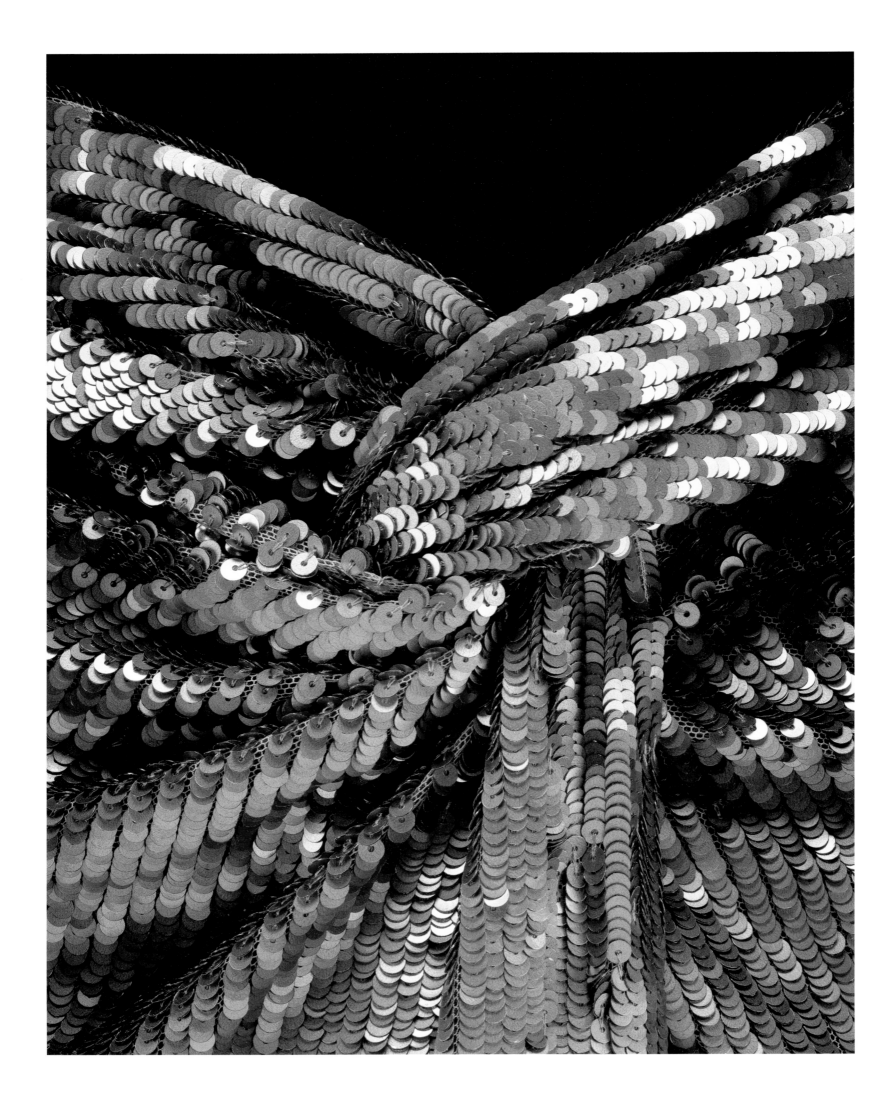

— SPONTANEITY —

SPONTANEITY

FREEDOM

FLUENCY

FACILITY

RELIEF

EASE

CONVICTION

HARMONY

ASSURANCE

SURENESS

SPONTANEITY

—

1 — Voluntary action or movement
2 — The quality or state of being spontaneous:
proceeding from natural feeling or native tendency
without external constraint

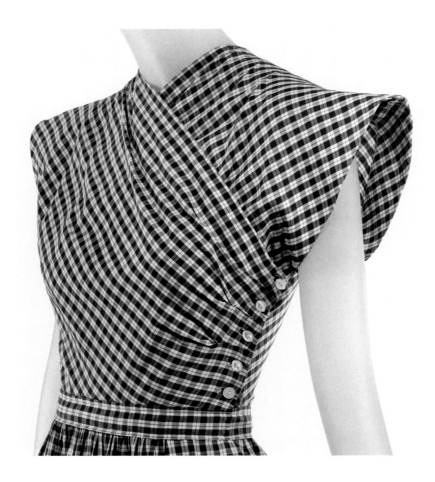

Claire McCardell created countless variations of the "wraparound" dress, a simply cut, one-piece garment that neatly encircles the body. In this example, the bodice is draped on the bias, adding dynamism by shifting the orientation of the pattern and introducing a slight elasticity for ease of fit. McCardell's designs have a forthright quality: they stay true to the wearer, never reshaping the body or overwhelming it with showy ornamentation. As *Time* magazine opined when McCardell appeared on its cover in May 1955, her work exemplified a key tenet of American fashion—that it compliment the wearer rather than the designer.

Claire McCardell (American, 1905–1958)

DRESS, 1943

Polychrome checked cotton plain weave

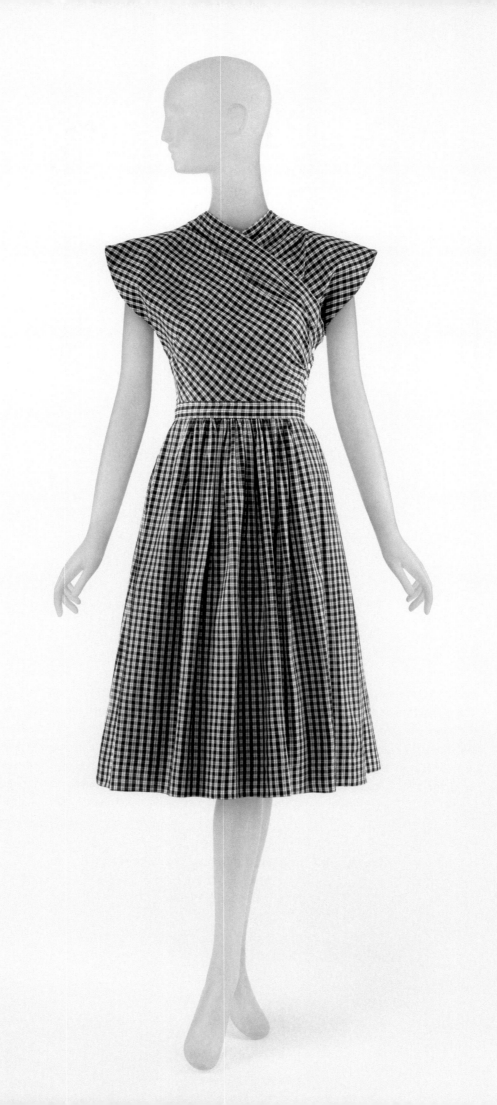

FREEDOM

—

The quality or state of being free
(independent)

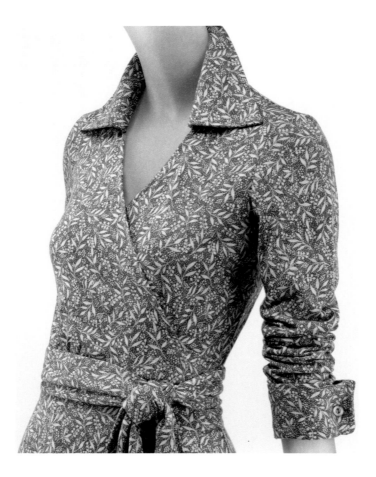

Diane von Furstenberg introduced her popular version of the wrap dress in 1974, dispelling
the notion that a dress is a fussy or constricting garment at odds with the lifestyle of
an active professional woman. Composed of supple jersey in striking prints, the dress
wrapped easily around the body and secured with a self-fabric tie. The simple cut freed
the wearer from restrictive seaming or fastenings and ensured a body-conforming fit on
a range of individuals. Fashion journalist Carrie Donovan, writing in 1977, credited
Von Furstenberg with the "renaissance of the dress."

Diane von Furstenberg (American, born Belgium, 1946)

DRESS, 1970S

Polychrome printed cotton jersey

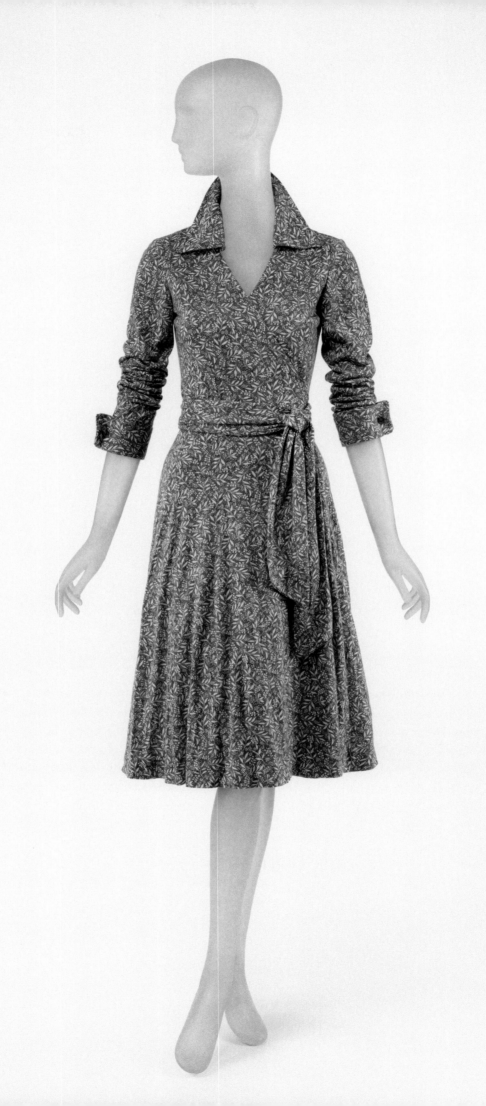

FLUENCY

*Fluent quality;
smoothness, ease, and readiness*

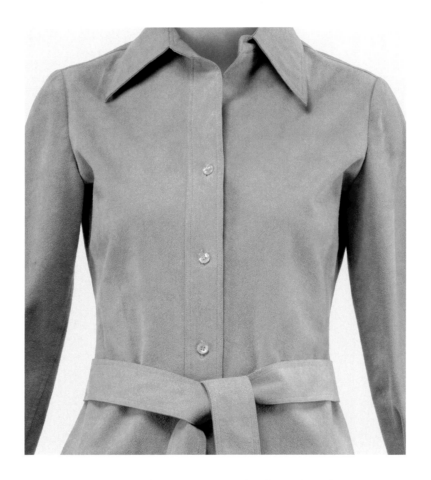

Halston's shirtdress, introduced in 1972 and made of supple and washable Ultrasuede, became a staple item for the many women who appreciated its effortless quality. His adaptations of the basic construction of a man's shirt included slimmer sleeves, a slight A-line flare, the addition of a self-fabric belt, and the elimination of a collar-height button, subtly revealing the décolletage. Although one journalist called it "the suede uniform," the dress facilitated individual styling—the collar could be worn up or down, the sleeves straight or rolled up, and the belt tied as the wearer chose.

Halston (American, 1932–1990)

DRESS, CA. 1974

Camel Ultrasuede

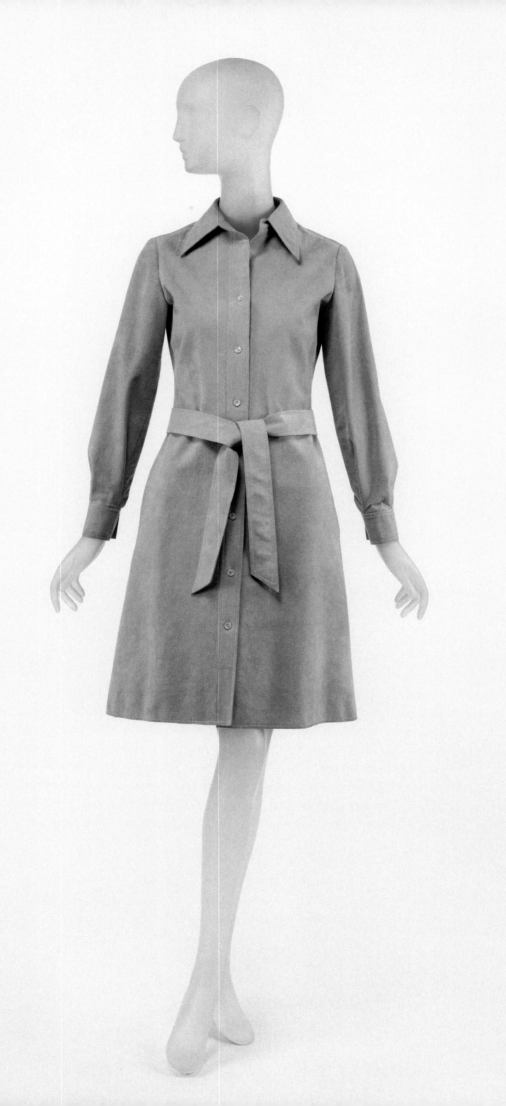

FACILITY

—

Ease in performance

Vera Maxwell is best known for combining form and function in modular separates responsive to the active personal and professional lives of women. Maxwell introduced her travel suit in the late 1930s and continued to modify it over the course of her career. This three-piece example from 1948 exemplifies her belief that "clothes should be beautiful, adaptable, and sound." The trousers and top are made of wool jersey, favored for its elastic and wrinkle-resistant properties. The jacket of wool tweed, lined at the front opening with coordinating jersey, is cut with fullness in the body and sleeves for ease and mobility. Its conspicuous patch pockets, lined with plastic, were designed to hold necessities for an overnight flight—cosmetics, a toothbrush, toothpaste, and a washcloth.

Vera Maxwell (American, 1901–1995)

ENSEMBLE, 1948

Jacket of light brown and white wool tweed and clear plastic;
top and trousers of brown wool jersey

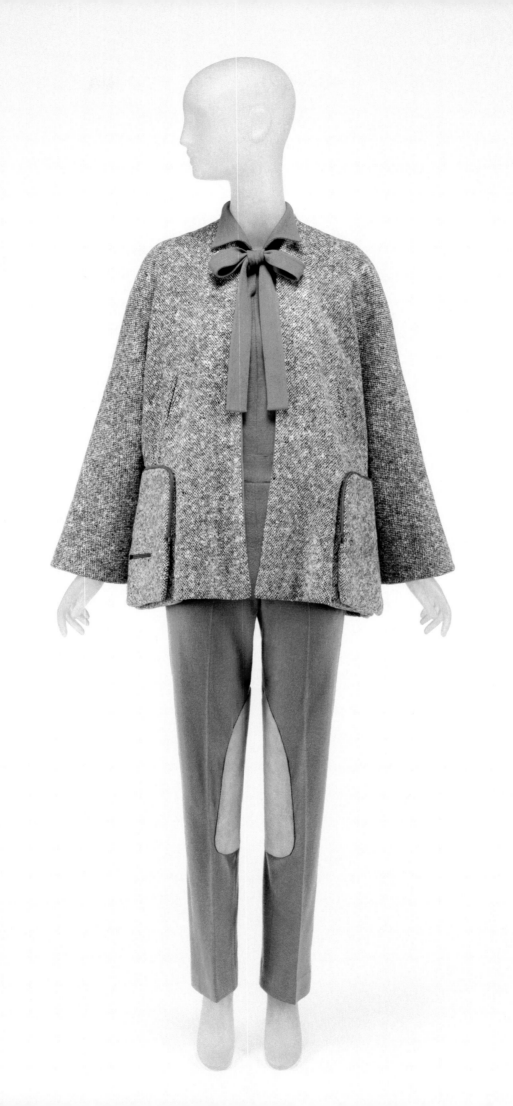

RELIEF

—

Removal or lightening of something burdensome

Writing in 1950, Bonnie Cashin argued that American sportswear designers were "the only fashion group in the world . . . [that] has successfully interpreted the tempo of our day." Among her innovations in that period was the introduction of "purses" incorporated into garments as integral pockets, offering women functionality and security without the encumbrance of handbags. In the 1970s this hands-free convenience aligned with the cadence of contemporary life, and Cashin designed a coat equipped with spacious saddlebag pockets. Their conspicuous visibility signals that the garment as well as the wearer prioritize functionality along with aesthetics.

Bonnie Cashin (American, 1908–2000)
ENSEMBLE, SPRING/SUMMER 1973
Coat of beige-and-camel wool tweed edged with camel suede;
belt of camel suede; dress of camel wool jersey

EASE

—

Facility, effortlessness

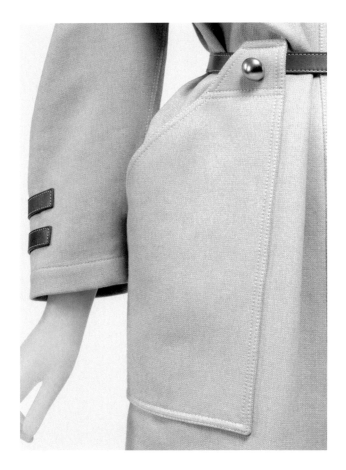

Recalling Bonnie Cashin's experimentation with inventive fastenings in the mid-twentieth century, this coat from Tory Burch's spring/summer 2018 collection highlights details that equally assert their aesthetic and functional value, including neat leather strapping and striking brass buttons. The sturdy tan leather serves as a subtle accent at the waist while also facilitating adjustments in fit. Two capacious pockets provide added versatility, offering a liberating alternative to the handbag.

Tory Burch (American, born 1966)
ENSEMBLE, SPRING/SUMMER 2018
Coat of beige double-face cotton canvas trimmed with brown leather;
trousers of white cotton canvas

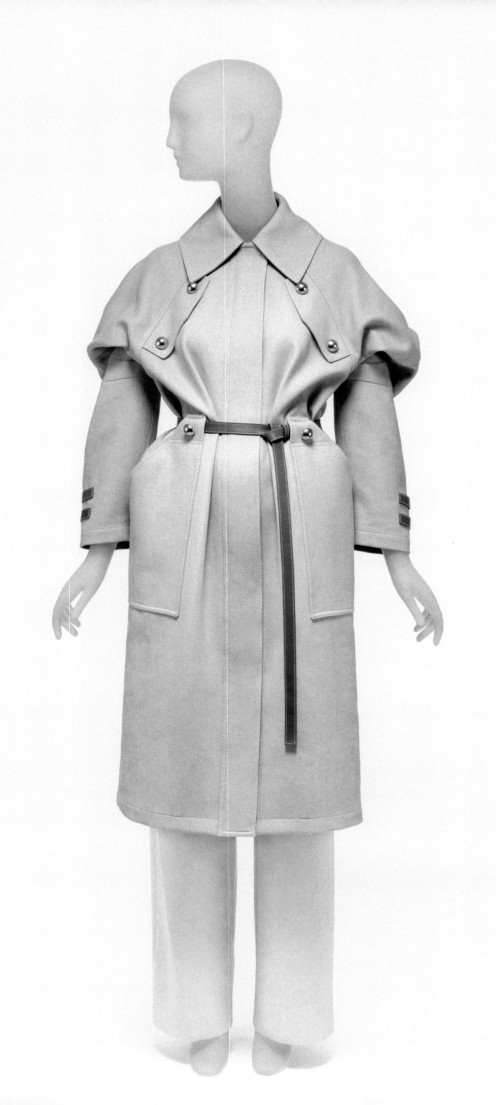

CONVICTION

—

*A state of mind
in which one is free from doubt*

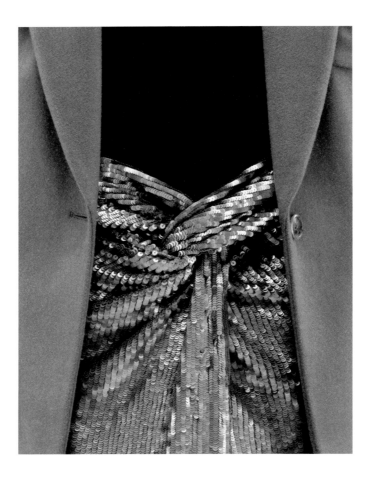

In Donna Karan's first collection for her own label, she introduced a concept that became known as "Seven Easy Pieces." This series of coordinated separates—bodysuits, trousers, skirts, and jackets—could be variously combined for different occasions and formed the foundation of a modular wardrobe. These fashions offered the wearer an alternative language of professional dress that was both commanding and feminine while providing a sense of assurance due to their comfort, ease of coordination, and compatibility with work and personal life.

Donna Karan (American, born 1948)

ENSEMBLE, AUTUMN/WINTER 1985–86; JACKET AND BODYSUIT, EDITION 2020

Jacket of camel felted wool broadcloth; bodysuit of black cotton-elastane jersey;
skirt of gold synthetic knit embroidered with gold

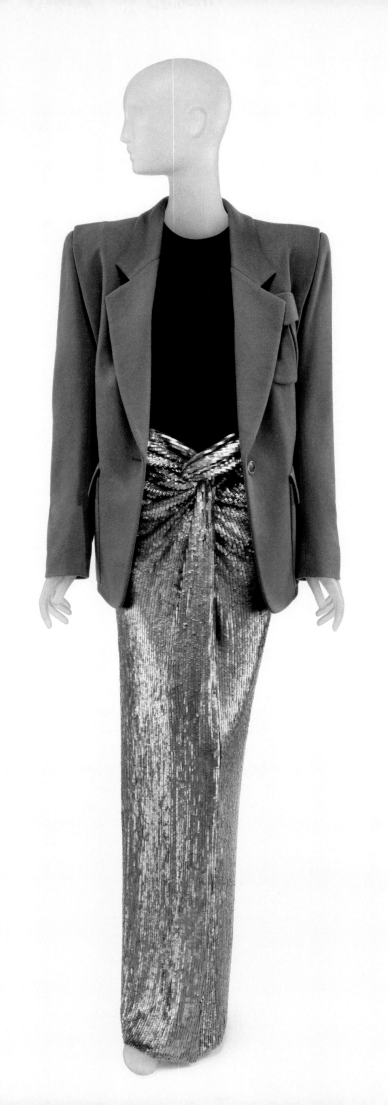

—
HARMONY
—

*The arrangement of parts
in pleasing relation to one another*

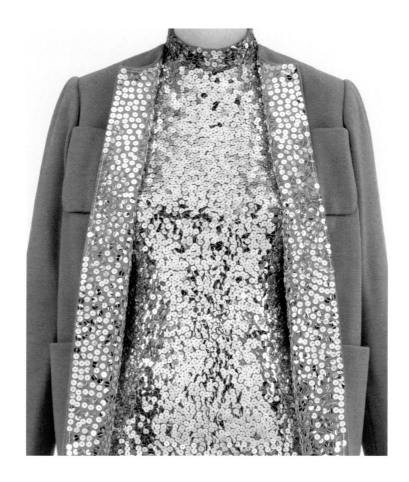

Norman Norell's fashions were defined by an inherent balance that gave them
a timeless appeal. Luxurious materials were worked into pared-down silhouettes and
coupled with more discreet fabrics, and couture-quality workmanship was combined
with the comfort and easy styling of sportswear. In this carefully composed evening
suit, Norell paired the flash of a gold-sequined blouse with the subtlety of a camel-colored
wool skirt. The matching wool jacket with its sequin-embroidered lining suggests
a continuous relationship between these components, making the combination seem
faultless and intuitive.

Norman Norell (American, 1900–1972)
ENSEMBLE, AUTUMN/WINTER 1972–73
Skirt and jacket of camel wool double knit; shirt of camel silk jersey
embroidered with gold paillettes

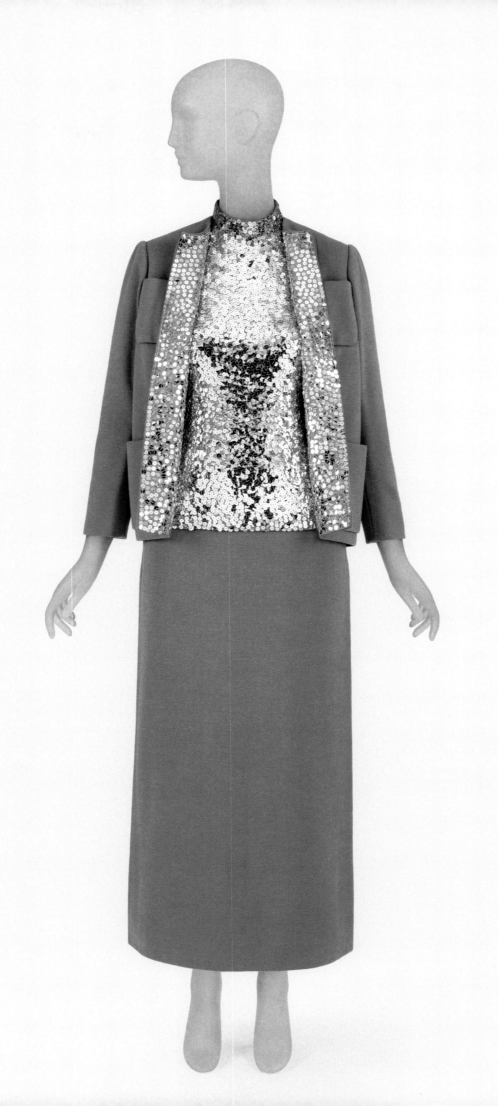

ASSURANCE

—

*Confidence of mind or manner;
easy freedom from self-doubt or uncertainty*

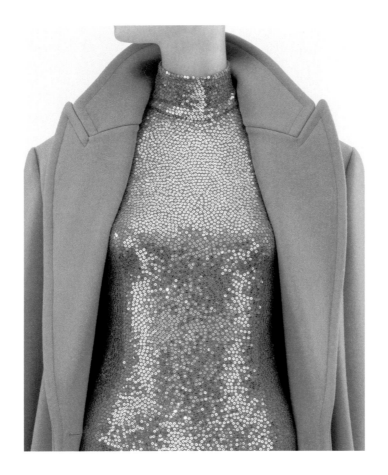

For his autumn/winter 2021–22 collection, Michael Kors celebrated the fortieth anniversary
of his womenswear line with a presentation that included reinterpretations of designs
from his past collections. This gold-sequined dress, paired here with a cashmere coat that
has a coordinating sequin-embroidered lining, is a reprisal of a design he debuted in 2000
and a nod to one of Norman Norell's favored combinations. The ensemble exemplifies
Kors's facility for executing opulent garments in a relaxed manner intended to offer the
wearer a sense of confidence and ease.

Michael Kors (American, born 1959)
ENSEMBLE, AUTUMN/WINTER 2021–22
Dress of gold viscose matte jersey embroidered with gold paillettes;
coat of camel wool melton lined with gold paillette embroidery

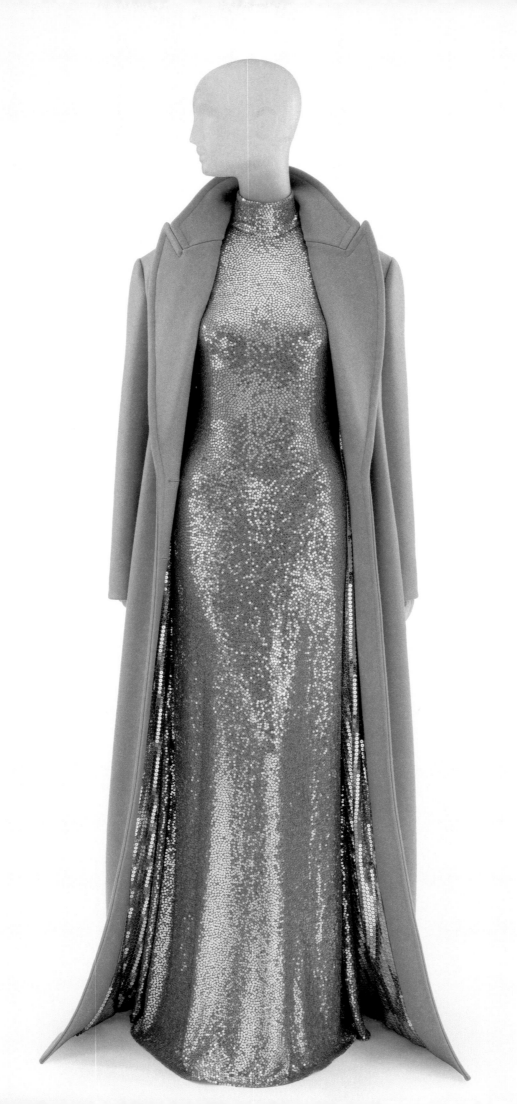

SURENESS

—

*The quality or state of being sure;
certainty, confidence*

Marc Jacobs described his spring/summer 2020 collection as a "celebration of life,"
showcasing garments that expressed the joy of dressing up and embracing "grand
gestures," such as this floor-length dress densely embroidered in gold sequins. The
collection conveyed optimism for the future as well as confidence in the past. Here, Jacobs
echoes the poised assurance of Norman Norell's mid-twentieth-century "mermaid"
gowns—sleek evening sheaths covered in shimmering paillettes—revealing his
appreciation for what he has called "the comforts of tradition."

Marc Jacobs (American, born 1963)
DRESS, SPRING/SUMMER 2020
Gold viscose jersey embroidered with gold paillettes

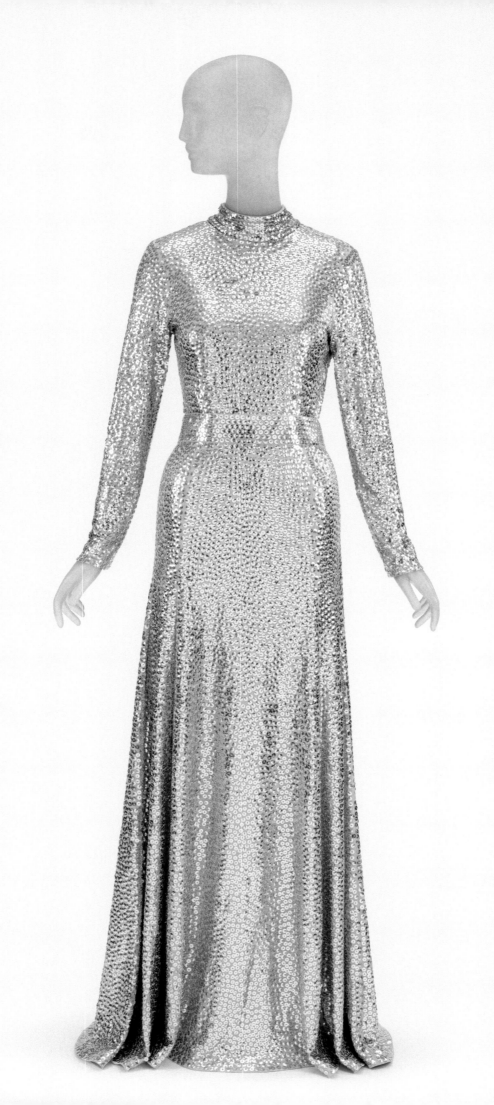

COMFORT

COMFORT

SUSTENTATION

SECURITY

REASSURANCE

WARMTH

EASEFULNESS

RETREAT

REFUGE

CALM

COZINESS

SUPPLENESS

COMFORT

—

Contented enjoyment in physical or mental well-being, especially in freedom from want, anxiety, pain, or trouble

Chickasaw artist and fashion designer Margaret Roach Wheeler created this caftan as a tribute to her father, Diamond Roach, whose work with the Bureau of Indian Affairs introduced her to the artistic traditions of Native communities across the country. Wheeler began her career as a fine artist before focusing on weaving in the 1980s. In 2021, when asked about the sources of her work, Wheeler explained that "the paints and the sculptures were my own, but the textiles were my family." She designed this handwoven caftan using different techniques and colorways on the exterior and the interior to convey solidity and strength when worn closed and beauty when left open, as shown here.

Margaret Roach Wheeler (Chickasaw, born 1943)
"TRIBUTE TO DIAMOND" CAFTAN, 1996
Polychrome silk and wool

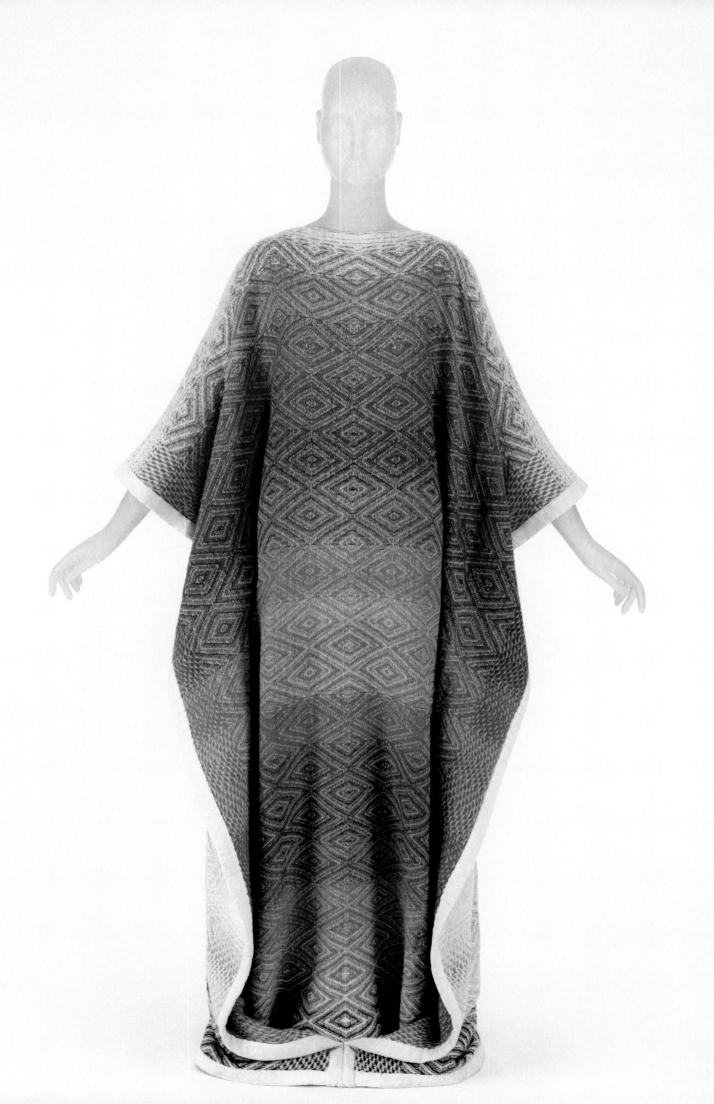

SUSTENTATION

—

*The careful maintenance and protection
of something valuable, especially in its natural or original state*

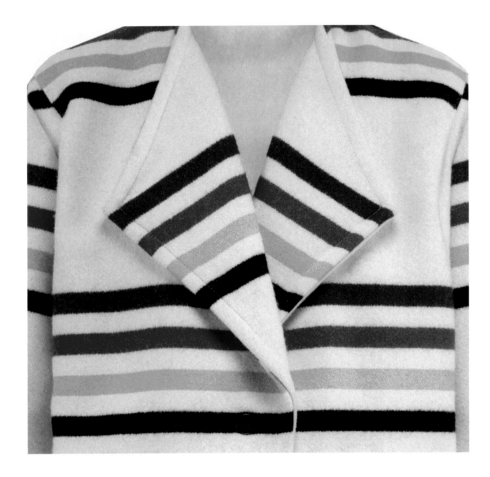

Korina Emmerich of EMME Studio draws on her patrilineal Indigenous heritage to
inform the aesthetic and philosophy of her work. Respecting the life cycle of a garment,
Emmerich utilizes upcycled, recycled, and natural materials while minimizing waste.
This ensemble comprises regenerative and compostable wool and upcycled buttons.
It references Hudson's Bay Company's iconic Point Blanket, highlighting the company's
fraught colonial history with Emmerich's Coast Salish Territory Puyallup tribe and
reclaiming that history for the designer, whose ancestors worked for the company in
the early nineteenth century.

EMME Studio (American, founded 2015)
Korina Emmerich (Puyallup descent, born 1985)
"CASCADE" ENSEMBLE, WINTER 2021
Jacket and coat of polychrome wool broadcloth

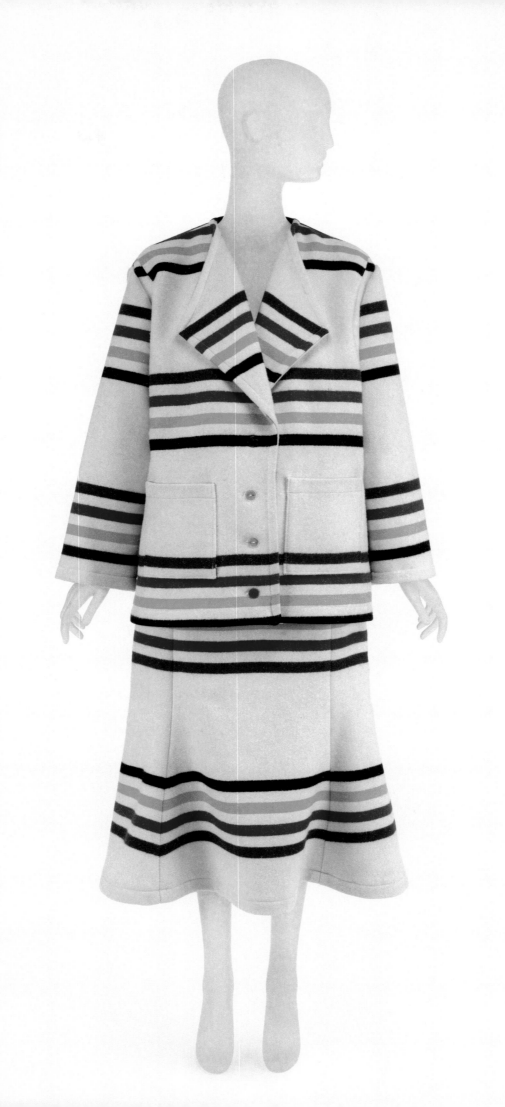

SECURITY

—

1 — The quality or state of being secure: easy in mind
2 — Affording safety

Since his first collection in 1981, Andre Walker has become known for creating flat versions of garments cut freehand without a pattern. For spring/summer 2018, Walker reprised designs from 1982–86 using fabrics from Pendleton Woolen Mills. Constructed from the mill's Glacier National Park blanket, this coat encases the body in its planar but malleable volumes. Its seeming two-dimensionality provides a canvas for the bold stripes and, like Korina Emmerich's design, recontextualizes the blanket's historically problematic connotations.

Andre Walker (American, born 1967)
COAT, SPRING/SUMMER 2018
Polychrome combed wool broadcloth

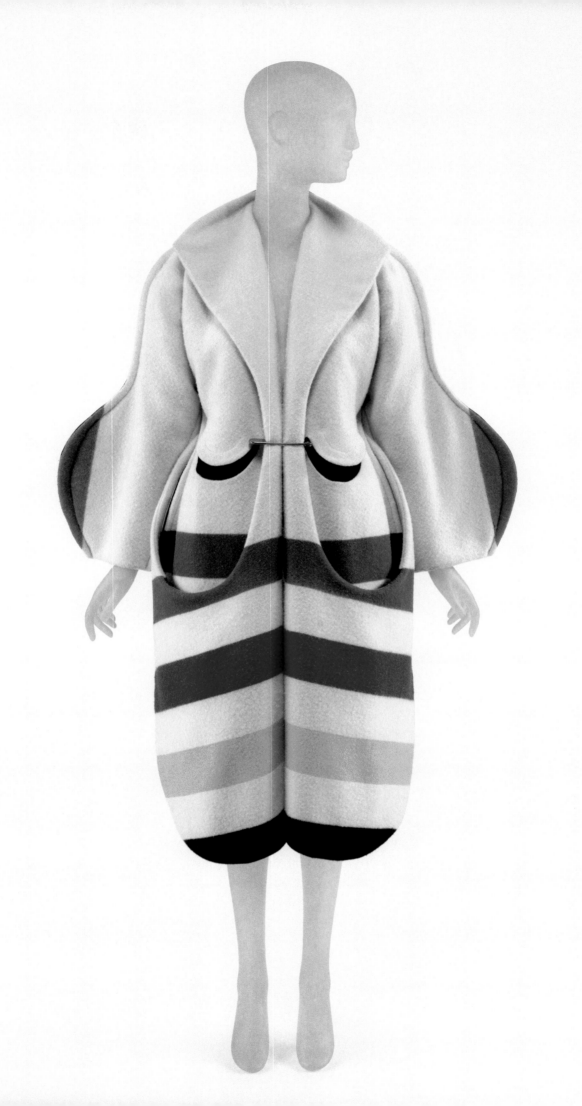

REASSURANCE

The state of being reassured
(having confidence restored; free from fear or anxiety)

Gabriela Hearst's commitment to sustainable practices is evident through her embrace of artisan-driven processes. This ruana is hand knit by the Manos del Uruguay, a nonprofit women's collective in the designer's native country. It features designs based on Hearst's daughter's renderings of flowers, which are in turn inspired by the illustrations of Saint Hildegard of Bingen, a twelfth-century botanist and philosopher who challenged the institutions of her day. "She believed in 'green' power," commented Hearst. "If she had been a man we'd know her name like we do Leonardo da Vinci."

Gabriela Hearst (Uruguayan, born 1976)
ENSEMBLE, AUTUMN/WINTER 2021–22
Ruana of polychrome cashmere knit; turtleneck of ivory cashmere knit;
shirt of ivory wool crepe; trousers of ivory wool Ponte de Roma knit

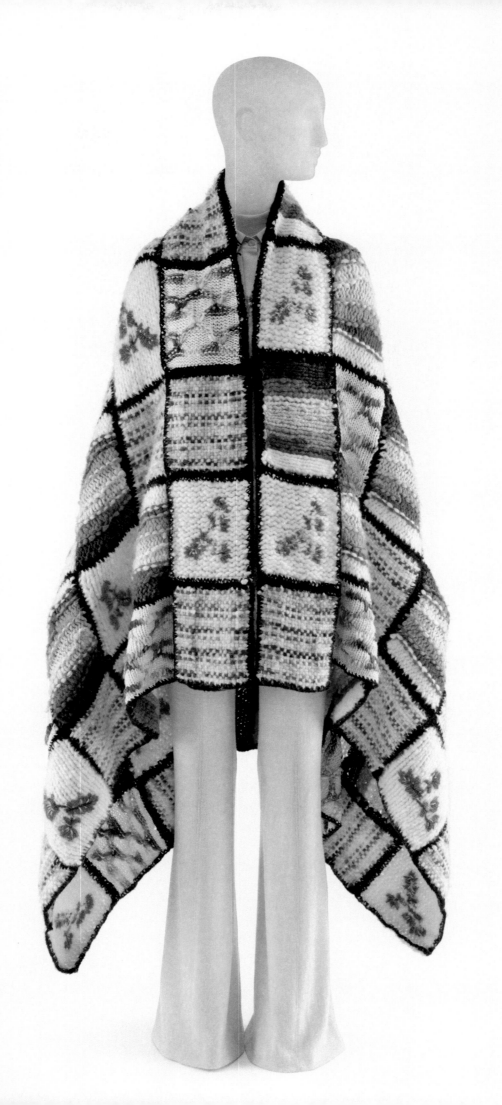

WARMTH

—

The quality or state of being warm in temperature or feeling; emotional intensity

Designer Aaron Potts conceived APOTTS as a unisex line of modular and trans-seasonal pieces for everyday use. Fueled by a need for optimism during the COVID-19 pandemic, Potts's autumn/winter 2021–22 collection conveys notions of comfort and uplift. With its pared-down but ample silhouette and serene yet sunny color palette, the ensemble displayed here emanates a homey sophistication. Its generously gathered, serpentine scarf affords style experimentation while providing an added component of cold-weather versatility.

APOTTS (American, founded 2018)
Aaron Potts (American, born 1972)
ENSEMBLE, AUTUMN/WINTER 2021–22
Tunic of polychrome brushed wool jersey and quilted gray cotton jersey
trimmed with gray cotton ribbed knit; scarf of polychrome and yellow brushed wool jersey
trimmed with gray cotton knit

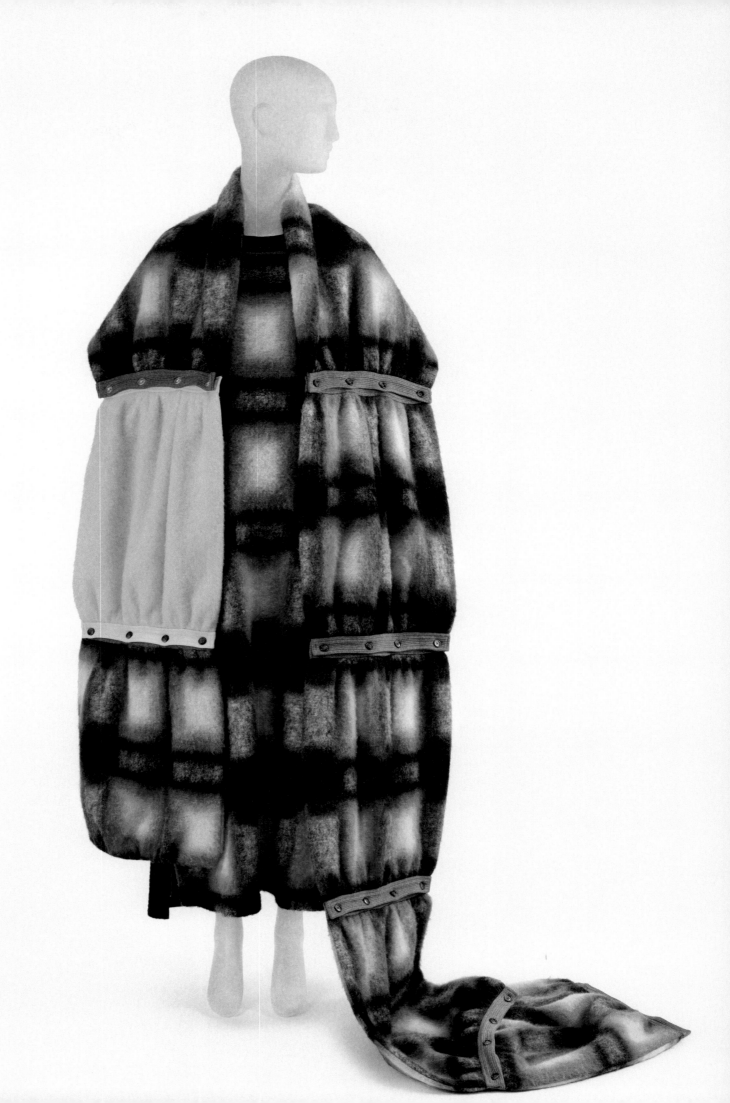

EASEFULNESS

—

*The state of being easeful
(suitable for affording ease or rest)*

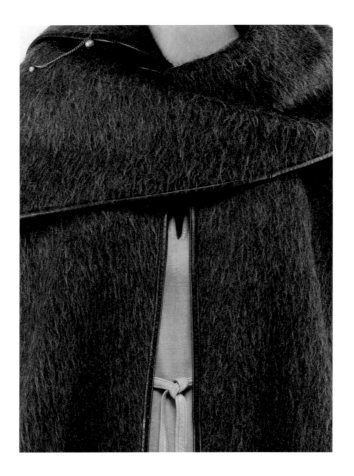

Bonnie Cashin's pioneering contributions to American fashion include her popularization of luxurious organic materials and her promotion of layering. Here, a leather-trimmed shift dress nestles effortlessly within a mohair coat—a complete look easily modulated to suit various activities and lifestyles. The coat's built-in scarf offers additional protection from the cold and, when secured to the shoulder with a pin, provides an added element of style. "The warmth, the softness, the weightlessness, the comfortableness—everything great a coat can be," declared *Vogue*, encapsulating Cashin's approach to dressing the woman on the go.

Bonnie Cashin (American, 1908–2000)

ENSEMBLE, 1972

Coat of gray wool mohair edged with black leather;
dress of yellow wool knit edged with yellow leather

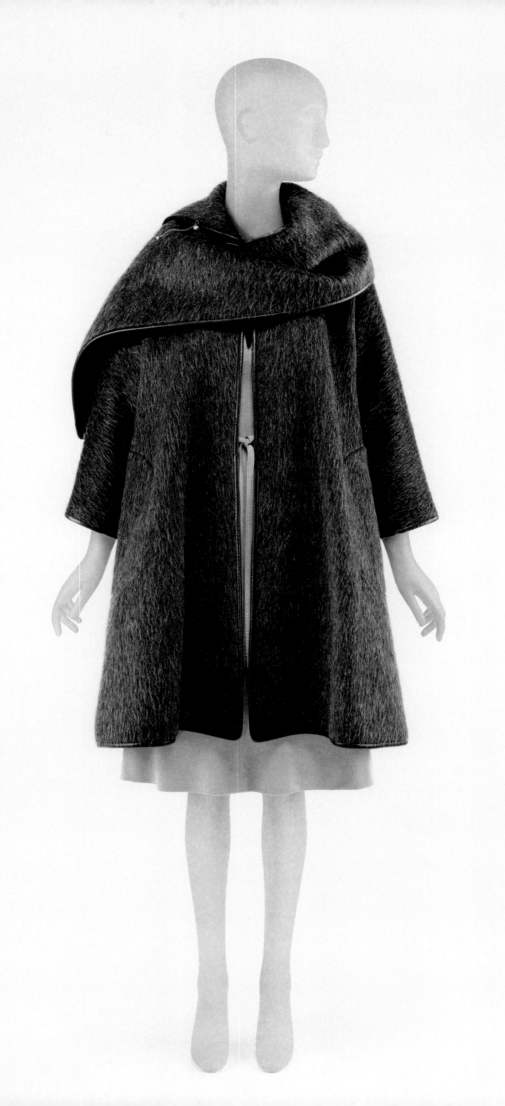

RETREAT

—

An act or process of withdrawing especially from what is difficult, dangerous, or disagreeable

The blurring between the home and the office, relaxation, and responsibility that resulted from the COVID-19 pandemic provided the stimulus for Lazaro Hernandez and Jack McCollough's autumn/winter 2021–22 collection, which emphasized elements of ease and versatility. This knitted dress for the designers' label Proenza Schouler features a gathering that twists around the body, as if its wearer is draped in a blanket while en route to the office. Its high neckline and extra-long hem provide maximum coverage, offering physical and psychological sanctuary.

Proenza Schouler (American, founded 2002)
Lazaro Hernandez (American, born 1978)
Jack McCollough (American, born 1978)
DRESS, AUTUMN/WINTER 2021–22
Olive wool-synthetic-elastane knit

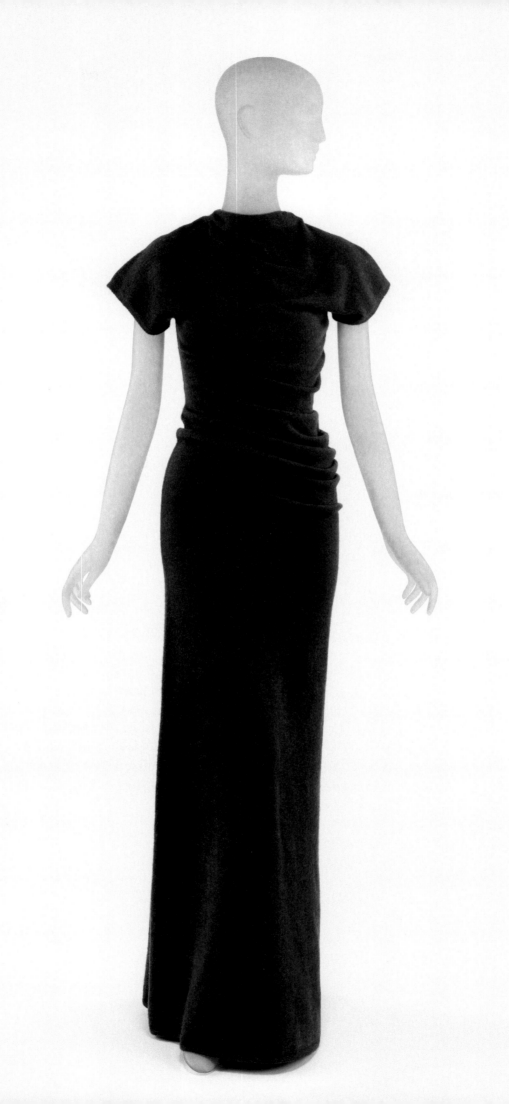

REFUGE

—

A means of resort for help in difficulty

Yeohlee Teng coined the term "urban nomad" for her autumn/winter 1997–98 collection to describe "a person fully engaged and living a twenty-first-century lifestyle which is urban and global." This coat, which features the designer's signature simple geometric cuts, reflects her interest in architecture, inspired as it was by Renzo Piano's curvilinear Kansai International Airport. Rendered in a striped alpaca, it also references the blanket-like coverings of the nomads of Mongolia. Its materiality offers versatility and movement, while its construction encapsulates Teng's vision of clothing as shelter.

YEOHLEE (American, founded 1981)
Yeohlee Teng (American, born Malaysia, 1951)
COAT, AUTUMN/WINTER 1997–98
Brown ombre stripe alpaca cut pile weave

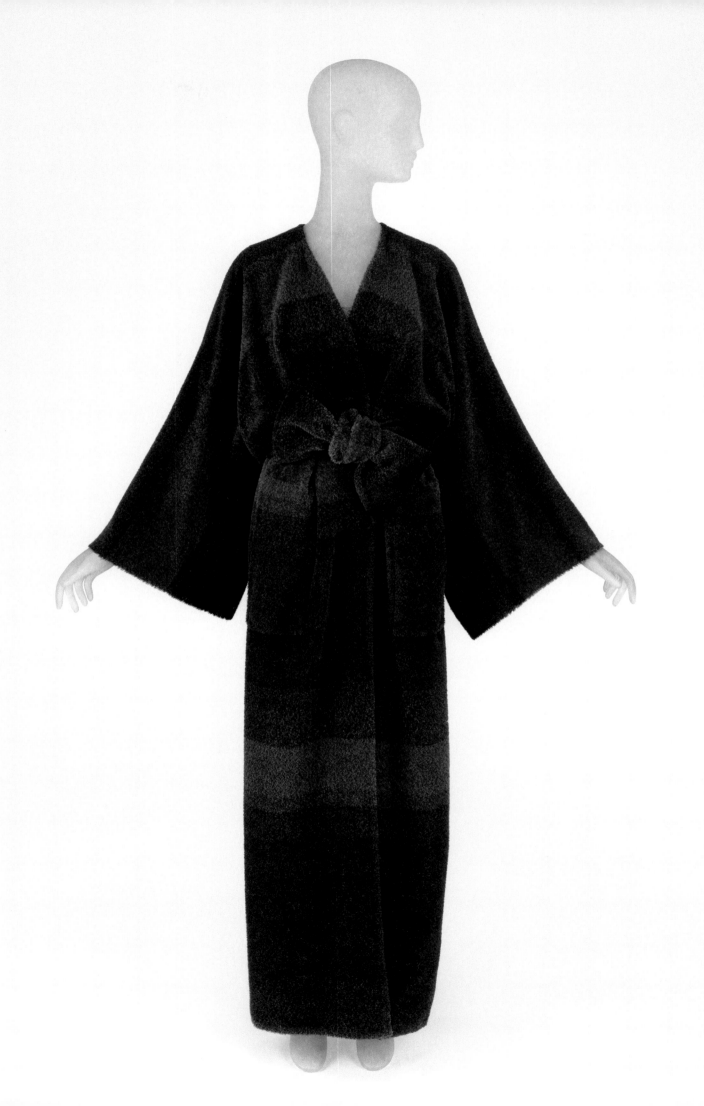

CALM

—

*A state or condition of repose and freedom from turmoil,
disturbance, or marked activity or from agitation,
tension, or vexation*

Known for bold, intricately seamed garments informed by the body's natural shape, Joseph Altuzarra softened his distinctive audacious silhouettes for autumn/winter 2021–22. Inspired by the process of a chrysalis turning into a butterfly, Altuzarra explored the concept of transformation through notions ranging from cocooning and protection to release and freedom. This ensemble comprises four blanket-like pieces of chunky knit and affords its wearer multiple options for intimate envelopment, whether out in the world or nestled at home.

Altuzarra (American, founded 2008)
Joseph Altuzarra (French-American, born 1983)
ENSEMBLE, AUTUMN/WINTER 2021–22
Camel wool-camel hair knit

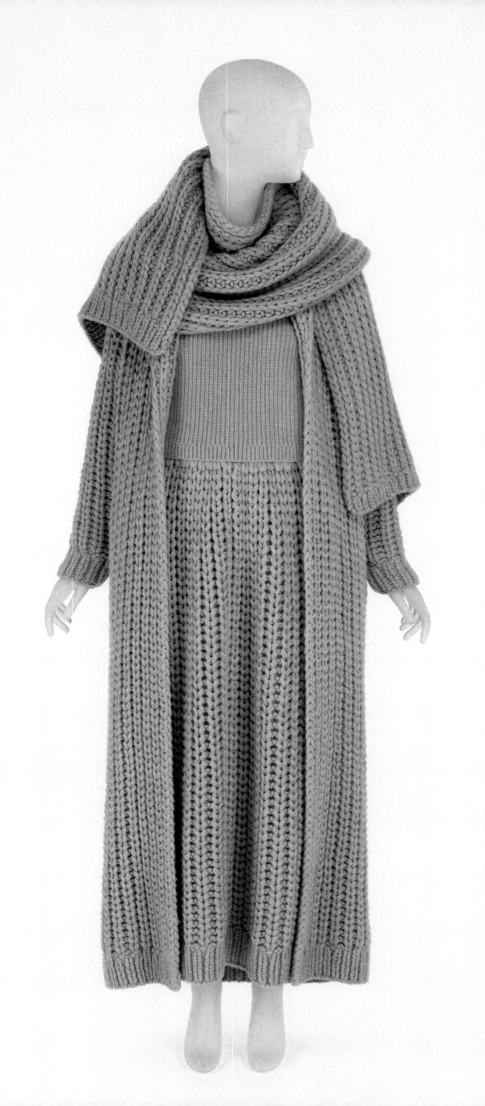

COZINESS

—

*The quality or state of being cozy
(enjoying, affording, or suggesting warmth, homey ease,
and freedom from care in inconvenience)*

Ashley and Mary-Kate Olsen founded The Row with an emphasis on luxurious fabrics
and uncomplicated silhouettes, both of which are reflected in this ensemble. Rendered
in sumptuous "fur cashmere," a three-piece set of blanket-like knitwear cocoons the body
in comfort, while a languid pair of silk-cashmere trousers suggests the ease of pajamas.
Bold in texture but minimal in form and detail, the ensemble exudes serenity and
indulgence while delivering warmth and protection.

The Row (American, founded 2006)
Ashley Olsen (American, born 1986)
Mary-Kate Olsen (American, born 1986)
ENSEMBLE, AUTUMN/WINTER 2021–22

Sweater, cardigan, and scarf of ivory cashmere knit;
trousers of ivory silk-cashmere knit

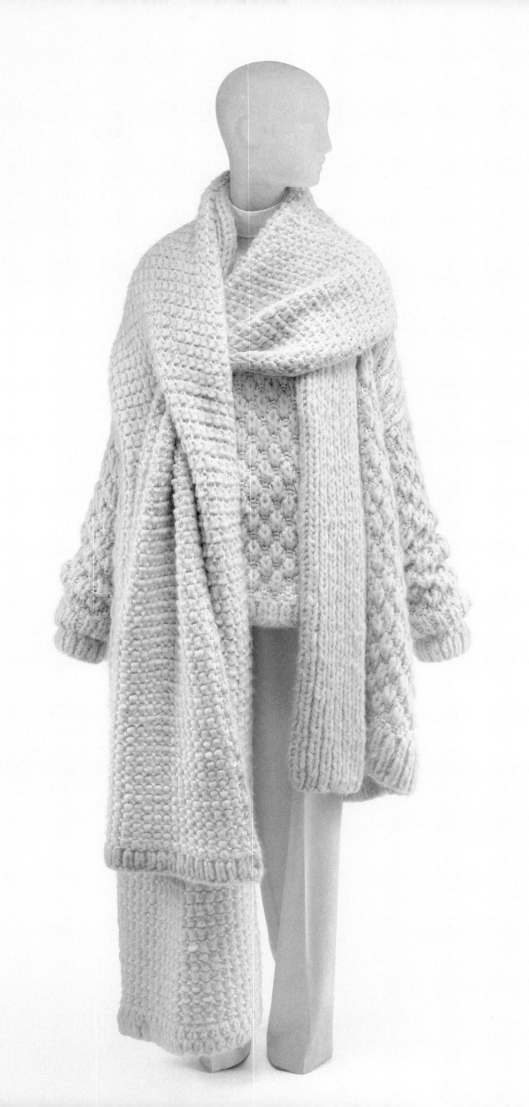

SUPPLENESS

—

*The quality or state of being supple
(characterized by ease and readiness in bending or other actions
and often by grace and agility)*

Maria Cornejo's autumn/winter 2016–17 collection for her label Zero + Maria Cornejo
was informed by the feelings of freedom the designer derived from being at one with
nature. This ensemble boasts Cornejo's signature techniques of cutting fabric based
on simple geometric forms and using as few seams as possible. The tee-shaped top
and ankle-gathered trousers are relaxed yet graceful. The cocoon coat—composed of
four pieces joined by three seams—swathes the body with gentle undulations
while simultaneously providing ease of movement.

Zero + Maria Cornejo (American, founded 1998)
Maria Cornejo (American, born Chile, 1962)
ENSEMBLE, AUTUMN/WINTER 2016–17
Coat of light pink alpaca-wool knit; shirt of light pink synthetic plain weave;
trousers of light pink synthetic twill

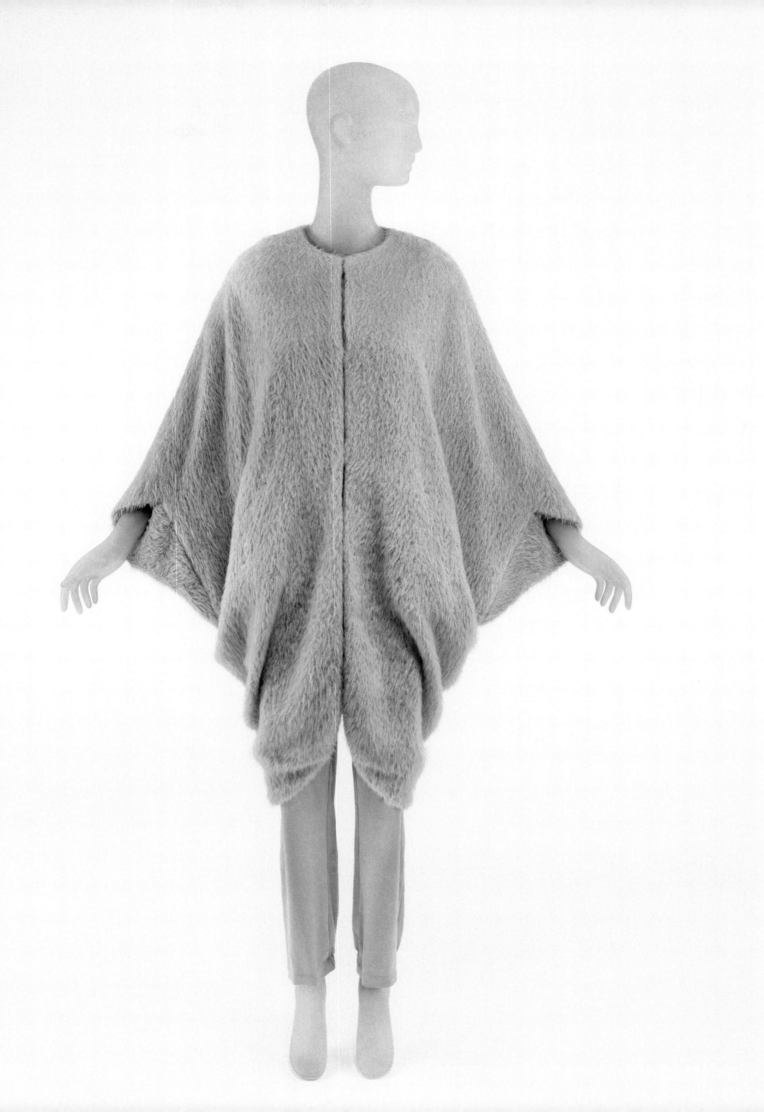

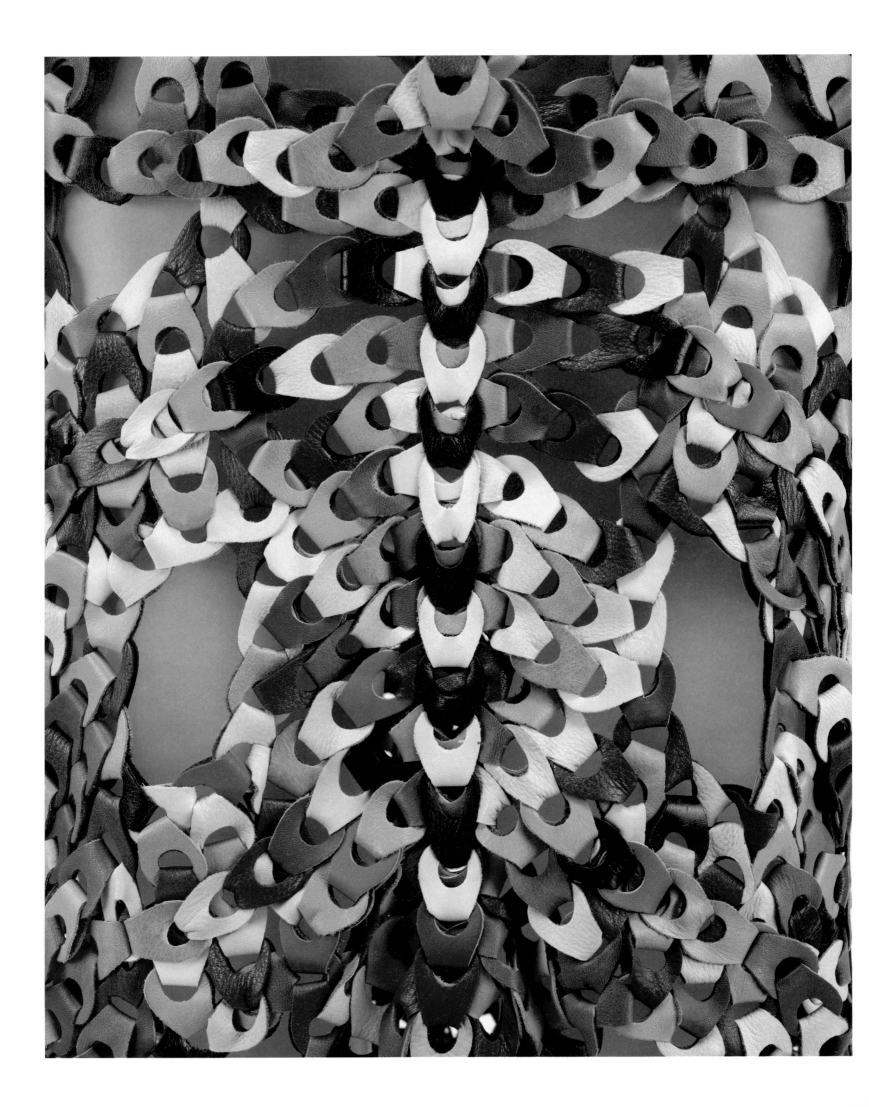

— REVERENCE —

REVERENCE

RESPECT

CARE

ADMIRATION

GRATITUDE

DEDICATION

REALNESS

AUTHENTICITY

RENEWAL

SALVATION

PERMANENCE

AWARENESS

CONSCIOUSNESS

MINDFULNESS

REVERENCE

—

Honor or respect felt or manifested;
deference duly paid or expressed;
profound respect mingled with love and awe

London-based, American-born designer Conner Ives places ethical practices at the center of his creative output. This ensemble was part of his graduate collection for Central Saint Martins titled "American Dream," inspired by the female archetypes he grew up with in Bedford, New York. It is a contemporary representation of the working girl, made from a reconstituted military blanket and felted with a painting by the designer of a rising or setting sun. The garment is dedicated to his mother, whose folk-art collection influenced the image and the technique, which promote a new, optimistic Americana.

Conner Ives (American, born 1996)
"THE 9–5 WORKING GIRL" ENSEMBLE, AUTUMN/WINTER 2021–22
Polychrome felted wool

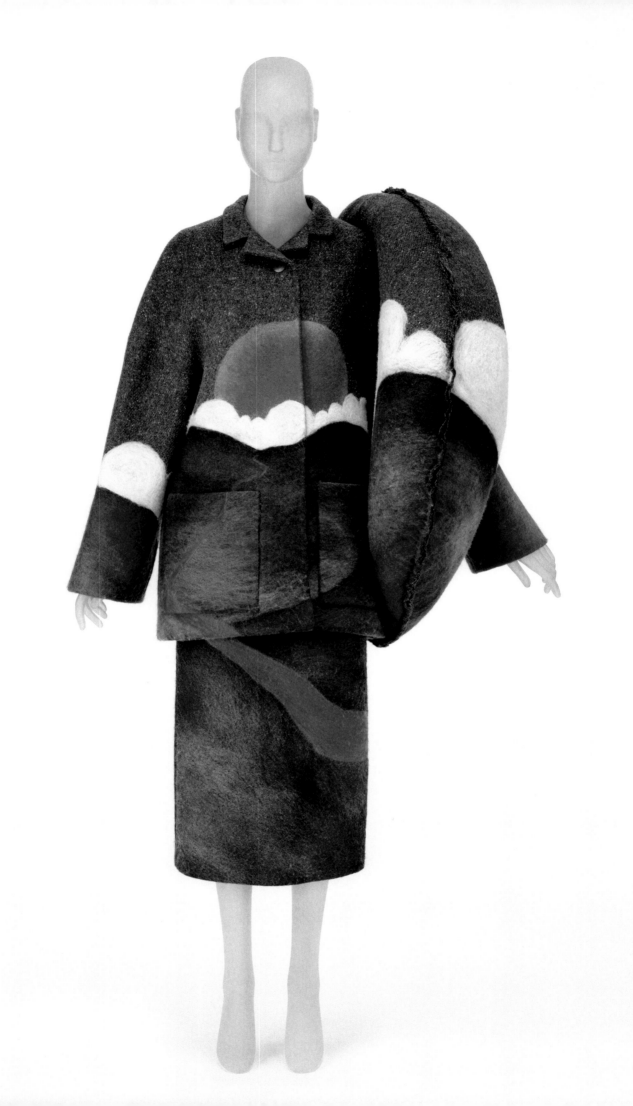

RESPECT

—

An act of giving particular attention

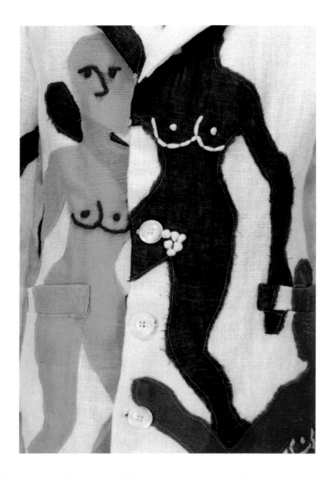

Colm Dillane, founder of the art and design collective KidSuper, presented the studio's debut collection as a stop-motion animation featuring twenty-two miniature ensembles dressed on Barbie dolls with 3D-printed heads, each resembling one of Dillane's heroes. For Dillane, the process significantly reduced the amount of material required to make garment samples, and he used frayed and unfinished scraps to create this full-size version of the "People's Jacket" and "People's Pants." These titles and the overlapping brown, yellow, and blue figure appliqués reflect the studio's communal spirit.

KidSuper (American, founded 2011)
Colm Dillane (American, born 1991)
ENSEMBLE, SPRING/SUMMER 2021
Off-white linen plain weave appliquéd with polychrome cotton plain weave
and embroidered with polychrome cotton thread

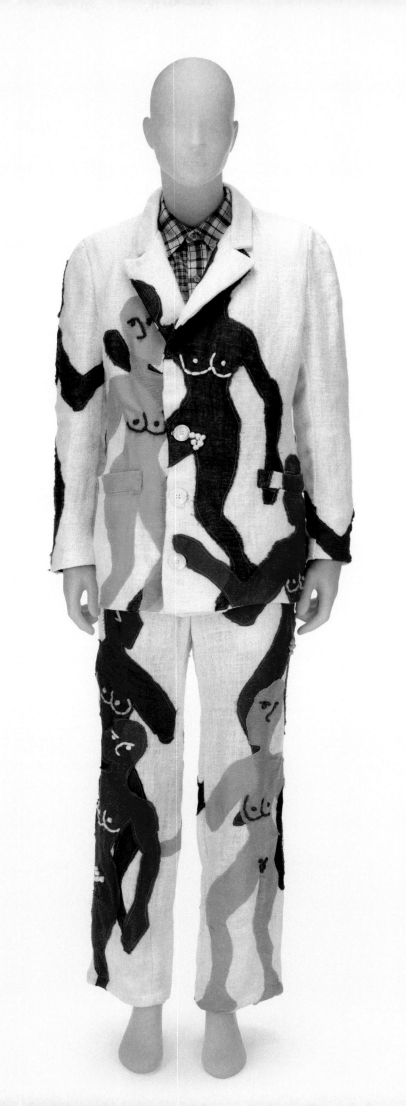

CARE

—

Attention accompanied by caution, pains, wariness,
personal interest, or responsibility

Raffaella Hanley's autumn/winter 2018–19 collection for Lou Dallas was inspired by Edgar Allan Poe's short story "The Masque of the Red Death." This handmade baby-doll dress is composed of deadstock fabric and features looped appliqués in colors that symbolize the progression of life in Poe's story. The fanciful, narrative qualities of Hanley's designs belie their earnest ethical and political messages. Each of her collections features the slogan "Think Otherwise," a call for intuitive and conscious creation.

Lou Dallas (American, founded 2017)
Raffaella Hanley (American, born 1989)
DRESS, AUTUMN/WINTER 2018–19
Dress of beige wool-synthetic novelty weave and net embroidered with clear sequins
and crystals and polychrome wool bouclé cord

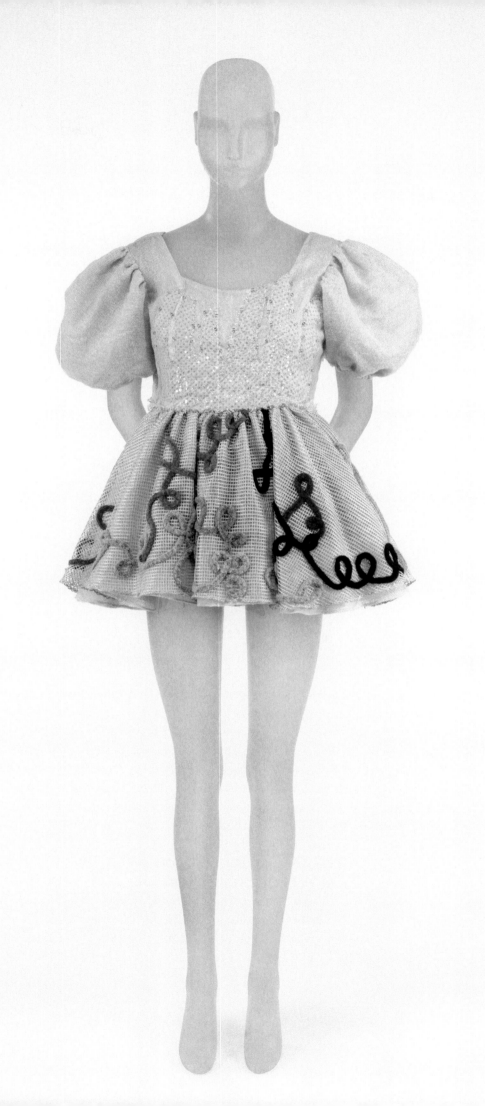

ADMIRATION

—

1 — A feeling of respect and approval
2 — A feeling of mingled wonder, esteem, approbation, and delight

Mike Eckhaus and Zoe Latta credit Susan Cianciolo's "RUN" collections for inspiring their fashion practice, which includes handcraft, recycling, and blurring the boundaries between art and fashion. Their artisanal collections of hand-knit, hand-dyed, and repurposed garments were featured in a solo exhibition at the Whitney Museum of American Art in 2018. The duo's background in sculpture and textiles is evident in the dramatic shape and construction of this ensemble, which was made from a repurposed plush blanket woven with a contrasting fabric in a rectangular panel at the back.

Eckhaus Latta (American, founded 2011)
Mike Eckhaus (American, born 1987)
Zoe Latta (American, born 1987)
ENSEMBLE, AUTUMN/WINTER 2015–16
Painted polychrome polyester plain weave pieced with gray wool knit

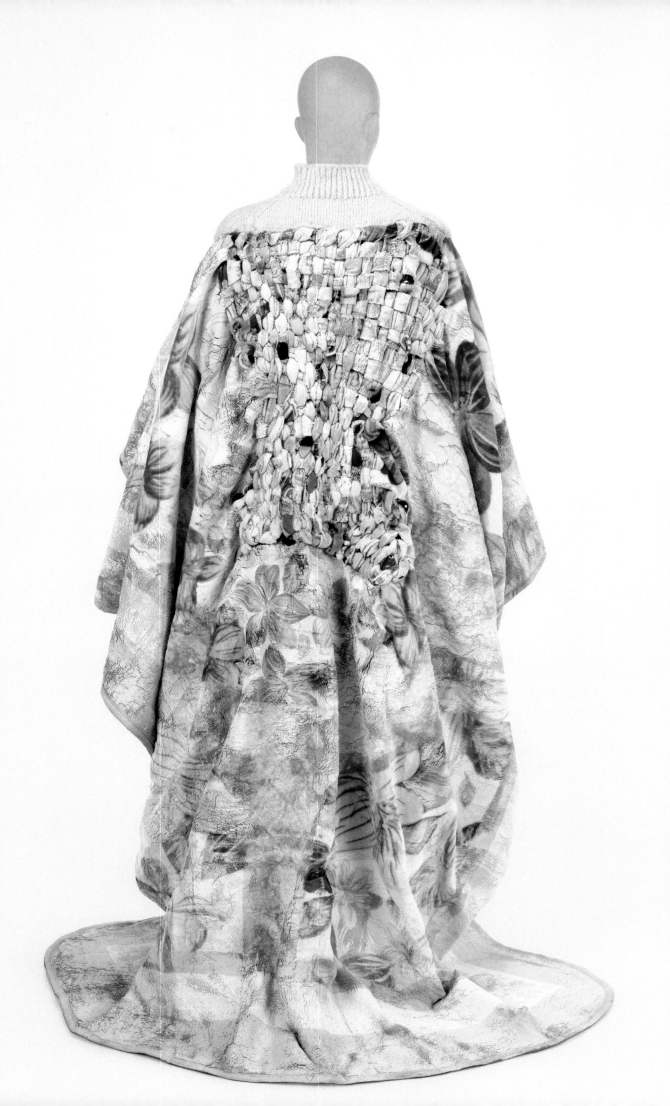

GRATITUDE

—

The state of being grateful
(appreciative of benefits received)

Before launching their first collection in September 2019, sc103's Sophie Andes-Gascon and Claire McKinney were students of Susan Cianciolo at Pratt Institute in New York. Like Cianciolo, they are dedicated to handcraftsmanship. Their technique of interlocking strips of deadstock leather has become a design signature, inspiring the title of their 2019 collection, "Bonds." This ensemble, originally shown with a bucket hat made using the same technique, covers the wearer from head to toe in soft chain mail.

SC103 (American, founded 2019)
Sophie Andes-Gascon (Canadian, born 1993)
Claire McKinney (American, born 1993)
ENSEMBLE, AUTUMN/WINTER 2021–22
Polychrome leather

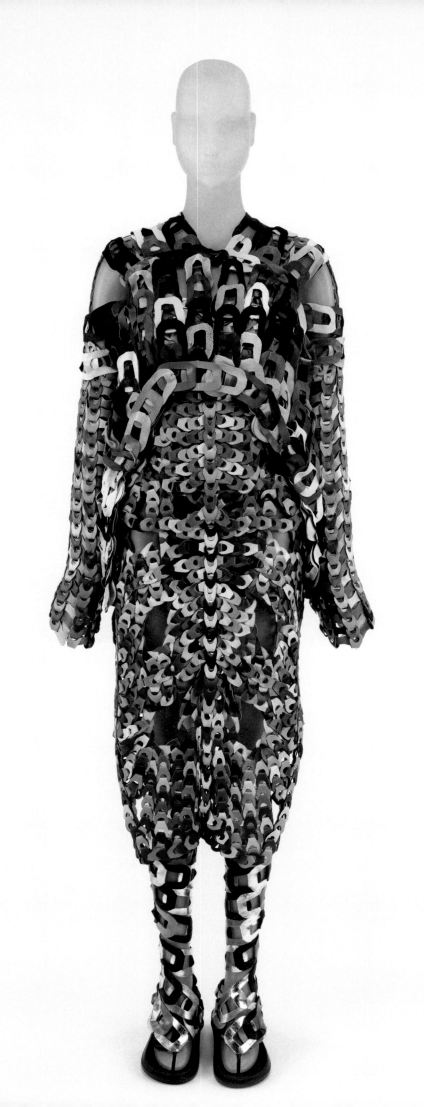

DEDICATION

—

The fact or state of being ardently dedicated and loyal

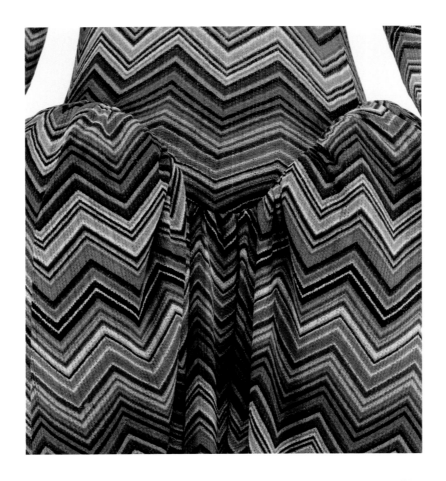

Like Raffaella Hanley and Connor Ives, Hillary Taymour founded her line Collina Strada with a commitment to sustainable practice. In order to produce multiples of her early collections, Taymour used fabric from discarded white T-shirts. She now uses deadstock and engineered fabrics—including Rose Sylk, a by-product of the floral industry—as well as remnants from past collections. This "Princess Bodysuit Gown" from her autumn/ winter 2021–22 collection is made of a deadstock fabric she refers to as Chocolate Lace Zigzag and features a chevron pattern that accentuates its pannier-like extensions.

Collina Strada (American, founded 2008)
Hillary Taymour (American, born 1987)
DRESS, AUTUMN/WINTER 2021–22
Polychrome printed textured synthetic knit

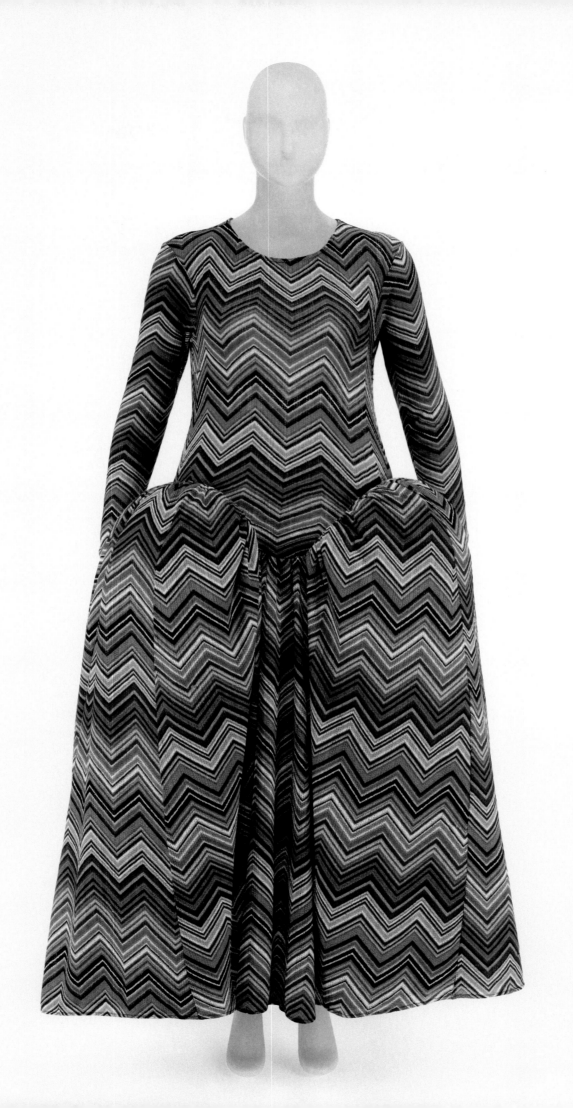

REALNESS

The quality or state of being real

Daniel Day opened Dapper Dan's Boutique in Manhattan's Harlem neighborhood in 1982. Inspired by the symbolic power of branding to express status and prestige, Day silk-screened the trademarked logos of European luxury houses onto tailored suits and jackets, finding a strong following among hip-hop artists. This coat is made from leather screen printed with Louis Vuitton's "LV" monogram. Unlike the other fashions in this chapter, it demonstrates the reuse of a concept rather than a fabric or garment.

Dapper Dan of Harlem (American, founded 1982)
Daniel Day (American, born 1944)

COAT, 1988

Brown and beige plongé leather

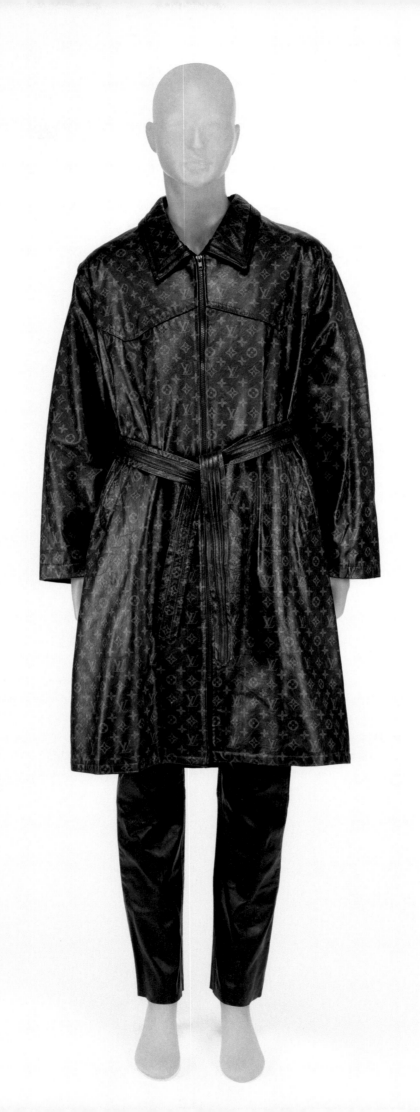

AUTHENTICITY

The quality of state of being authentic

The designer Miguel Adrover presented his collections regularly in New York from 1999 to 2005. An early proponent of diverse and inclusive casting, he became renowned for his political engagement, creative use of repurposed fabrics, and local production. This dress from his autumn/winter 2000–2001 "Meet Town" collection is a customized Burberry trench coat turned inside out and dressed backward. Adrover's unapproved use of a Burberry garment provoked a lawsuit for copyright infringement from the British house.

Miguel Adrover (Spanish, born 1965)

DRESS, AUTUMN/WINTER 2000–2001

Polychrome plaid cotton-synthetic twill, beige cotton-synthetic satin,
and khaki cotton-synthetic twill

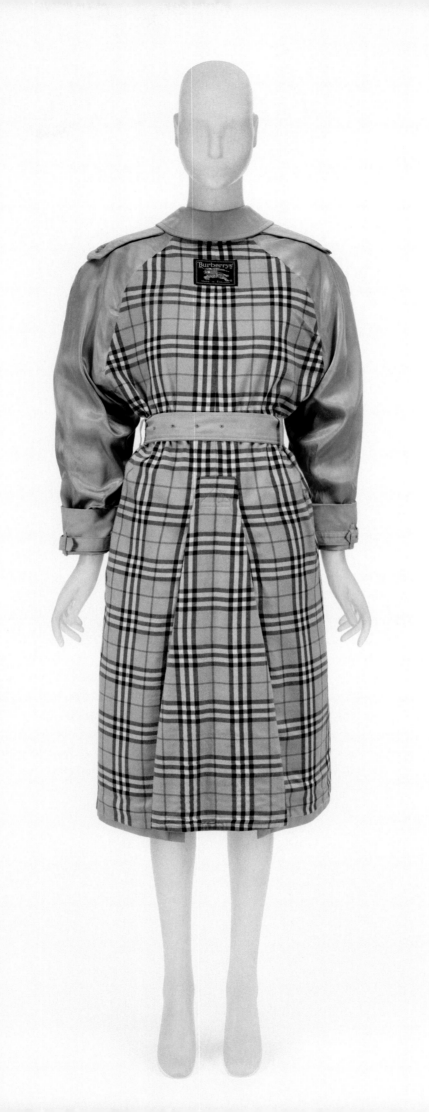

RENEWAL

—

The quality or state of being renewed

Johnson Hartig's designs for Libertine typically feature elaborate prints and embroideries that cite popular culture and art historical references. Due to necessity and an appreciation of punk's do-it-yourself aesthetic, his earliest designs included applied decoration on used and vintage garments. Hartig customized this tailcoat with heat-applied rhinestones in the shape of a skull. It was bought by Karl Lagerfeld, who—fearful of death—veiled the image with a tulle overlay embroidered by the House of Lesage.

Libertine (American, founded 2001)
Johnson Hartig (American, born 1970)
COAT, 2004
Gray wool gabardine appliquéd with silk tulle and embroidered
with black and clear crystals, beads, and sequins

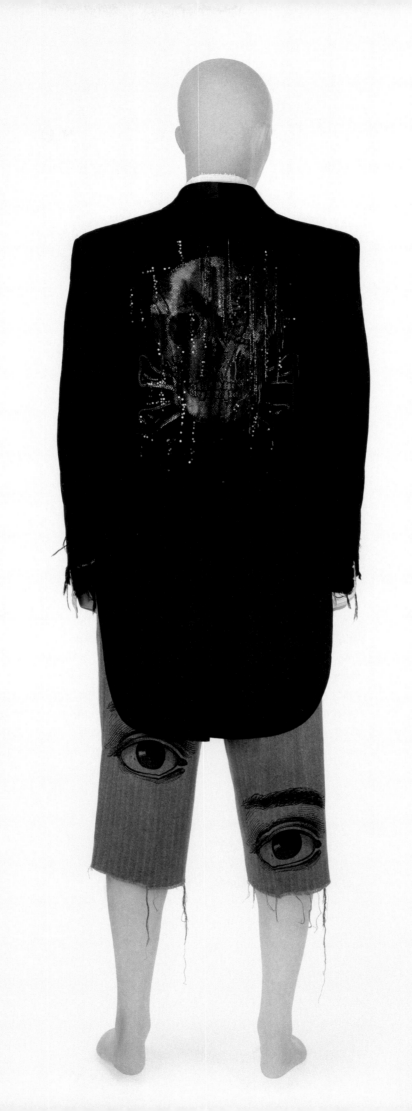

SALVATION

—

Preservation from destruction or failure

Matthew Damhave and Tara Subkoff introduced Imitation of Christ in spring 2001 as a response to the waste generated by the fashion industry. Conceived as an art project, Imitation of Christ developed into a fashion line of modified secondhand garments. Damhave and Subkoff presented this vintage 1920s black beaded chemise with little alteration in their debut collection, which was staged at a funeral parlor on Manhattan's Lower East Side.

Imitation of Christ (American, founded 2000)
Matthew Damhave (American, born 1978)
Tara Subkoff (American, born 1972)
ENSEMBLE, SPRING/SUMMER 2001
Dress of black cotton lace embroidered with black paillettes and black beads;
bolero of white cotton lace

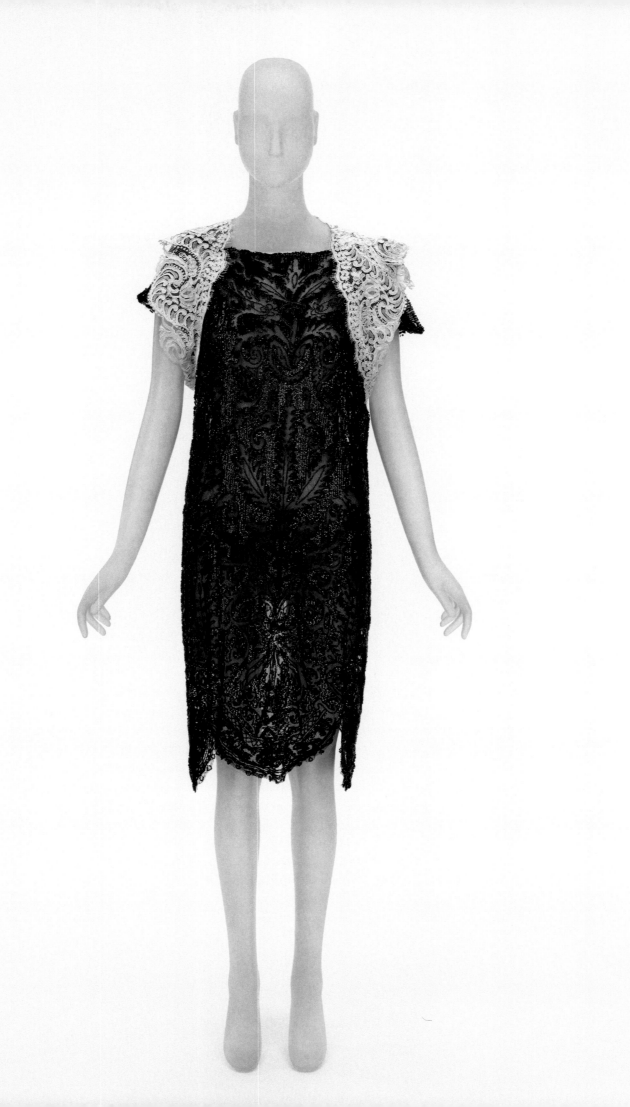

— PERMANENCE —

*The quality or state of being permanent;
durability*

An early exponent of recycling and upcycling, Susan Cianciolo created new garments and modified existing ones for her clothing line RUN (1995–2001). Working with a community of collaborators, she then presented the pieces in performances that blurred the boundaries between art and fashion. This sheath dress from her "RUN 8" collection is stitched in irregular lines that reshape the silhouette. Recalling the improvisational aesthetic and emotional quality of the collection, a friend reminisced: "The stitches. I remember the stitches. They were everywhere. They were brutal and fragile at the same time."

Susan Cianciolo (American, born 1969)

DRESS, 1998

Black wool plain weave

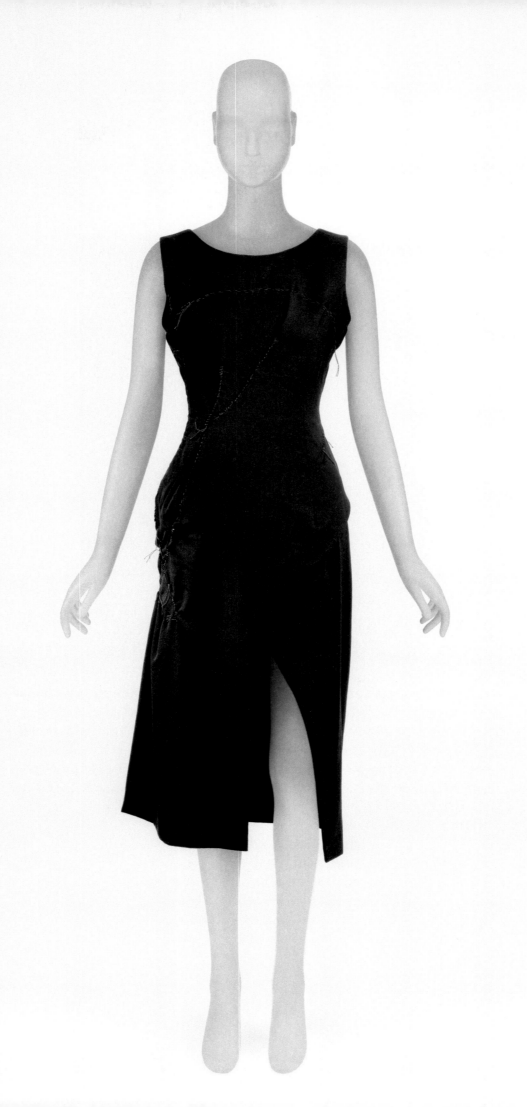

AWARENESS

—

The quality or state of being aware
(having or showing realization, perception, or knowledge)

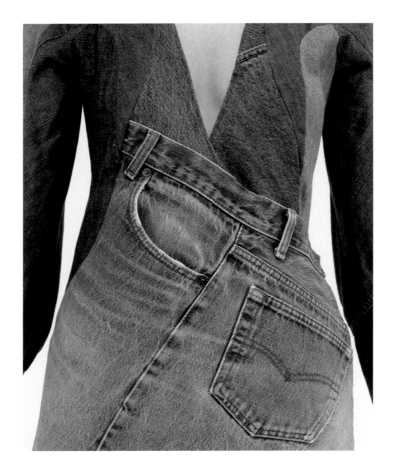

The conceptual, nonbinary designs of fashion collective threeᴀꜱꜰᴏᴜʀ have placed Gabriel Asfour, Angela Donhauser, and Adi Gil at the forefront of American fashion's avant-garde since their first collection in 1999. A collaboration with the artist Stanley Casselman prompted the use of denim in their pre-fall 2019 collection, which included pieces recycled from his paint-splattered denim jeans. Made from new and vintage denim collaged together, this ensemble features the designers' trademark spiral patterning.

threeᴀꜱꜰᴏᴜʀ (American, founded 2005)
Gabriel Asfour (American, born Lebanon, 1966)
Angela Donhauser (German, born Tajikistan, 1971)
Adi Gil (American, born Israel, 1974)
ENSEMBLE, PRE-FALL 2019
Pieced blue cotton denim and chambray

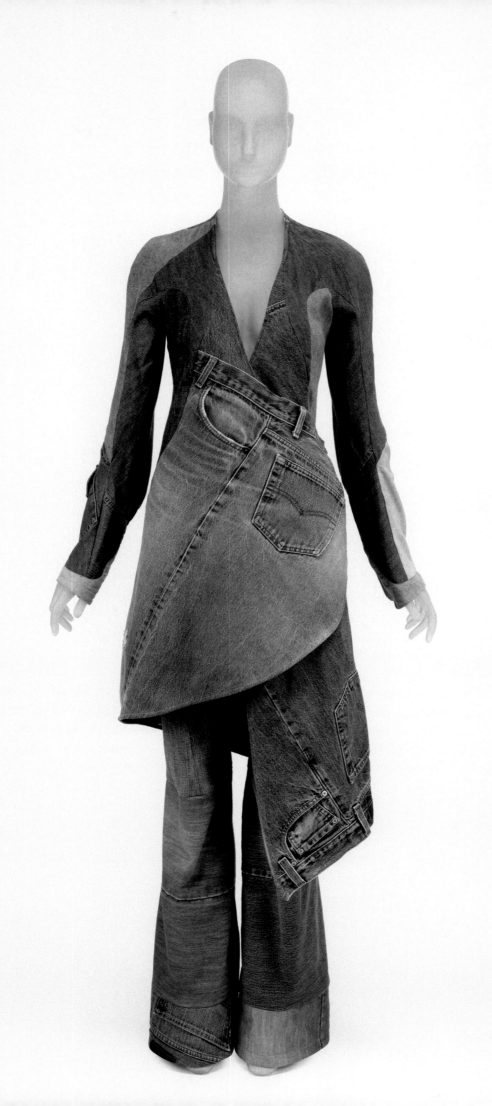

CONSCIOUSNESS

—

Concern for some social or political cause

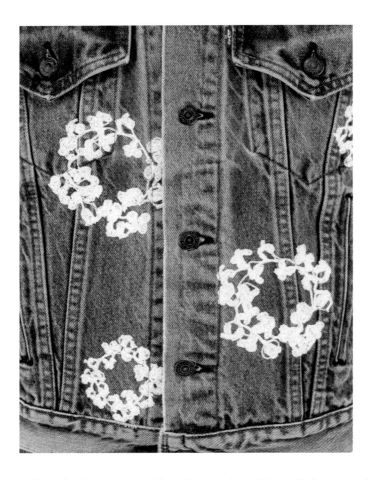

Tremaine Emory of Denim Tears began his collaboration with Levi's in 2019—four hundred years after the first enslaved Africans arrived in Point Comfort, Virginia. The legacy of the cotton industry in America, as well as Emory's own family's history as enslaved laborers, cotton pickers, and cotton-field owners, informed his concept for the partnership. The circular cotton wreaths, applied in print and appliqué on vintage denim, symbolize the intertwined past and future experiences of Black Americans.

Denim Tears (American, founded 2019)
Tremaine Emory (American, born 1981)
Levi Strauss and Company (American, founded 1853)
ENSEMBLE, 2020
Blue cotton denim embroidered with white cotton thread

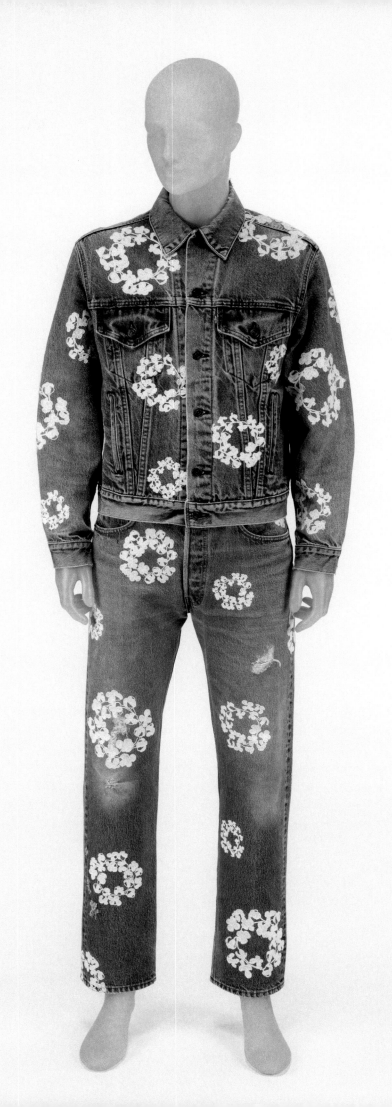

MINDFULNESS

—

*The practice of maintaining a nonjudgmental state of heightened
or complete awareness of one's thoughts, emotions,
or experiences on a moment-to-moment basis*

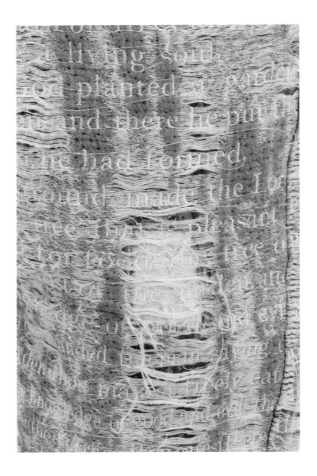

Everard Best, or Ev Bravado, began designing his one-of-a-kind streetwear-inspired
fashions while in high school, using skills he learned from his father, a tailor. His intricately
handworked denim caught the attention of the designers Heron Preston and Virgil Abloh.
After collaborating with them, Best launched his own label, Who Decides War, under
the name Mrdr Brvdo in 2016. In this ensemble, he elevates repurposed denim through
couture-like treatments, spending more than forty hours meticulously stitching, shredding,
and embroidering the otherwise quotidian fabric.

Who Decides War (American, founded 2015)
Everard Best (American, born 1993)
ENSEMBLE, 2021
Jacket of blue and white cotton matelassé; trousers of blue and white cotton matelassé
embroidered with white cotton thread

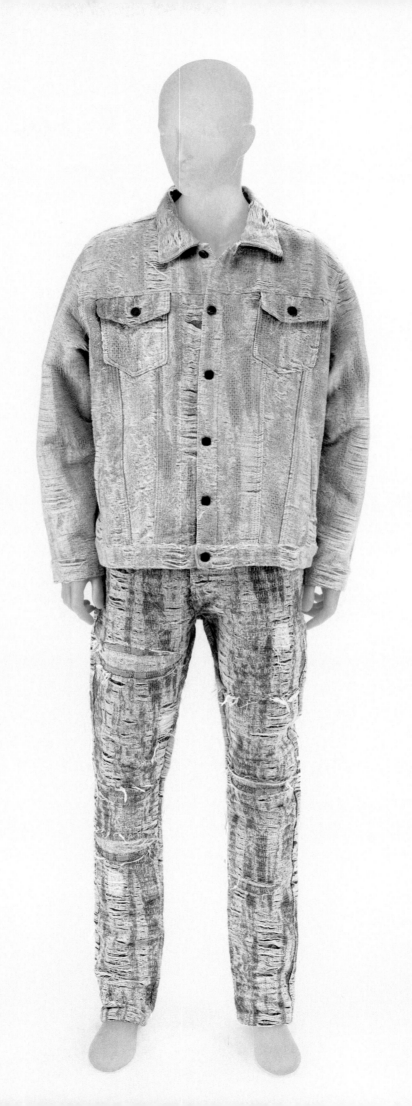

—

ACKNOWLEDGMENTS

SELECTED READINGS

INDEX OF DESIGNERS

CREDITS

—

Acknowledgments

—

I am grateful to the many people who provided generous support for the exhibition *In America: A Lexicon of Fashion* and this associated publication. In particular, I am fortunate to have had the advice and encouragement of Daniel H. Weiss, President and CEO of The Metropolitan Museum of Art; Max Hollein, Marina Kellen French Director of The Met; Quincy Houghton, Deputy Director for Exhibitions; Andrea Bayer, Deputy Director for Collections and Administration; Inka Drögemüller, Deputy Director for Digital, Education, Publications, Imaging, Library, and Live Arts; Clyde B. Jones III, Senior Vice President for Institutional Advancement; Lavita McMath Turner, Chief Diversity Officer; and Anna Wintour, Metropolitan Museum of Art Trustee, Global Editorial Director, *Vogue*, and Chief Content Officer, Condé Nast. I would also like to thank Timothée Chalamet, Billie Eilish, Amanda Gorman, and Naomi Osaka, co-chairs of the Costume Institute Benefit, and recognize honorary chair Tom Ford. I offer my special gratitude to Instagram and Adam Mosseri and Eva Chen for sponsoring the exhibition, catalogue, and this year's Costume Institute Benefit, and to Condé Nast for its longtime sponsorship of The Costume Institute's exhibitions. Their generosity has made these projects possible.

Sincere thanks go to exhibition designer Shane Valentino, LAMB Design Studio, and lighting designer Bradford Young.

Special thanks to my colleagues at The Met: Sylvia Yount, Lawrence A. Fleishman Curator in Charge of The American Wing; Amelia Peck, Marica F. Vilcek Curator of American Decorative Arts and Supervising Curator of the Antonio Ratti Textile Center; Patricia Marroquin Norby, Associate Curator of Native American Art; Tom Scally, Buildings General Manager; Taylor Miller, Buildings Manager for Exhibitions; Alicia Cheng, Head of Design; Maanik Singh Chauhan, Patrick Herron, Aichi Lee, Frank Mondragon, and Alexandre Viault of the Design Department; Gillian Fruh, Manager for Exhibitions; Douglas Hegley, Chief Digital Officer; Sofie Andersen, Melissa Bell, Paul Caro, and Kate Farrell of the Digital Department; Meryl Cohen, Chief Registrar; and Becky Bacheller of the Registrar's Office.

The Publications and Editorial Department of The Met, under the direction of Mark Polizzotti, Publisher and Editor in Chief, provided the expertise to realize this book. Special thanks to Gwen Roginsky, who oversees all Costume Institute books, along with a dedicated publication team that includes editorial manager Elizabeth Levy and editor Jane Takac Panza; production managers Nerissa Dominguez Vales and Sue Medlicott; and project coordinator Rachel High. I would also like to thank Willem van Zoetendaal, as well as Maud van Rossum, for the beautiful design and art direction of the book. Sincere thanks also to Anna-Marie Kellen for her extraordinary photographs and to Jesse Ng. We were fortunate to work with Massimo Tonolli, who oversaw the printing at Trifolio in Verona, Italy.

As always, my colleagues in The Costume Institute have been invaluable every step of the way. I extend my deepest gratitude to Tae Ahn, Nancy Chilton, Michael Downer, Alexandra Fizer, Joyce Fung, Amanda Garfinkel, Bethany Gingrich, Adam Hayes, Alyssa Hollander, Mellissa J. Huber, Mika Kiyono, Stephanie Kramer, Julie Tran Lê, Kai Marcel, Christopher Mazza, Marci K. Morimoto, Rebecca Perry, Glenn O. Petersen, Melina Plottu, Elizabeth D. Randolph, Jessica Regan, Laura Scognamiglio, Elizabeth Shaeffer, Shelly Tarter, and Anna Yanofsky.

I would also like to express my sincere appreciation to the docents, interns, volunteers, and fellows of The Costume Institute: docents Sarah Baird, Peri Clark, Ronnie Grosbard, Francesca Gysling, Ruth Henderson, Dorann Jacobowitz, Betsy Kahan, Linda Kastan, Susan Klein, Mary Massa, Charles Mayer, Ginny Poleman, Eleanore Schloss, and Charles Sroufe; interns Isaiah Anglin, Mary-Kate Farley, Emily Fuquay, Emily Mushaben, Chloe Powers, and Ayaka Sano; volunteer Tomas Avila; and fellows Sequoia Barnes, Kaelyn Garcia, Alexis Romano, and Jonathan Michael Square.

For the ongoing support of Friends of The Costume Institute, chaired by Wendi Murdoch and co-chaired by Eva Chen, Mark Guiducci, and Sylvana Ward Durrett, I am especially grateful. Sincerest thanks also to Lizzie and Jonathan Tisch for their constant friendship and encouragement. And a special thank you to Wendy Yu for endowing this position at The Costume Institute.

I would also like to thank colleagues from various departments at The Metropolitan Museum of Art for their assistance, including Young Bae; Ann M. Bailis; Peter Berson; Hillary Bliss; Emily Blumenthal; Eric Breitung; Jennifer Brown; Suhaly Bautista Carolina; Luke Chase; Joel Chatfield; Kimberly Chey; Jennie Choi; Skyla Choi; Marie Clapot; Kathrin Colburn; Clint Ross Coller; Sharon H. Cott; Cristina Del Valle; Elizabeth De Mase; Christopher DiPietro; Kate Dobie; Michael Doscher; Izabella Dudek; Sean Farrell; Jourdan Ferguson; Zoe Florence; Harrison Furey; William Scott Geffert; Leanne Graeff; Deborah Gul Haffner; Ashley J. Hall; Jason Herrick; Heidi Holder, Frederick P. and Sandra P. Rose Chair of Education; Lela Jenkins; Dennis Kaiser; Marci L. King; Aubrey L. Knox; Amy Lamberti; Claire

Lanier; Chad Lemke; Lewis Levesque; Chloe Lovelace; Matthew Lytle; Victoria Martinez; Rebecca McGinnis, Mary Jaharis Senior Managing Educator, Accessibility, Education Department; Ann Meisinger; Grace Mennell; Darcy-Tell Morales; Amy Nelson; Maria Nicolino; Jennifer Oetting; Leela Outcalt; Sarah M. Parke; Briana Parker; Morgan Pearce; Sarah Pecaut; Elizabeth Perkins; Mario Piccolino; Lisa Pilosi, Sherman Fairchild Conservator in Charge, Department of Objects Conservation; Rogelio Plasencia; Arthur Polendo; Jose Rivero; Leslye Saenz; Frederick J. Sager; Rebecca Schear; Gretchen Scott; Jessica M. Sewell; Jenn Sherman; Marianna Siciliano; Lisa Silverman Meyers; Sean Simpson; Kenneth Soehner, Arthur K. Watson Chief Librarian; Soo Hee H. Song; Yu Tang; Mabel Taylor; Kate Thompson; Limor Tomer; Kristen Vanderziel; Emma Wegner; Kenneth Weine; John L. Wielk; Anna Zepp; and Philip Zolit.

I am extremely grateful to our lenders: Altuzarra (Joseph Altuzarra, Kate Coats); APOTTS (Henry Kessler, Aaron Potts); Bill Blass (Savanah Riordan); Bode (Emily Adams Bode, Mackenzie Schmaltz, Lillian Whittaker); Thom Browne (Tianni Graham); Bstroy (Dieter Grams and Brick Owens); Tory Burch (Frances Pennington); CDLM (Chris Peters); Willy Chavarria (Dustin Hellinger); Chromat (Becca McCharen-Tran); Susan Cianciolo (Bridget Donahue, Liz Goldwyn); Collina Strada (Hillary Taymour); Dapper Dan of Harlem (Daniel Day, Jelani Day); Dauphinette (Olivia Cheng); Denim Tears (Daniel Corrigan, Tremaine Emory); Matthew Adams Dolan (Steven Threet); Eckhaus Latta (Mike Eckhaus, Zoe Latta); EMME Studio (Korina Emmerich); ERL (Emma Doherty, Eli Russell Linnetz); Fear of God (Laron Howard, Jerry Lorenzo); Tom Ford (Stephanie Ogden); Prabal Gurung (Marianna Biela, Molly Brown); Gypsy Sport (Emily Morales, Rio Uribe); Gabriela Hearst (Stephanie de Lavalette, Caroline Smith); Carolina Herrera (Stephanie Castillo, Jenna Cavanagh, Wes Gordon, Megan Thelen); Tommy Hilfiger (Rebecca Love); Hood By Air (Zacharri Lobo, Shayne Oliver); Caroline Hu; Imitation of Christ (Matthew Damhave, Tara Subkoff); Conner Ives (Andy Coppins); Marc Jacobs (Michael Ariano, Jordan Martini); Norma Kamali (Marissa Santalla); KidSuper (Colm Dillane); Calvin Klein (Jessica Barber, Vanessa Garver); Michael Kors (Madison Boudinot, Keaton McGinty, Mona Swanson); Stephanie Lake; La Réunion (Sarah Nsikak); Greg Lauren (George Macpherson); Ralph Lauren (Allison Johnson); Lavie by Claude Kameni (Claude Kameni, Eve Nguemegne); Libertine (Stephanie Adleson, Sydney Fibble, Johnson Hartig); Lou Dallas (Raffaella Hanley); LRS (Raul Solís); Isaac Mizrahi (Luke Hogan); Nihl (Neil Grotzinger); No Sesso (Pierre Davis); Off-White™ c/o Virgil Abloh (Virgil Abloh, Simon Lee, Erica Morelli); Oscar de la Renta (Fernando Garcia, Laura Kim, Vhanessa Krauter); Patricia Pastor;

Zac Posen (Stephanie Bond, Ron Burkle, Susan Posen, Molly Sorkin); Heron Preston (Sabrina Albarello, Jenna Ebbink, Emma Ferretti); Mimi Prober; Proenza Schouler (Lazaro Hernandez, Emma Loy, Jack McCollough, Tasa Stratis); Puppets and Puppets (Carly Mark); Pyer Moss (Nate Hinton, Kerby Jean-Raymond, Omari Williams); Rentrayage (Erin Beatty, Jameela Lake); Rodarte (Kate Mulleavy, Laura Mulleavy); Narciso Rodriguez (Daniel Pfeffer); Christopher John Rogers (Christina Ripley); Ralph Rucci; Savage X Fenty (Robyn Rihanna Fenty, Jess Rosales, Emma Tully); SC103 (Sophie Andes-Gascon, Claire McKinney); Jeremy Scott (Stefan Fior, Pablo Olea, Juliana Shyu); Shy Natives (Jordan Craig, Madison Craig); Christian Siriano (Catherine Lewis); LaQuan Smith (Dana Deutsch, Dylan Hunt); S.R. Studio. LA. CA. (Tamara Choksey, Sterling Ruby); Stan (Tristan Detwiler); Anna Sui (Isabelle Sui); Telfar (Telfar Clemens, Katiuscia Gregoire); The Row (Michelle Bowers, Ashley Olsen, Mary-Kate Olsen, Nicolas Turko); threeASFOUR (Gabriel Asfour, Angela Donhauser, Adi Gil); Ruben Toledo; Vaquera (Patric DiCaprio, Claire Sullivan, Bryn Taubensee); Diane von Furstenberg (Luisella Meloni, Costanza Reiser); Andre Walker (Nancy Stannard); Vera Wang (Priya Shukla); Margaret Roach Wheeler; Who Decides War (Everard Best, Téla D'Amore); YEOHLEE (Yeohlee Teng); Lily Yeung; Jean Yu; and Zero + Maria Cornejo (Maria Cornejo, Haley Lim).

I am also grateful to DK Display (Neal Rosenberg); Frank Glover Productions (Margaret Karmilowicz); and Benjamin Klemes.

Special thanks to Raul Avila, Keith Baptista, Sonja Bartlett, Remi Berger, Hamish Bowles, Tyler Britt, Miranda Brooks, Jodi Cailler, Dario Calmese, Rachel Chavkin, Fiona Da Rin, Dylan Farrell, Vinson Fraley, Carolina Gonzalez, Mark Guiducci, Mark Holgate, Dwayne Holmberg, Kimberly Jenkins, Raja Feather Kelly, Eaddy Kiernan, Catherine Kirk, Sergio Kletnoy, Hildy Kuryk, Chloe Malle, Brooke McClelland, Jessica Nichols, Chioma Nnadi, Caroline Noseworthy, Sophie Pape, Sterling Ruby, Marcus Samuelsson, Melanie Schiff, Sandy Schreier, Chloe Sevigny, Anna Suarez, Sam Sussman, Sache Taylor, Jill Weiskopf, Ashley Wolff, and Anna-Lisa Yabsley.

For their ongoing support, I would like to extend my deepest and heartfelt thanks to Paul Austin; Shannon Bell Price; Harry and Marion Bolton; Miranda, Ben, Issy, and Emily Carr; Alice Fleet; Harold Koda; Alexandra and William Lewis; Rebecca Ward; and especially Thom Browne.

Andrew Bolton
Wendy Yu Curator in Charge of The Costume Institute

Allaire, Christian. "Meet Two Northern Cheyenne Sisters Using Lingerie to Empower Indigenous Women." *Vogue*, August 14, 2019. https://www.vogue.com/vogueworld/article/shy-natives-indigenous -lingerie-jordan-madison-craig.

——. "This Indigenous Model Launched a Hand-Crocheted Knitwear Line." *Vogue*, August 24, 2021. https://www.vogue.com/article/lily -yeung-crochet-knitwear-line.

Ang, Christina. "Ji Won Choi on Dual Heritage." CFDA (website), May 19, 2020. https://cfda.com/news/ji-won-choi-on-dual-heritage.

Araujo, Aldo. "Latinx and Proud: Raul Solís." CFDA (website), October 10, 2018. https://cfda.com/news/latin-and-proud-raul-solis.

Banks, Jeffrey, and Doria de La Chapelle. *Norell: Master of American Fashion*. New York: Rizzoli Electa, 2018.

Banks, Jeffrey, et al. *Perry Ellis: An American Original*. New York: Rizzoli, 2013.

Beard, Alison. "Life's Work: An Interview with Vera Wang." *Harvard Business Review*, July 1, 2019. https://hbr.org/2019/07/lifes-work-an -interview-with-vera-wang.

Blasberg, Derek. "Fashion and Art: Proenza Schouler." *Gagosian Quarterly* (Spring 2020). https://gagosian.com/quarterly/2021/06/07 /interview-fashion-and-art-proenza-schouler/.

Bluttal, Steven, and Patricia Mears, eds. *Halston*. London: Phaidon Press, 2001.

Bobb, Brooke. "La Réunion's Patchwork Dresses Turn Symbols of Suffering into Things of Beauty." *Vogue*, August 6, 2020. https://www.vogue.com/article/la-reunion-patchwork-dresses.

Bolton, Andrew. *Anna Sui*. San Francisco: Chronicle Books, 2010.

Borrelli-Persson, Laird. "An Oral History of New York's Most Avant-Garde (and Underrated) Creators, Threeasfour." *Vogue*, September 3, 2019. https://www.vogue.com/vogueworld/article/20-years-on-fashions -fringes-an-oral-history-of-threeasfour-new-yorks-most-avant-garde -and-underrated-creators.

——. "An Oral History of Susan Cianciolo's Run Collections—and of a Long Lost 1990s New York." *Vogue*, June 20, 2017. https://www.vogue.com /projects/13532668/the-nineties-susan-cianciolo-oral-history.

——. "It's Been 20 Years Since Miguel Adrover Disrupted NYFW—Here Are All the Ways He Was Ahead of His Time." *Vogue*, September 4, 2019. https://www.vogue.com/article/its-been-20-years-since-miguel-adrover -disrupted-nyfw-8-ways-that-he-was-ahead-of-his-time.

——. "You Had to Be There: Remembering Imitation of Christ's Shock-Goth Funeral Parlor Show of Spring 2001." *Vogue*, October 24, 2019. https://www.vogue.com/article/reflections-on-imitation-of-christ -spring-2001-ready-to-wear-funeral-parlor-show.

Boy, Pam. "Ten Meets Andre Walker, the Fashion Industry's Favourite Creative Polymath." *10*, November 7, 2020. https://www.10magazine .com/menswear/andre-walker-10-men-issue-52-ten-meets/.

Brown, Sasha. "Korina Emmerich on Ethics & Sustainability." CFDA (website), June 22, 2021. https://cfda.com/news/korina-emmerich-on -ethics-sustainability.

Bullock, Allie. *Vera Maxwell Unstitched*. Self-published, Barnes & Noble Press, 2021.

Bumpus, Jessica. "Joseph Altuzarra: 'The Fashion Landscape Has Changed So Dramatically.'" *The Week*, December 15, 2020. https://www.theweek.co.uk/108864/joseph-altuzarra-interview.

Burrows, Stephen, Daniela Morera, and Phyllis Magidson. *Stephen Burrows: When Fashion Danced*. New York: Rizzoli in association with Museum of the City of New York, 2013.

Caramanica, Jon. "After Kanye, After Virgil, After Heron." *New York Times*, September 11, 2019, Style. https://www.nytimes.com/2019/09/11/style /after-kanye-after-virgil-after-heron.html.

Colón, Ana. "A Decade in, Becca McCharen-Tran Is Still Breaking the Mold with Chromat." *Glamour*, September 5, 2019. https://www.glamour.com /story/becca-mccharen-tran-chromat-10-year-anniversary-interview.

Cornejo, Maria, et al. *Zero, Maria Cornejo*. New York: Rizzoli, 2017.

Darling, Michael, ed. *Virgil Abloh: "Figures of Speech."* New York: DelMonico Books/Prestel, 2019.

Eckardt, Stephanie. "Susan Cianciolo, the '90s Artist-Designer Inspiring Eckhaus Latta." *W*, April 29, 2016. https://www.wmagazine.com/story /susan-cianciolo-eckhaus-latta-90s-artists-designers.

Elizee, Naomi. "An Interview with New York Designer Christopher John Rogers." *Teen Vogue*, February 18, 2019. https://www.teenvogue.com /story/christopher-john-rogers-interview.

Finley, Cheryl, et al. *My Soul Has Grown Deep: Black Art from the American South*. New York: Metropolitan Museum of Art, 2018.

Green, Penelope. "Todd Oldham's Life after Fashion." *New York Times*, September 12, 2015, Fashion. https://www.nytimes.com/2015/09/13 /fashion/todd-oldhams-life-after-fashion.html.

Gurung, Prabal. *Prabal Gurung: Style and Beauty with a Bite*. New York: Harry N. Abrams, 2019.

Hambleton, Merrell. "The Designer Making Dreamy Baroque Clothing in Her New York Apartment." *New York Times*, September 12, 2018, T Magazine. https://www.nytimes.com/2018/09/12/t-magazine/lou -dallas-fashion-brand-raffaella-hanley.html.

Hartig, Johnson, Thom Browne, and Betty Halbreich. *Libertine: The Creative Beauty, Humor, and Inspiration behind the Cult Label*. New York: Rizzoli, 2015.

Herrera, Carolina, and J. J. Martin, eds. *Carolina Herrera: 35 Years of Fashion*. New York: Rizzoli, 2016.

Hilfiger, Tommy, and Peter Knobler. *American Dreamer: My Life in Fashion & Business*. New York: Ballantine Books, 2016.

Hoo, Fawnia Soo. "How Christian Siriano's Inclusive Approach to Fashion Revolutionized an Industry." *Glamour*, February 9, 2018. https://www.glamour.com/story/christian-siriano-10-year-anniversary.

Hyl, Véronique. "Conner Ives Knows Weird Girls Are the Future." *ELLE*, May 27, 2021. https://www.elle.com/fashion/a36521085/conner-ives-fall-2021-interview/.

Jacobs, Marc, Grace Coddington, and Sofia Coppola. *Marc Jacobs Illustrated*. Special ed. London: Phaidon Press, 2019.

Karan, Donna, and Ingrid Sischy. *The Journey of a Woman: 20 Years of Donna Karan*. New York: Assouline, 2004.

Klein, Calvin. *Calvin Klein*. New York: Rizzoli, 2017.

Koda, Harold, et al. *Charles James: Beyond Fashion*. New York: Metropolitan Museum of Art, 2014.

Lake, Stephanie, and Jonathan Adler. *Bonnie Cashin: Chic Is Where You Find It*. New York: Rizzoli, 2016.

Macias, Ernesto. "Puppets and Puppets Serves Up Joyfully Demented Fashion." *Interview*, April 23, 2020. https://www.interviewmagazine.com/fashion/puppets-and-puppets-new-york-fashion.

Martin, Richard. *American Ingenuity: Sportswear, 1930s–1970s*. New York: Metropolitan Museum of Art, 1998.

Mears, Patricia. *American Beauty: Aesthetics and Innovation in Fashion*. New Haven, Conn.: Yale University Press, 2010.

Milbank, Caroline Rennolds. *New York Fashion: The Evolution of American Style*. New York: Harry N. Abrams, 1996.

Miller, M. H. "The Designer Changing How We Think about Fashion and Race in America." *New York Times*, March 5, 2020, T Magazine. https://www.nytimes.com/2020/03/05/t-magazine/pyer-moss-kerby-jean-raymond.html.

Moffitt, Peggy, and William Claxton. *The Rudi Gernreich Book*. Cologne: Taschen, 1999.

Moore, Booth. "LaQuan Smith Is in an Empire State of Mind." *WWD*, September 7, 2021, Fashion. https://wwd.com/fashion-news/fashion-features/laquan-smith-an-empire-state-of-mind-1234907438/.

Moss, Hilary. "Brand to Know: A Men's Wear Line Made from Vintage Quilts." *New York Times*, July 7, 2016, T Magazine. https://www.nytimes.com/2016/07/07/t-magazine/fashion/emily-adams-bode-menswear-brand.html.

Mulleavy, Kate, et al. *Rodarte: Catherine Opie, Alec Soth*. Zurich: JRP Ringier, 2010.

Nash, David. "Fabrice's Lavish Beaded Dresses Defined '80s Party Culture. It's Time He Got His Due." *Town & Country*, June 23, 2020. https://www.townandcountrymag.com/style/fashion-trends/a32870442/fabrice-fashion-designer/.

Neuhaus, Sophie. "UNIFORM by Heron Preston." Sanitation Foundation (website). Accessed December 20, 2021. https://www.sanitationfoundation.org/blog/uniform-by-heron-preston.

Obrist, Hans Ulrich. "'We're an Underground American Brand Being Mainstream.'" *System*, January 14, 2019. https://system-magazine.com/telfar-clemens/.

O'Hagan, Helen, Kathleen Laurie Rowold, and Michael Vollbracht. *Bill Blass: An American Designer*. New York: Harry N. Abrams in association with the Elizabeth Sage Historic Costume Collection, Indiana University, 2002.

Owens, Rick, and Danielle Levitt. *Rick Owens*. New York: Rizzoli, 2019.

Padilha, Roger, and Mauricio Padilha. *Stephen Sprouse: The Stephen Sprouse Book*. New York: Rizzoli, 2009.

Pearlman, Chee, Lynn Yaeger, and Isaac Mizrahi. *Isaac Mizrahi*. New York: Jewish Museum; New Haven, Conn.: Yale University Press, 2016.

Radin, Sara. "SC103 Is the New Cult Label Blurring the Lines between Practical and Absurd." *i-D* (blog). *Vice*, November 19, 2019. https://i-d.vice.com/en_uk/article/zmjd7y/sc103-is-the-new-cult-label-blurring-the-lines-between-practical-and-absurd.

Rodriguez, Narciso, et al. *Narciso Rodriguez*. New York: Rizzoli, 2008.

Roger, Robin. "Designer Shares Her Love of Sustainable Luxury." Cornell Chronicle (website), October 13, 2021. https://news.cornell.edu/stories/2021/10/designer-shares-her-love-sustainable-luxury.

Romack, Coco. "A Designer Making Clothes for Black Femmes—and for Everyone Else, Too." *New York Times*, August 10, 2020, T Magazine. https://www.nytimes.com/2020/08/10/t-magazine/pierre-davis-no-sesso.html.

Saunders, Brycen. "The Rising Unisex Label Who Brought Black Joy to Fashion Week." *Paper*, February 24, 2021. https://www.papermag.com/apotts-aaron-potts-2650733354.html.

Schneier, Matthew. "The Graduates." *New York Times*, October 18, 2018, Fashion. https://www.nytimes.com/2018/10/18/fashion/vaquera-designers.html.

Scott, Jeremy. *Jeremy Scott*. New York: Rizzoli, 2014.

Slinkard, Petra, and Mainbocher. *Making Mainbocher: The First American Couturier*. Chicago: Chicago History Museum, 2016.

Stanley, Leonard, and Mark A. Vieira. *Adrian: A Lifetime of Movie Glamour, Art and High Fashion*. New York: Rizzoli, 2019.

Steele, Valerie, and Patricia Mears. *Isabel Toledo: Fashion from the Inside Out*. New Haven, Conn.: Yale University Press in association with the Fashion Institute of Technology, 2009.

Steele, Valerie, Patricia Mears, and Clare Sauro. *Ralph Rucci: The Art of Weightlessness*. New Haven, Conn.: Yale University Press in association with the Fashion Institute of Technology, 2007.

Stein, Melody. "When the Mission Is to Be an Outcast." *New York Times*, September 15, 2015, T Magazine. https://www.nytimes.com/2015/09/15/t-magazine/gypsy-sport-designer-rio-uribe-fashion-week-spring-2016.html.

Talley, André Leon, et al. *Oscar de la Renta: His Legendary World of Style*. New York: Skira Rizzoli, 2015.

Tashjian, Rachel. "Why Collina Strada Designer Hillary Taymour Refuses to Call Her Brand Sustainable." *GQ*, February 11, 2020. https://www.gq.com/story/collina-strada-sustainable-nyfw-fall-20.

Teng, Yeohlee, Ellen Shanley, and Valerie Steele, eds. *Yeohlee: Supermodern Style*. New York: Museum at the Fashion Institute of Technology, 2001.

Trebay, Guy. "KidSuper Wants to Bring Back Warhol's Factory." *New York Times*, April 28, 2021, Fashion. https://www.nytimes.com/2021/04/28/fashion/kidsuper-wants-to-bring-back-warhols-factory.html.

——. "Men's Wear Is on a Quilt Trip." *New York Times*, February 17, 2021, Style. https://www.nytimes.com/2021/02/17/style/mens-wear-is-on-a-quilt-trip.html.

——. "Mr. Chavarria Will See You Now." *New York Times*, September 8, 2021, Style. https://www.nytimes.com/2021/09/08/style/willy-chavarria-calvin-klein.html.

Tschorn, Adam. "L.A. Designer Greg Lauren Heeds the Racial Wake-Up Call." *Los Angeles Times*, November 18, 2020, Lifestyle. https://www.latimes.com/lifestyle/story/2020-11-18/greg-lauren-label-10-patchwork-fashion-racial-equity.

Tung, Jennifer. "Unmentionables You Want to Mention." *New York Times*, December 5, 2004, Style. https://www.nytimes.com/2004/12/05/fashion/unmentionables-you-want-to-mention.html.

Way, Elizabeth, ed. *Black Designers in American Fashion*. London: Bloomsbury Visual Arts, 2021.

Well-Off-Man, Manuela, et al., eds. *Visual Voices: Contemporary Chickasaw Art*. Edmond, Okla.: Visual Voices/Chickasaw Press, 2018.

Welters, Linda, and Patricia A. Cunningham, eds. *Twentieth-Century American Fashion*. Oxford: Berg, 2005.

West, Kanye. "Shayne Oliver Tells Kanye West That He Won't Be Rushed into Creating the Future of Streetwear." *Interview*, February 27, 2019. https://www.interviewmagazine.com/fashion/shayne-oliver-tells-kanye-west-that-he-wont-be-rushed-into-creating-the-future-of-hood-by-air.

White, Brooklyn. "The Inclusivity of Savage X Fenty's Fashion Show Was a Game Changer for Fashion." *Essence*, November 4, 2020. https://www.essence.com/fashion/savage-x-fenty-show-op-ed/.

Whittle, Andrea. "Olivia Cheng, Dauphinette's Designer of Delight." *W*, November 15, 2021. https://www.wmagazine.com/fashion/dauphinette-olivia-cheng-designer-interview.

Yaeger, Lynn. "Matthew Adams Dolan on Reinventing American Cool and Working With Rihanna." *Vogue*, March 16, 2018. https://www.vogue.com/article/matthew-adams-dolan-interview-vogue-april-2018.

Yohannan, Kohle. *Claire McCardell: Redefining Modernism*. New York: Harry N. Abrams, 1998.

Yotka, Steff. "How Eli Russell Linnetz Built the Ultimate Californian Brand." *Vogue*, November 11, 2020. https://www.vogue.com/article/how-eli-russell-linnetz-built-the-ultimate-californian-brand-erl-dover-street-market-paris.

——. "Who Is Thom Browne, the Man Behind the Suit?" *Vogue*, January 11, 2018. https://www.vogue.com/article/thom-browne-interview-career-personal-life.

Index of Designers
—

Credits

—

Page VIII
The Metropolitan Museum of Art, New York, Purchase, William Cullen Bryant Fellows Gifts, 1996 (1996.4)

Pages 2, 14–15
Courtesy Heron Preston

Pages 4–5, 36–37
Courtesy Ralph Lauren Corporation

Pages 6–7
Courtesy Tristan Detwiler of Stan

Pages 8–9
Courtesy Mimi Prober

Pages 10–11
Courtesy Bode

Pages 12–13
The Metropolitan Museum of Art, New York, Gift of Serendipity3 Denim Clothing Collection, 1977 (1977.333.6)

Pages 16–17
Courtesy No Sesso

Pages 18–19
Courtesy Greg Lauren

Pages 20–21
Courtesy Rentrayage

Pages 22–23
Courtesy La Réunion

Pages 24–25
Courtesy Puppets and Puppets

Pages 26–27, 218, 228–29
Courtesy SC103

Pages 28–29, 100–101
Courtesy ERL

Pages 30, 42–43, 120–21
Courtesy Willy Chavarria

Pages 32–33
Courtesy Prabal Gurung

Pages 34–35
Courtesy LRS

Pages 38–39, 244–45
Courtesy Denim Tears

Pages 40–41, 96–97, 164–65
Courtesy PVH Archives

Pages 44, 56–57
Courtesy Lavie by Claude Kameni

Pages 46–47
Courtesy Christopher John Rogers

Pages 48–49
Courtesy Rodarte

Pages 50–51
Courtesy Oscar de la Renta Archive

Pages 52–53
Courtesy Carolina Herrera

Pages 54–55
Lent by the Zac Posen Archive, courtesy Ron Burkle

Pages 58, 60–61
The Metropolitan Museum of Art, New York, Gift of Elaine Blatt, 2005 (2005.92)

Pages 62–63
Courtesy Jeremy Scott

Pages 64–65
The Metropolitan Museum of Art, New York, Gift of Todd Oldham Studio, 2002 (2002.193.37)

Pages 66–67
The Metropolitan Museum of Art, New York, Gift of Muriel Kallis Newman, 1987 (1987.136.4)

Pages 68–69
The Metropolitan Museum of Art, New York, Gift of Amy Fine Collins, 1994 (1994.490.5)

Pages 70–71
The Metropolitan Museum of Art, New York, Gift of Jamie de Roy, 1999 (1999.375.1)

Pages 72–73
The Metropolitan Museum of Art, New York, Promised Gift of Sandy Schreier (L.2018.61.52)

Pages 74, 80–81
Courtesy Dauphinette

Pages 76–77
Courtesy Isaac Mizrahi

Pages 78–79
The Metropolitan Museum of Art, New York, Gift of Anna Sui, 2021 (2021.248.2a-c)

Pages 82–83
Courtesy Caroline Hu

Pages 84–85
Courtesy Vaquera

Pages 86–87
Courtesy Matthew Adams Dolan

Pages 88–89
Courtesy Norma Kamali

Pages 90–91
The Metropolitan Museum of Art, New York, Gift of Marc Jacobs, 2019 (2019.376a)

Pages 92, 98–99
Courtesy Fear of God

Pages 94–95
Courtesy Patricia Pastor

Pages 102–3
Courtesy Bstroy

Pages 104–5
Gift of Andrew Bolton

Pages 106–7
Courtesy Kerby Jean-Raymond and Pyer Moss

Pages 108–9
Courtesy Virgil Abloh c/o Off-White™

Pages 110, 126–27
Courtesy Savage X Fenty

Pages 112–13
The Metropolitan Museum of Art, New York, Gift of Rudi Gernreich Revocable Trust, 1985 (1985.374.24a)

Pages 114–15
Courtesy Telfar

Pages 116–17
Courtesy Nihl by Neil Grotzinger

Pages 118–19
Courtesy Hood By Air

Pages 122–23
Courtesy Christian Siriano

Pages 124–25
Courtesy Chromat

Pages 128, 144–45
Courtesy Heron Preston for DSNY

Pages 130–31
Courtesy Bill Blass

Pages 132–33
The Metropolitan Museum of Art, New York, Gift of Mark Cohen for Carmelo Pomodoro Company, 1993 (1993.90.1a–f)

Pages 134–35
The Metropolitan Museum of Art, New York, Gift of Janet Gaynor Adrian, 1960 (C.I.60.7a, b)

Pages 136–37
Courtesy Thom Browne

Pages 138–39
The Metropolitan Museum of Art, New York, Gift of Jean Stralem, 1993 (1993.463.8a–f)

Pages 140–41
The Metropolitan Museum of Art, New York, The Jacqueline Loewe Fowler Costume Collection, Gift of Jacqueline Loewe Fowler, 1983 (1983.44.6a–c)

Pages 142–43
Brooklyn Museum Costume Collection at The Metropolitan Museum of Art, Gift of the Brooklyn Museum, 2009; Gift of Helen Cookman, 1964 (2009.300.7336a)

Pages 146, 170–71
Private Archival Collection of Ralph Rucci

Pages 148–49
Brooklyn Museum Costume Collection at The Metropolitan Museum of Art, Gift of the Brooklyn Museum, 2009; Bequest of Marta C. Raymond, 1989 (2009.300.576)

Pages 150–51
Courtesy Tom Ford

Pages 152–53
Courtesy Isabel and Ruben Toledo Archives

Pages 154–55
The Metropolitan Museum of Art, New York, Gift of Rick Owens, in Celebration of the Museum's 150th Anniversary, 2020 (2020.246.2a, b)

Pages 156–57
Courtesy Vera Wang

Pages 158–59
Courtesy Jean Yu

Pages 160–61
Private collection

Pages 162–63
Courtesy LaQuan Smith

Pages 166–67
Courtesy Narciso Rodriguez

Pages 168–69
The Metropolitan Museum of Art, New York, Gift of Geoffrey Beene, 2001 (2001.393.90)

Pages 172, 186–87
The Metropolitan Museum of Art, New York, Gift of Donna Karan, in celebration of the Museum's 150th Anniversary, 2021 (2021.66.2, .3, .9)

Pages 174–75
The Metropolitan Museum of Art, New York, Gift of Claire McCardell, 1949 (C.I.49.37.41)

Pages 176–77
Private collection

Pages 178–79
Brooklyn Museum Costume Collection at The Metropolitan Museum of Art, Gift of the Brooklyn Museum, 2009; Gift of Ethel Scull, 1979 (2009.300.7975)

Pages 180–81
The Metropolitan Museum of Art, New York, Gift of Vera Maxwell, 1953 (C.I.53.61a–f)

Pages 182–83
The Metropolitan Museum of Art, New York, Gift of Helen and Philip Sills Collection of Bonnie Cashin Clothes, 1979 (1979.431.106a–c)

Pages 184–85
Courtesy Tory Burch

Pages 188–89
The Metropolitan Museum of Art, New York, Gift of Constance Montgomery, 1973 (1973.327.1a–c)

Pages 190–91
Courtesy Michael Kors Collection

Pages 192–93
Courtesy Marc Jacobs

Pages 194, 214–15
Courtesy The Row

Pages 196–97
Courtesy Collection of Diamond Wade Wheeler

Pages 198–99
Courtesy Korina Emmerich, EMME Studio

Pages 200–201
Courtesy Andre Walker Studio

Pages 202–3
Courtesy Gabriela Hearst

Pages 204–5
Courtesy APOTTS

Pages 206–7
Courtesy Stephanie Lake, The Bonnie Cashin Archive

Pages 208–9
Courtesy Proenza Schouler

Pages 210–11
Courtesy Yeohlee Teng, YEOHLEE

Pages 212–13
Courtesy Altuzarra

Pages 216–17
Courtesy Maria Cornejo for Zero + Maria Cornejo

Pages 220–21
Courtesy Conner Ives

Pages 222–23
Courtesy KidSuper by Colm Dillane

Pages 224–25
Courtesy Lou Dallas

Pages 226–27
Courtesy Eckhaus Latta

Pages 230–31
The Metropolitan Museum of Art, New York, Purchase, The Gould Family Foundation, in memory of Jo Copeland, 2021 (2021.254)

Pages 232–33
Courtesy Dapper Dan of Harlem

Pages 234–35
The Metropolitan Museum of Art, New York, Gift of Miguel Adrover, 2010 (2010.358a–d)

Pages 236–37
Courtesy Libertine

Pages 238–39
Courtesy Imitation of Christ

Pages 240–41
Courtesy Liz Goldwyn, Collection Liz Goldwyn

Pages 242–43
Courtesy threeASFOUR

Pages 246–47
Courtesy Who Decides War

This catalogue is published in conjunction with *In America: A Lexicon of Fashion*,
on view at The Metropolitan Museum of Art, New York, from September 18, 2021, through September 5, 2022.

The exhibition is made possible by Instagram.

Additional support is provided by
CONDÉ NAST

Published by The Metropolitan Museum of Art, New York
Mark Polizzotti, Publisher and Editor in Chief
Peter Antony, Associate Publisher for Production
Michael Sittenfeld, Associate Publisher for Editorial

Publication Management by Gwen Roginsky
Editorial Management by Elizabeth Levy
Edited by Jane Takac Panza
Designed by Willem van Zoetendaal, with assistance by Maud van Rossum
Production by Nerissa Dominguez Vales and Sue Medlicott, The Production Department
Project Coordination and Marketing by Rachel High

Photographs by Anna-Marie Kellen
Image Production by Jesse Ng

Typeset in Meta
Printed on 135 gsm Gardapat Kiara
Separations by Altaimage, London/New York
Printed and bound by Trifolio Srl, Verona, Italy

Cover: Conner Ives, *"The 9–5 Working Girl" Ensemble* (detail), pp. 220–21
Pages II and IV: Installation views, *In America: A Lexicon of Fashion*, The Metropolitan Museum of Art,
September 18, 2021–September 5, 2022
Page 2: Heron Preston, *Ensemble* (detail), pp. 14–15
Page 30: Willy Chavarria, *"Falling Stars" Sweater* (detail), pp. 42–43
Page 44: Lavie by Claude Kameni, *Dress* (detail), pp. 56–57
Page 58: Patrick Kelly, *Dress* (detail), pp. 60–61
Page 74: Dauphinette, *Ensembles* (detail), pp. 80–81
Page 92: Fear of God, *Ensemble* (detail), pp. 98–99
Page 110: Savage X Fenty, *Ensemble* (detail), pp. 126–27
Page 128: Heron Preston, *Ensemble* (detail), pp. 144–45
Page 146: Ralph Rucci, *"Vertebrae" Dress* (detail), pp. 170–71
Page 172: Donna Karan, *Ensemble* (detail), pp. 186–87
Page 194: The Row, *Ensemble* (detail), pp. 214–15
Page 218: SC103, *Ensemble* (detail), pp. 228–29

The Metropolitan Museum of Art
1000 Fifth Avenue
New York, New York 10028
metmuseum.org

Distributed by
Yale University Press, New Haven and London
yalebooks.com/art
yalebooks.co.uk

Cataloguing-in-Publication Data is available from the Library of Congress.
ISBN 978-1-58839-734-8

Andrew Bolton and **Amanda Garfinkel**
with **Jessica Regan** and **Stephanie Kramer**

—

IN AMERICA
A LEXICON
OF FASHION

—

*A new glossary of American fashion explores the expressive qualities of works
by pioneering designers, who established the nation's style, and
the up-and-coming designers shaping its future.*

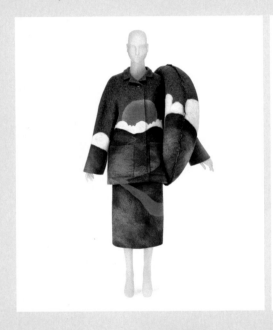
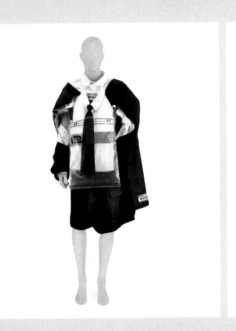
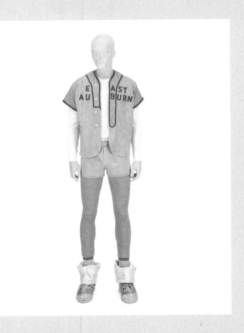

In America: A Lexicon of Fashion presents a modern vocabulary of American dress that emphasizes
emotions while not discounting the simple, practical, and egalitarian character that has traditionally
separated American ready-to-wear from European haute couture. Stunning new photography
showcases over 100 garments from the 1940s to the present that offer a timely new perspective on the
diverse and multifaceted nature of American fashion.
The catalogue features works that display qualities such as belonging, comfort, desire, exuberance,
fellowship, joy, nostalgia, optimism, reverence, spontaneity, strength, and sweetness
by well-known designers and emerging creatives, including:

Gilbert Adrian	Colm Dillane	Conner Ives	Claire McCardell
Geoffrey Beene	Perry Ellis	Charles James	Norman Norell
Thom Browne	Tremaine Emory	Kerby Jean-Raymond	Heron Preston
Bonnie Cashin	Tom Ford	Donna Karan	Christopher John Rogers
Willy Chavarria	Rudi Gernreich	Calvin Klein	Raul Solís
Olivia Cheng	Halston	Michael Kors	Hillary Taymour
Telfar Clemens	Elizabeth Hawes	Ralph Lauren	Diane von Furstenberg
Oscar de la Renta	Carolina Herrera	Vera Maxwell	Vera Wang

Hardcover; 272 pages; 236 color illustrations

ISBN 978-1-58839-734-8

9 781588 397348

PRINTED IN ITALY

THE METROPOLITAN MUSEUM OF ART, NEW YORK
DISTRIBUTED BY YALE UNIVERSITY PRESS, NEW HAVEN AND LONDON